# ART IN CONTEXT

ART

# N CONTEXT

## Jack A. Hobbs

Illinois State University

HARCOURT BRACE JOVANOVICH, INC.

New York / Chicago / San Francisco / Atlanta

To
   Marge
   Amy
   Marty

# ART IN CONTEXT

Cover photograph shows the location and surroundings of René Magritte's *Les Promenades d' Euclide,* 1955, in the collection of The Minneapolis Institute of Arts. Photographed by Gary Mortensen, through the courtesy of Gregory Hedburg, Curator of Painting.

Picture credits and acknowledgments continued on p. 309

ISBN: 0-15-503469-3

Library of Congress Catalog Card Number: 74-22510

Printed in the United States of America

# Preface

There has been a growing tendency in recent years to emphasize the purely visual aspects of the visual arts and to ignore or underplay all other aspects. But perception does not take place in a vacuum; it is influenced by a complex setting of concepts and values. *Art in Context* proceeds on the premise that interpretation and appreciation require a viewer to give at least as much attention to the intellectual and emotional elements that are involved in the meaning of a work of art as to the visual elements. It is an equally important premise of this book that these other elements are so basic to human experience that they provide the beginning student with the most direct and comprehensible introduction to art.

This book has been organized according to the major contexts and themes of art rather than the history of art. It is an approach that permits a free treatment of each topic and a broad range of examples. Works of art of different periods, places, and mediums can be compared and contrasted in ways that provide students with a far more vivid sense of the purposes as well as the forms of art. It can be shown, for example, that a twentieth-century comic-strip pilot and a bronze sculpture of a fifteenth-century

warrior served much the same purpose—even though they differed radically in just about everything else. Wherever feasible, I selected works that would not only serve to illustrate the particular points I was making but would offer striking juxtapositions that would encourage students to experience the pleasures of making their own connections and drawing their own conclusions.

The material is divided into three parts, each of which deals with a basic context of art. Part I introduces the perceptual bases of experiencing art. It discusses the visual elements of which works of art are composed, the many different forms that works of art may take, and the highly significant—but often overlooked—influence that different cultural backgrounds can have on the understanding of art. Part II, the heart of the book, is organized around such major themes as nature, sex, and myth in order to emphasize the reciprocal relationship between art and life. Part III examines the process of change in art and reviews the major developments of the modern era in a historical context, focusing on the influence of artists on one another in the evolution of new forms of expression.

The sequence of the chapters in Part II is not inviolable, and the material in all three parts can be used flexibly and can be adapted to the individual situation. Virtually all the concepts treated can be illustrated by other examples, and the instructor can easily extend the discussion to take advantage of works available in local galleries and museums.

I wish to thank the professors and doctoral students of Illinois State University whose advice I sought while I was writing this book. I am especially grateful to George D. Asdell of Glenbrook North High School, Eric Bickley and Harold Gregor of Illinois State University, Benton P. Patten of Texas Women's University, Lee A. Ransaw of Morris Brown College, and Edward Sturr of Kansas State University for their help with specific chapters; to Hugh W. Stumbo, formerly of Illinois State University, Brent Wilson of Pennsylvania State University, and the late Duane B. McCardle of Hanover Park, Illinois, for their contribution to the development

of my ideas; and to Bernard Goldman of Wayne State University, Timothy Haven of Northern Essex Community College, Isabelle Kobernick of Wayne State University, Frederick S. Levine of the University of Texas at Austin, Anne Shaver of the City College of New York, Patricia Sloane of New York City Community College, and Peter Taylor of Hudson Valley Community College, who read the manuscript at different stages and offered helpful criticism and suggestions.

I also wish to thank editors Nina Gunzenhauser, William Dyckes, and Paula F. Lewis, designer Marilyn Marcus, and photo researchers Kate Guttman, Marian Griffith, and Lynda Gordon of Harcourt Brace Jovanovich for their efforts during the critical stages of completing the book.

JACK A. HOBBS

# Contents

ART IN CONTEXT

# PERCEPTUAL CONTEXT

What we see depends in large part on *how* we see. Seeing an ordinary object such as a hamburger depends not only on the visual data of its shape and color but also on one's knowledge of hamburgers, including their taste, smell, feel, and ability to satisfy hunger. A hamburger would look very different to a person who came from a society that did not make hamburgers and who had never seen one before—regardless of his appetite.

What we see in a work of art also depends on a combination of visual data and past experience. The ability to perceive images in the lines and shapes that an artist puts on a piece of paper or canvas is not automatic. It requires practice and experience—usually when one is very young— just to develop the ability to interpret the kind of pictures that are widely familiar in one's own society.

Today, art museums and art books generally show art not only from our own society but from societies of the past and from other parts of the world. Furthermore, artists of our own society are constantly defying traditions and creating new forms of art, thus increasing the variety of art we may encounter. The knowledge and perceptual habits that we have developed in the past may therefore be inadequate for the present day. Just as if we were growing up in a new environment, we must enlarge our abilities in order to understand and enjoy a great array of unfamiliar art.

In Part I of this book we shall examine art in the perceptual context, looking first at such relative factors as how culture determines how we interpret what we see. But for the most part we shall examine the elements of vision that are common to all visual experience and that form the essential groundwork for the understanding of any art.

# 1
# Faces

You have no doubt had conversations in which you learned more from the speaker's facial expressions and bodily movements than from his words. This is true not only of emotional situations in which, for example, an angry person becomes red in the face and makes violent gestures, but also of situations in which a calm person speaks in ordinary tones. He may simply be giving you information, yet you may be left with a distinct feeling that he is hiding something from you. Or perhaps you have even gone so far as to assess a person's character or draw conclusions about his private life from a conversational encounter in which neither of these things was mentioned. These are examples of nonverbal communication.

A wrinkling of the brow, a tightening of the jaw muscles, a lowering of the eyes are examples of common facial signs that we read subconsciously. There is nothing mysterious or hocus-pocus about this; it doesn't require special schooling or a dictionary on body language to understand these signals. They are things we learn to read as a part of growing up, much as we learn to understand a spoken language. But the information that we receive from

this unspoken language is often quite different from that communicated with words. A person would have difficulty getting across factual information, such as telling you that he had just come back from a weekend of fishing in the mountains, through bodily movements alone. But he could easily convey to you his feelings about it, indeed he would probably do this unintentionally.

To what degree these signals are conscious or unconscious ones, either in our ways of expressing them or of perceiving them in others, probably depends on the individual and the situation. Just how many of these signals are conventions is an even more intriguing question. It has been observed that when an Oriental's eyes widen it usually means anger, whereas with an Occidental it almost always means surprise. Do Americans make gestures that are characteristic of them as a group when they have a stomach ache, experience grief, or fall in love? Some of our expressions, no doubt, are individual, some may be fairly common to the human race, but many are conventional, that is, rooted in the customary language of gestures of the national or racial groups to which we belong. These conventional expressions are very complex and subtle and virtually infinite in their possible manifestations.

## Art as Language

Art is another kind of nonverbal language. To the extent that it is not restricted to a specific system, this language can usually be understood by people from different nations. It makes little difference to us whether a landscape (fig. 1-1) was the work of a Dutchman or an American, because both share an artistic tradition of pictorial realism that differs from those of many non-Western cultures (fig. 1-2). But what about people who do not share this

artistic tradition, who have never seen realistic pictures or photographs? In *The Shape of Time,* art historian George Kubler described this experience with a Peruvian shepherd who had never seen a photograph before:

> . . . when I produced a photograph of him . . . he was unable to orient the flat, spotty paper or to read it as a self-portrait, for want of those complicated habits of translation which the rest of us perform from two to three dimensions without effort.

The Peruvian shepherd, because of a lack of experience with these particular pictorial conventions, could not even identify his own image. But we who have grown up with photography, movies, and similar forms of pictorial art take these things so much for granted that it is hard for us to imagine anyone in the world not being able to grasp their meaning immediately. In order to understand this, let us turn the situation around and look at an image that is not familiar to our culture.

*An Alaskan Mask*

Can we say that an Alaskan Indian mask (fig. 1-3) has no meaning at all for us? Surely anything—if we take the time to examine it closely—has *some* meaning, even if our only response to it is that it is strange, or funny, or beautifully made. All of us have stereotyped notions about primitive people who live in huts, wigwams, or igloos and who don masks for various ceremonies. These notions, simplistic as they are, may lead us to suspect that the mask has some religious meaning. Before speculating any further, however, let us study the mask in more detail. The following description will be objective; that is, we will attempt to make statements about the mask's appearance that we can all agree on.

To begin with, it is obviously a face but certainly not a very realistic image of anyone's face we've ever seen before—or hope to see. Consequently, we may say that it is a "stylized" image of a human face. The shape of the head and the arrangement of the features are asymmetrical and do not seem very precise or detailed. Most of the volume of the mask is convex, but there is a concave, or "scooped out," area surrounding the main features. The eyes and mouth are holes, but the nose grows outward from the concave area. A spiral movement starts along the edge of the scroll-shaped nose, moves around the circular eye, and is

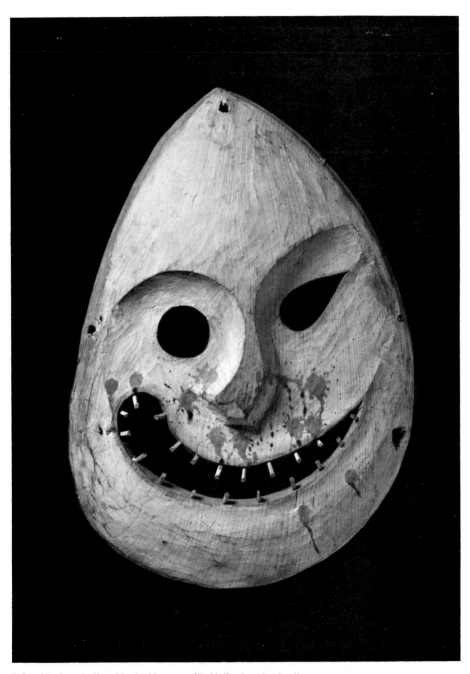

1-3  *Alaskan Indian Mask.* Museum für Volkerkunde, Berlin.

continued by the crescent-shaped mouth around to the other side of the face. There it almost joins with the s-shaped line that forms the right eyebrow and the right edge of the nose. One eye is circular, the other is almond-shaped. The surface of the mask reveals the marks of the carver's tool, and there is a spattering of color around the mouth.

With only holes to indicate the eyes and mouth, and a curving ridge for the nose, the mask offers very little information to indicate that it is intended to represent a face. Communications specialist Marshall McLuhan describes visual images like this one as being ''low in definition''; that is, they provide us with such a small amount of visual information that we are compelled to supply the rest. And because we must fill in so much of the meaning our-selves, McLuhan calls these images ''highly participational.''

We would probably try to interpret this mask in the same way that we try to interpret images of faces in our own art. Charac-teristically, we read an upturned mouth as smiling or laughing. Simple round spots or almond shapes for eyes are in themselves neutral unless in association with a pair of eyebrows that indicate a look of surprise, of scowling, or whatever. In this case, the eyebrows are represented by the gentle arcs over the eyes, which are really just segments of the whole spiral. The mouth rather than the eyes seems to offer more meaning, but it is still not very easy to understand. We are not accustomed to asymmetry in represent-ing a face. Why are the eyes different shapes? Why is the nose twisted and the mouth off to the side? Is the mask winking at us? Does it represent someone who has been frightened? Is that a laughing mouth? Or does it represent a simple-minded person or a madman?

It quickly becomes obvious that our own cultural conventions are inadequate for understanding the mask. Even if we were told that it represents a man-eating mountain demon with a blood-stained face, many things would remain unclear. We still do not know how these Alaskan Indians regarded demons. Were they all alike? Was this one to be feared or pitied? Did the Alaskan Indians represent both their benevolent and their malevolent spirits with lopsided faces? Obviously there are too many questions that would need to be answered for us to understand this particular art work. We can enjoy looking at it, but, like the Peruvian shepherd who was unfamiliar with the laws of photographic perspective, we are not able to interpret it fully.

*Peanuts*  An American looking at a comic strip of Charlie Brown and his dog Snoopy (fig. 1-4) will understand what is going on and will be able to relate it to his own experience, even though it is an improbable situation. Moreover, if he had never seen the *Peanuts* comic strip before but was a reasonably well-informed person, three years old or more, he would still understand that this is a picture of a little boy and his pet dog. Now, let us look at this comic strip as closely as we did the Alaskan mask. It is very decidedly low in definition and highly participational. If anything, it has less detail and is less realistic than the mask. Everything is perfectly expressed with extreme economy. Charlie's mouth, like that of the mask, is a simple void when he speaks. In the final frame, however, it is downturned, and we immediately interpret this as unhappiness. The eyes are no more than a pair of dots bounded by curved lines, but they help us to define his reaction. Charlie's hair is an abstract scrawl above his eyes, and Snoopy's nose is a black dot stuck to the side of his face. But because we are so familiar with these conventions of drawing, we grasp their meaning at a glance.

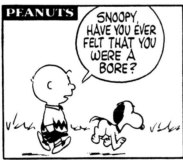
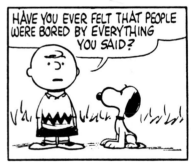
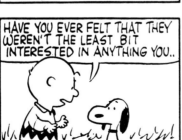
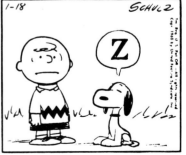

**1-4**
Charles M. Schulz,
*Charlie Brown
and Snoopy.*

We should not, however, conclude from this analysis that good cartooning is a simple art. People who try to copy a comic-strip character soon discover that one little line out of place, a minor variation in contour, or the slightest change of proportion will throw the whole thing off. And this is to say nothing of the difficulty of expressing different emotions and attitudes and making the character "come alive." One reason for the difficulty, despite how good the artist may be, is that the character is not his own creation. Charlie Brown is as much a product of the drawing habits and the personality of Charles Schulz, the creator of *Peanuts,* as he is a product of American comic-strip conventions in general. We can only admire the skill of Mr. Schulz in expressing, with only a few simple lines and a great deal of imagination, very convincing—very "real"—human situations.

*Picasso*    The celebrated artist Pablo Picasso was a great admirer of both American comic strips and the art of primitive people. Compare the face of the infant in *First Steps* (fig. 1-5) with the Alaskan mask and the face of Charlie Brown; it shares with these the distortion of "real" appearances and the low definition of detail. People who are unfamiliar with Picasso or who are unwilling to accept his personal artistic language are apt to criticize such things as the gross hands and feet, the lopsided face and body, the masklike eyes, and the abnormally foreshortened head of the mother. Oddly enough, these same critics are rarely aware of the radical distortions of anatomy that are committed daily in *Peanuts* and other comic strips. However, the difference between the art of Picasso and that of Schulz does not rest only on the fact that the latter uses more familiar conventions. A Picasso painting is not meant to be as easily understood as a frame of a Schulz cartoon. In the first place, just describing *First Steps* is a rather formidable task compared to that of describing the picture of Charlie Brown and Snoopy. In studying this painting, therefore, let us concentrate on only its more conspicuous aspects.

The dominant feature in the painting is the child's face, especially his eyes, which are wide ellipses staring straight at us. Like the Alaskan mask, the shape of the head and the arrangement of facial features are asymmetrical, but unlike the mask, which was dominated by a spiral form, the face of the infant contains lines and shapes that come and go in opposing directions. The mother's face, which is smaller than the child's, seems to be

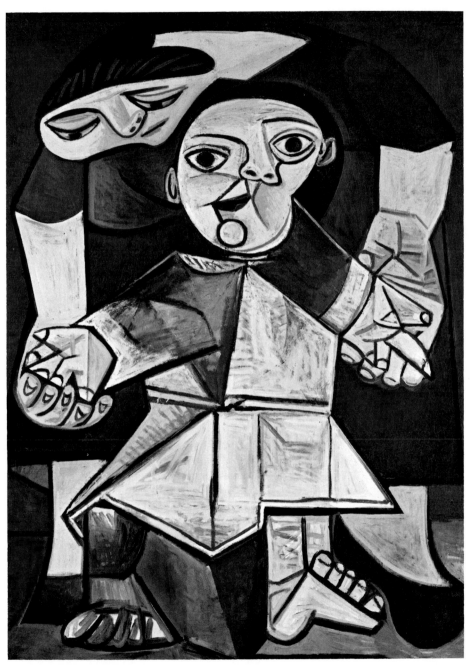

1-5  Pablo Picasso, *First Steps,* 1943. Oil on canvas, 51¼'' x 38¼''.
Yale University Art Gallery, New Haven, Connecticut (gift of Stephen C. Clark, B.A. 1903).

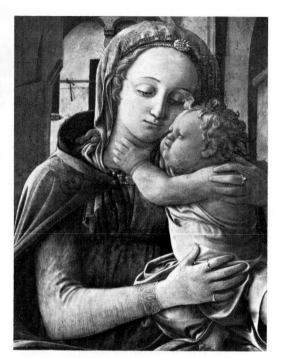

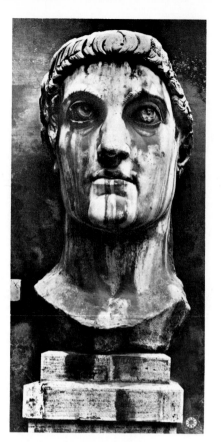

1-6  Fra Filippo Lippi, *Madonna and Child*
(detail), 1437. Galleria Nazionale
d'Arte Antica, Rome.

1-7  *Constantine the Great, c.* A.D.
330. Marble, approx. 8'6" high.
Palazzo dei Conservatori, Rome.

looking downward. Her head, neck, and body arch around the infant, while her elongated hand on the right side seems to be both prodding and supporting his hand. Although we recognize the forms of two different people, the many shapes and lines within the picture tend to confuse their separateness so that, in places, the bodies of mother and child and the space around them become a single shape. This effect can be seen at the top of the painting, where the arched lines of the mother's head, eyes, and breasts complement the lines in the child's head; at the right and left sides, where the stubbier lines of hands interpenetrate; and at the bottom, where legs, feet, and ground are all warped in similar ways.

If a *Peanuts* frame is participational art giving us only a few simple notations to indicate what is happening, then Picasso's painting is a rich puzzle of lines, shapes, and visual ideas chal-

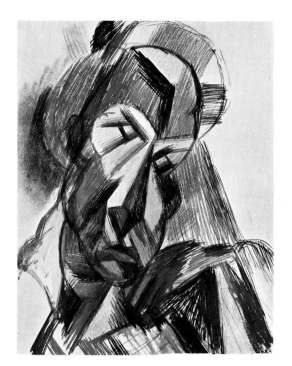

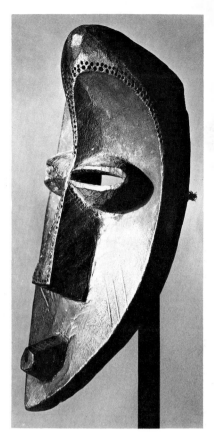

1-8  Pablo Picasso, *Head of a Woman,* 1909.
Gouache, 24¼″ x 18¾″. The Art Institute of
Chicago (Edward E. Ayer Fund).

1-9  Itumba mask. 14″ high.
The Museum of Modern Art, New York
(The Mrs. John D. Rockefeller, Jr.
Purchase Fund).

lenging us with several kinds of information. Picasso includes
references to Christian madonnas, Greco-Roman sculpture, primi-
tive masks, and his own earlier painting. But these are nonverbal
footnotes. To understand Picasso's art it is better to have some
direct knowledge of Mediterranean painting and sculpture. But
one does not have to be steeped in art history to appreciate his
art, for it is very much in the spirit of the twentieth century. By
fracturing the shapes of people and things, he created a new reality
that collapsed the traditional Western conception of time and
space; in a single picture we can see several views of a subject
simultaneously. It is worth noting that Picasso's art has even had
a significant influence on the conventions of the comic strip. Were
it not for his example, Snoopy's nose and eyes would never have
gotten together on the same side of his face.

**Meaning**    In the narrowest sense, the meaning of Picasso's *First Steps* is expressed by the title, which encourages us to see "a mother helping her infant son to take his first steps." But this alone is insufficient, just as a narrow meaning of the mask—"man-eating mountain demon"—is. To be satisfied with this level of meaning alone would be a serious impoverishment of an exceptional work of art. The subject is, in fact, nothing less than a major moment in the life of a human being—"a moment of crisis in which eagerness, determination, insecurity, and triumph are mingled," as the art critic and museum director Alfred Barr once wrote of this painting. To remain ignorant of this kind of content is to lose one of the most rewarding aspects of looking at paintings.

Yet the act of enjoying art also requires that the viewer be involved in something more than a quest for human meaning, no matter how profound that meaning might be. Examining and understanding the structure or *form* of a work of art is an essential dimension of the experience as well. In the case of *First Steps,* for example, the form consists of such things as the prominent size of the child's face and its location at the top and center of the composition, the radiating lines of his clothing, and the umbrellalike protective shape of the mother, all of which help to convey the meaning of the work, the feelings of crisis, eagerness, determination, insecurity, and triumph.

The debate over which is more important—human meaning or form—when looking at a work of art is analogous to looking at a football game: being interested in human meaning alone is like being interested only in who wins; being interested just in the form is like being interested only in how the game is played. The person whose emotional reactions are limited to whether or not his team is winning, and who does not know a good pass execution when he sees one, certainly misses a great deal of enjoyment. On the other hand, a lot of excitement—the passion of winning or losing—is lost when a person's only interest is in the strategies and techniques of playing the game.

The game analogy also lends itself to the problems people have in understanding unfamiliar art. Most Americans would be at least as puzzled seeing an English cricket match as we would be seeing an Alaskan mask. Our lack of knowledge of an Alaskan Indian's feelings about mountain demons is comparable to our lack of knowledge of a Yorkshire fan's feelings about the traditional rivalry between his team and the Lancashire team, and our ignorance

of the reasons for carving a lopsided, spiral face can be equated with our ignorance of terms like "no ball" and "wide."

We should, therefore, be sensitive to the fact that a Peruvian shepherd or an Alaskan Indian may find an American comic strip as incomprehensible as he would find our game of football. To know nothing about the anxieties of growing up in suburban America, public schools, summer camps, and peer relationships is to virtually eliminate the whole content of *Peanuts.* But before a Peruvian shepherd could even get to this point, he would still have to make sense out of the little lines and shapes drawn on the paper.

The lesson is not that one group of people is more sophisticated or more primitive than another, but that each group develops different ways of seeing and behaving. One's environment and past experience affect the way that one sees things, and the *way* that one sees, in turn, affects much of *what* one sees. Any discussion of meaning and style in art should start with this as a base. The student who desires to discover more in art must be willing to make an effort to go beyond his own present habits of looking at art.

# 2
## Seeing

Seeing is an active and complex process of handling visual information. Light waves stimulate the retina of the eye, which in turn transmits these sensations to the brain, where they are translated into a meaningful, coherent image of the world. This activity is so spontaneous and automatic that most of us are completely unaware of it. Indeed, we do not ordinarily see light sensations at all, we see things. Only those who have become sighted after being blind from birth are conscious of light sensations. At first, all that they can sense are unmanageable and unintelligible patches of color. They must *learn* to see, to discover the relationships between this confusing mosaic and the things that they have previously known only through their other senses. An orange, which was distinguished from a tennis ball by weight, texture, smell, shape, and resilience, is now more easily identified—but only when the person has been able to compare the new sensations with the old.

Not all theories of perception are in agreement over the relative importance of heredity and past experience, but most people accept the idea that acquired tendencies play some determining role

in the way we see. A multitude of things—physical development, culture, training, and past experience—predispose us to organize visual information in certain ways. But even those of us who have been sighted since birth and who have cultivated the habits and attitudes for distinguishing objects or for understanding pictures cannot feel that our vision is completely adequate for *any* task. Anyone who has tried to interpret microscope images, X-rays, or aerial photographs realizes that seeing is not necessarily the same thing as understanding. Similarly, the student who is confounded by the unfamiliar images and conceptions of modern art can sympathize with the problems of the newly sighted or the Peruvian shepherd mentioned in chapter one.

**The Visual Elements**

Georges Seurat's painting *Bathing at Asnières* (colorplate 1) could be thought of as a rectangular surface covered with different colors, yet we translate it immediately into a picture of boys along a riverbank on a hot summer afternoon.

Seurat's task as an artist was not so automatic. The images that so readily stimulate us to see boys, shimmering water, sailboats, and trees had to be carefully formed out of colors, shapes, lines, and textures—the *visual elements*. Obviously, the artist—whether he is designing a building, welding together an abstract sculpture of steel beams, or making a relatively realistic oil painting such as Seurat's—is concerned with the ultimate effect of the visual elements. Seurat struggled mightily with shapes and colors, not only to make the images of *Bathing at Asnières,* but to arrange them and produce an overall harmony. In order to get the most out of the results of his struggle (and that of other artists), it is helpful for us, the viewers, to know more about the visual elements and how they function in a work of art. The number of visual elements and their names may vary. For example, the terms "light and dark" or "value" may be used in addition to "color," and "mass" or "volume" instead of or in addition to "shape." But the intent—to identify the most basic components of a work of visual art—is always the same.

*Color*

It is commonplace to regard some things, such as gray, stone buildings, white marble statues, and black-and-white photographs, as not having color. But if we accept the idea of black, white, and gray as being part of the total domain of color, then we may

say that color is basic to all things. Color, in this sense, is at the root of all visual appearances. In addition to being fundamental to our vision, color is often capable of having such an impact on our emotions that it is probably the most powerful means available to the artist.

In order to understand the role of color in art, it would be best to analyze it in terms of its three basic properties: *hue, value,* and *saturation.* Although all three are continually and inseparably present in normal vision, they can be easily isolated and discussed for the purposes of this analysis.

HUE    Words like "red" or "green" refer to hues, the qualities that differentiate one color from another. Our perception of them is dependent on the frequency of the light waves reflected to our eyes from the surface of an object, whether it be a green leaf, a poster printed with red ink, or particles in the atmosphere that make the sky seem blue. Hue can be established with great precision by measuring light waves with scientific instruments, but for everyday purposes this is certainly not necessary. The words for color that everyone learns in childhood are quite sufficient for communicating to other people what we mean. Yellow, red, blue, green, purple, and orange are rarely confused by anyone with normal vision.

The first three of these hues—yellow, red, and blue—are supposedly sufficient for the painter, because, theoretically at least, these can be combined to create any of the others. Yellow and red make orange, yellow and blue make green, and red and blue make purple. Combining all three at once produces dull versions of the hues, or browns and grays. (The aspect of dullness in color will be discussed under the heading of saturation.) The three basic hues are therefore known as the *primary colors,* while the other three—green, purple, and orange—are called the *secondary colors.* These relationships are clearly illustrated with the use of a *color wheel* (colorplate 2), a circular chart on which each secondary color is placed between the two primary colors of which it is composed. Most color charts also include *tertiary colors,* which are those that lie between the primaries and secondaries and are created by making unequal mixtures of any two of the primaries; many variations are possible. The names of these colors are somewhat arbitrary and often exotic, such as cerulean, aqua, and turquoise to name but a few of those that lie between blue and green.

Hues that are situated alongside one another on the color wheel are called *analogous,* while those that are directly opposite each other are called *complementary*. The former tend to relate to each other, while the latter tend to contrast with each other. Seurat made use of this characteristic of complementaries in *Bathing at Asnières*. He painted those surfaces that received the light of the sun directly in variations of orange, and the shadows in variations of the complement of orange—blue or blue-violet. He further employed complementaries to separate figures from their backgrounds—a color arrangement that is sometimes referred to as *hue contrast.* The orange cap of the bather on the far right contrasts sharply with the background blue of the water. Less vivid are the variations of mahogany red of the dog and objects on the bank that are roughly complementary to the green grass. The *optical mixing* of hues, in which small strokes of single colors applied to the canvas are mixed in the viewer's vision rather than on the canvas, is a principle that Seurat expanded much further in later paintings. But he had already developed it to quite a degree in *Bathing*. Rather than physically mixing a blue-green for the water, Seurat applied individual strokes for every pigment—but with a predominance of those in the blue-green range—knowing that these colors would blend at a normal viewing distance. The same principle was later applied to color printing, with only the three primaries and black ink used to recreate even as complex a subject as this painting.

VALUE    The scale between lighter and darker color is referred to as value (colorplate 2). Had Seurat chosen to paint *Bathing at Asnières* with just a single hue—say, red—we would still be able to distinguish the river bank and the boys and the water provided he used different *values* of red. We could easily make out the shapes of figures and detail on the basis of their differences in light and dark, for an all-red visual field is essentially the same situation we find in a black-and-white photograph.

The light and dark that we experience in everyday vision is much more relative than we often realize. We tend to think that a white sheet of paper is always the same white, whether it is in bright sunlight or shadow. This effect is referred to as *color constancy*. If you don't believe that a white sheet of paper changes its color, especially its value, try placing it in shadow and comparing it with another piece of paper under the light.

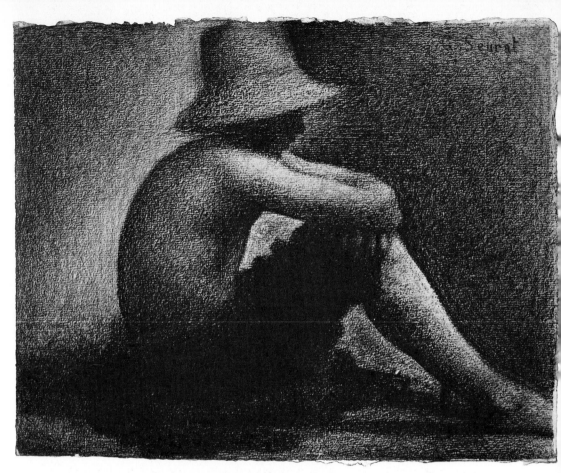

2-1  Georges Seurat, *Man with Straw Hat Sitting on Grass,* 1883–84. Conté crayon on paper, 9½″ x 11⅞″. Yale University Art Gallery, New Haven, Connecticut.

An uneven surface—such as a crumpled piece of white paper— creates many variations of light and dark, but again, because of color constancy, we perceive the paper as being just white. Artists, aware of this principle, use different values when they want to make an image appear solid. The method for showing the effect of reflected light as it plays across a solid surface was developed several centuries before the time of Seurat. Called shading or, technically, *chiaroscuro* (from the combined Italian words for light and dark), the method is admirably demonstrated in a study Seurat drew for *Bathing at Asnières* (fig. 2-1). Using broad strokes of crayon on rough-grained paper, the artist skillfully suggested the modeling of anatomical structure. The use of chiaroscuro is also clearly evident in the white of the jacket of the reclining man,

which fluctuates from light to dark as it wraps around his frame. Seurat went so far as to use a relatively dark blue-purple for the left sleeve.

Furthermore, *value contrasts,* like hue contrasts, were used in *Bathing at Asnières* to set off the figures from their surroundings. We can see the adjustments of color in the river where it forms the background of the central figure. The values of blue touching the shaded parts of the boy—his face, neck, and back—are lighter; those touching the sunlit portions—the front of his shoulder and arm—are darker. By using value contrasts, Seurat caused the figures in the foreground to stand out, while he did the opposite for those farther back. There, the values of objects and background—particularly between the buildings and the sky—are very nearly the same. This control of the relative contrasts is used to give the scene a convincing sense of depth.

SATURATION     Saturation refers to the relative purity of a color on a scale from bright to dull (colorplate 2). The oil or acrylic paints that an artist buys are intense to start with; thus, if the artist desires a strong blue, he uses the paint straight from the tube. If he wants less intensity, a ''muted'' blue, he usually makes it by mixing blue with brown or with its complement—in this case, orange. Some colors are so muted—such as most browns and grays—that they cannot be identified with any single hue and for this reason are sometimes called *neutrals*. Typically, most of the colors in a painting are intermixed and, as a result, tend to be departures from bright. But Seurat did not always mix his pigments; he preferred to use pure colors applied in individual strokes. The river, in addition to blues and blue-greens, contains dots of orange that, had they been mixed with the other paint, would have produced a dull, grayish blue. Instead, the orange interacts with the blues without sacrificing the intensity of either. We see a vibration of color, an appropriate equivalent of sparkling water.

EXPRESSIVE COLOR     Although some knowledge of color theory— such as we have just reviewed—is very helpful, the major concern when it comes to art is the effect of color on human feelings. There is no doubt that color *does* affect us emotionally, but questions still exist as to exactly why and in what ways. Without attempting to deal with these questions, some general tendencies of human responsiveness to color can be summarized.

Color qualities are often identified with thermal qualities, that is, they are said to be "warm" or "cool." Reds, yellows, and oranges are considered warm; blues, greens, and violets are considered cool. Correspondingly, we usually regard warm colors as stimulating and cool colors as relaxing. There are probably associations between this way of thinking of color and the colors of such things as fire, blood, and water. But there may also be a physiological reason to account for human responses to the different hues. Light consists of energy waves of different lengths. Warm colors have longer wave lengths than cool colors. Red, for example, has a length of about 650 millimicrons, while blue has one around 450 millimicrons.

Perhaps for the same reason, warm colors give the impression of advancing toward the viewer, while cool colors seem to recede. This effect is also achieved by the other properties of color—darker values advance over lighter values, and brighter intensities advance over duller intensities. Reasoning from this, one could assume that a red—the warmest hue—with a dark value and high intensity would advance the most. And indeed, this seems to be true. When one looks at a crowd of people in a stadium, one is invariably more aware of those who are wearing bright reds.

However, it must always be remembered that colors do not operate in isolation from each other or from the shapes to which they belong. Their effects are functions of their contexts, of their interaction with one another, and with other associations that may not even have anything to do with the work of art. The colors we perceive in Seurat's painting are not necessarily the colors that he actually used, but they may be the colors that we normally associate with people and landscapes. The contemporary painter Joseph Albers has carefully attempted to eliminate most of the factors except those of color interaction. His work often amounts to color experiments. He utilizes the tendencies of a color to advance or recede and to be affected in general by the presence of surrounding colors in order to create interesting ambiguities (colorplate 3).

*Shape*  It was pointed out earlier that color is the primary means for distinguishing shape. Therefore, technically, we cannot perceive shapes without color—or, at least, the value aspect of color. But we certainly can *conceive* of shapes independently of color. Our own bodies and the objects we live with are visualized primarily

2-2
Ellsworth Kelly,
*Untitled,* 1960.
Oil on canvas, 86" x 49".
Collection of
Mr. and Mrs. Melvin Kolbert,
Huntington Woods, Michigan.

in terms of their characteristic shapes. Indeed, in our everyday experience shape seems to take priority over color.

TWO-DIMENSIONAL SHAPES    We live in a three-dimensional world, surrounded by an infinite space in every direction and filled with three-dimensional objects. Originally, man did not think in two-dimensional terms at all. Indeed, it took him at least a million years to begin drawing images of any kind on cave walls. But after that, making marks on a flat surface—whether they functioned as images, symbols, or patterns—became one of the most common types of communication used by man in any place or at any time. To survey the nature of shape perception in two dimensions, it will be helpful to review two principles developed by Gestalt psychologists.

We say that a line or a dot or an outlined shape is *on* a page rather than *in* a page. This common usage reflects the *figure -ground* principle whereby a smaller figure (referred to by artists as the positive shape) usually seems to be on top of the background (the negative shape). This simple principle contributes to the fact that shapes in a painting can be made to seem to recede or advance according to whether they are figures or part of the ground.

2-3

2-4

2-5

Figure-ground relationships are especially visible in large simply patterned abstractions. Because it is established as a single unbroken shape, the white in Ellsworth Kelly's work *Untitled* (fig. 2-2) tends to become the figure, while the blue becomes the ground. However, partly because of the similarity of their knifelike shapes and the fact that dark values tend to advance, the dark shapes can also be interpreted as four separate figures on top of a white ground. Quite a bit of the interest in Kelly's painting derives from this shifting, conflicting, figure-ground relationship.

The tendency for incomplete figures to be completed by the perceiver is called *closure*. It occurs when a person sees a square in an arrangement of four dots—the mind's eye, so to speak, fills in and completes the latent connections along the side of the figure (fig. 2-3). Gestaltists reason that a person's mind searches for the simplest and most stable form in a complex optical situation. A square, therefore, is more satisfactory than four separate dots; similarly, a circle (fig. 2-4) is a more satisfactory form than a collection of eight dots or two overlapping squares.

But there is also reason to believe that experience plays an equal if not a more important role in the process of closure. A simple experiment demonstrates the role of prior knowledge through the use of "completion figures" that are designed to confuse a beholder. White patches on a black background (fig. 2-5) seem to resist any particular arrangement other than that of an abstract pattern. When, however, the viewer is told that the picture represents a train, the image of an approaching steam locomotive is apt to surface. Once it does, this interpretation of the completion figure becomes virtually irresistible.

Some of the most elegant examples of incomplete figures in art are found in Chinese painting (fig. 2-6), where the outlines of mountains, plants, and buildings are frequently suggested rather than actually drawn. Although these artists did not intend to confuse a beholder, the element of ambiguity encourages the viewer to search for the latent connections and to become more involved in the aesthetic experience.

THREE-DIMENSIONAL SHAPES    In our normal dealings with the world our eyes are almost always in motion. When we look at a small object—say, a seashell—we pick it up and rotate it not only to feel its surfaces with our fingers but to see its different shapes and contours with our eyes. When we look at a large object—say,

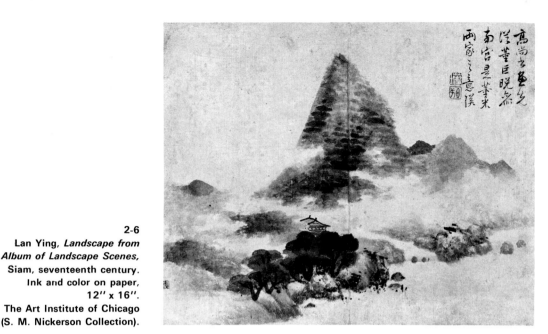

**2-6**
Lan Ying, *Landscape from Album of Landscape Scenes,* Siam, seventeenth century. Ink and color on paper, 12" x 16". The Art Institute of Chicago (S. M. Nickerson Collection).

a statue—we move around it and scan it with our eyes. Like the seashell, the statue rotates in our vision, yet we are scarcely aware of the fact that it is changing.

The constancy of our perception is an important factor in any discussion of three-dimensional shapes. When we perform the simple act of turning the cover of a book we can witness the paradox of *shape constancy*. As the cover swings toward us, its rectangular shape goes through a series of distortions (fig. 2-7). It changes to a trapezoid that grows progressively thinner, until at one point it becomes nothing more than a line that is the thickness of the cover material—its ultrathin shape contrasting with that of the rest of the unopened book. But what we perceive is an unchanging rectangular cover swinging on the hinges of the book's binding.

2-7

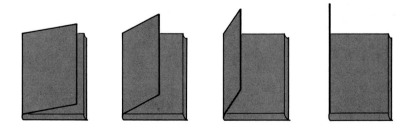

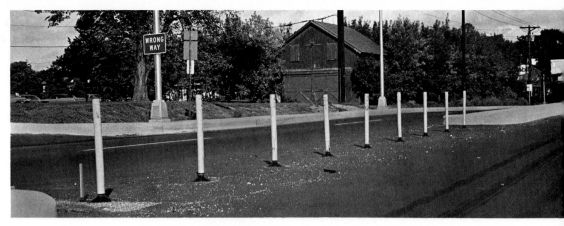

2-8

The phenomenon of shape constancy, like color constancy, has to be dealt with by the artist who tries to represent the third dimension in a flat picture. In a sense he has to distort a form in order to make it appear undistorted. The drawings of the book are a good example. The artist radically shortened the width of the cover in those drawings where it was necessary to make it appear to be a tilted plane in three-dimensional space. This is called *foreshortening.* In a natural-looking scene the use of foreshortening is much more complicated. In Seurat's painting of the bathers it is manifested in numerous places—for example, in the bodies of the dog and the man lying down in the foreground. Actually, foreshortening is present wherever anything—such as a forearm, a finger, or the brim of a hat—has to be represented in depth.

The tendency of objects to appear the same size regardless of their distance from us is called *size constancy.* A striking demonstration of this paradox is illustrated by a photograph (fig. 2-8) in which the image of the last post in a row of posts of equal height has been duplicated and placed beside the nearest one. The effect is so surprising that one is almost forced to measure the images.

The artist who tries to represent the third dimension in a flat picture also has to contend with size constancy. In order for objects in the picture to appear normal in size, he must make them larger or smaller depending on their apparent distance from the viewer. The artistic means for dealing with this problem—*linear perspective*—will be discussed in some detail a little later.

To a sculptor or an architect, shape, size, and depth are not merely things to represent in a picture; they are the bases of his art. Since he does not deal with illusions of objects but with real objects, he never has to concern himself with the methods of

foreshortening and linear perspective except, possibly, when he makes sketches for his works. The crucial difference, visually, between a painting and a piece of sculpture or architecture is that the latter are not restricted to a single point of view. A sculpture can be seen from numerous vantage points—each one showing a different shape. Yet, as was pointed out earlier, the factors of shape and size constancy operate to fuse the many different perceptions into a single perception. This would be true especially of a familiar realistic sculpture. But, in the case of an abstract sculpture that employs unfamiliar shapes in a novel composition, these factors are apt to be somewhat diminished. Barry Tinsley's *Untitled* (fig. 2-9), for example, permits a variety of interpretations because of the difficulty of establishing in the mind's eye a single configuration for the whole piece.

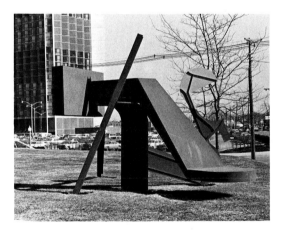

2-9 *(two views)*
**Barry Tinsley,**
***Untitled,* 1973.**
**Corten steel, 14½' high.**
**Illinois State University,**
**Normal, Illinois.**

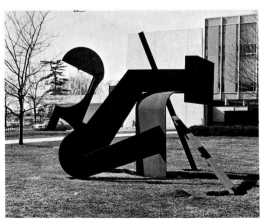

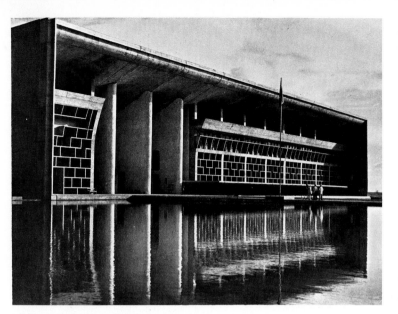

2-10 Le Corbusier, Palace of Justice,
Chandigarh, India, 1953.

2-11 Jacques Lipchitz, *Figure,*
1926. Bronze, 7'1" high.
The Hirshhorn Museum
and Sculpture Garden,
Smithsonian Institution,
Washington, D.C.

Such three-dimensional arrangements call attention to the changing spaces or "empty shapes" that exist in and around the solid shapes. Just as figure and ground are complementary in a flat painting, solid shapes and open spaces are complementary in three-dimensional art. Modern sculptors are particularly conscious of the interplay between negative and positive volumes, a concern that is shared by many modern architects. Le Corbusier's Palace of Justice in Chandigarh, India (fig. 2-10)—a magnificent illustration of the interpenetration of shape and space—is not too different from a modern sculpture by Jacques Lipchitz (fig. 2-11).

EXPRESSIVE SHAPES    We think of the shapes and spaces that we confront in our daily lives mostly in terms of their utility. But in art the consideration of shapes centers on their capacity to affect human feeling and thinking. Just as colors are spoken of as warm and cool, shapes are habitually grouped into organic and geometric categories. Organic shapes, those with curved surfaces and contours, are common in nature, while geometric shapes are almost entirely (though not exclusively) man-made. This division of shapes is accompanied by a set of associations, such as nature versus technology, human beings versus machines, or even life versus

death. The contrast between curved and straight (or round and rectangular) also inspires similar analogies of soft versus hard, feminine versus masculine, or affection versus indifference.

But, again, human feelings toward particular shapes cannot be isolated from numerous other factors within a context. As with colors, the expressiveness of shapes is a function of complex inter-relationships. Jean Arp frequently posed the theme of a life force with abstract sculptures of undulating, organic shapes. His small bronze sculpture *Growth* (fig. 2-12), a smooth compound of botanical and human sexual anatomy, unquestionably refers to the principle of life and procreation. But, because of the smooth finish and the continuous and unbroken envelope of surface, it also possesses a quality of self-containment that somewhat diminishes the sense of human involvement. Moreover, its twisting form and shining surface tend to suggest coldblooded rather than warm-blooded growth.

2-12
Jean Arp, *Growth,* 1938.
Bronze, 31½" high.
Philadelphia Museum of Art
(gift of Curt Valentin).

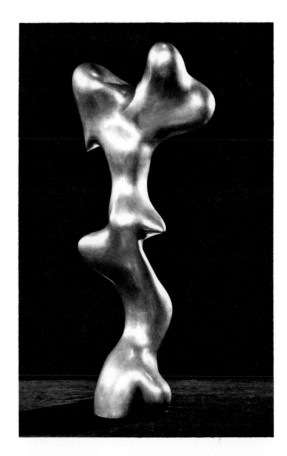

*Line*    In a sense, lines can be considered another species of the category of shapes—that is, very thin shapes. Practically, however, lines are easily distinguished from shapes in normal perception and thinking. It has been said that lines do not exist in nature, an aphorism that is intended to remind us of the fact that the Creator did not start out forming the earth and all its inhabitants by drawing outlines, as many human artists do when they start to create a picture. Yet nature did not exclude lines; they can be perceived everywhere—in the veins of leaves, in the spiny ridges on sea shells and crustaceans, or in the stalks of reeds.

In art, lines are very common and frequently crucial. The earliest visual expressions of a child are usually in the form of lines made either with a pointed instrument on a piece of paper (or wall) or with a blunt finger tracing a path through food on a plate. These first artistic efforts are probably inspired by the child's delight in seeing a record of his bodily movement and by pride in being able to leave a personal mark on his environment. Conscious image-making (fig. 2-13) occurs later when he names the scribbles ''Mommy'' or ''Daddy'' and eventually begins to delineate his forms to represent or symbolize specific aspects of his world. The important point is that, artistically, youngsters typically externalize their ideas and concepts in terms of line.

(*left*)  2-13
Martin Hobbs,
*Mommy and Daddy*, 1973.

(*right*)  2-15
Jackson Pollock,
*No. 3*, 1951.
Oil on canvas, 56⅛" x 24".
Collection of
Robert W. Ossorio.

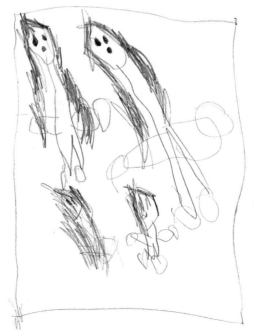

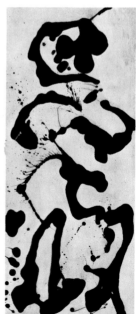

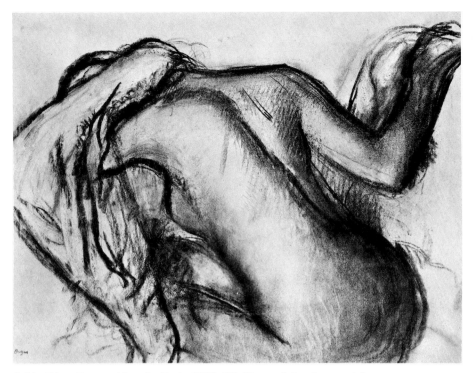

2-14  Edgar Degas, *After the Bath*, 1890–92. Charcoal drawing on pink paper,
19¾'' x 25⅝''. Fogg Art Museum, Harvard University, Cambridge,
Massachusetts (bequest of Meta and Paul J. Sachs).

FUNCTIONS OF LINES    Lines can be used as notations about the
shape of an object, or they can be refined and detailed to create
a highly finished and informative product. In Edgar Degas' *After
the Bath* (fig. 2-14), a stick of charcoal has been used to sketch
a very general impression of a woman drying her hair. Yet for all
its apparent simplicity, the drawing uses line in a highly sophis-
ticated way. The lines in the woman's shoulders and upper back
not only serve to indicate the outline of her body, but to suggest
the volumes of her back and even the soft texture of her skin.
In short, line in Degas' drawing is used primarily for repre-
sentation. In the twentieth century, however, abstract art has
liberated line from the need to represent things and has served
to promote its expressiveness (fig. 2-15).

EXPRESSIVE LINES    Whether intentionally used for expression or
for description, lines are, in one sense, inescapably expressive.
This claim is premised on the belief that expression is an exterior
sign of personal behavior and the fact that lines, like personal

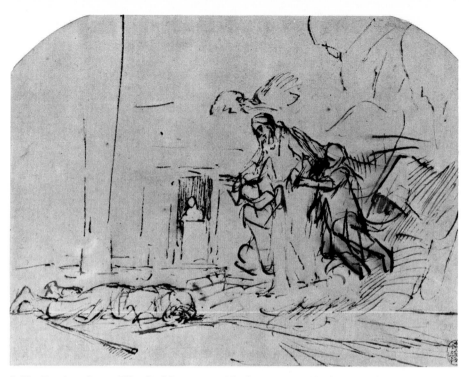

2-16  Rembrandt van Rijn, *God Announces His Covenant to Abraham, c.* **1656.**
**Kupferstichkabinett, Dresden.**

handwriting, are a fairly direct consequence of an artist's habits and thinking.

Rembrandt made numerous drawings of religious subjects. In *God and Abraham* (fig. 2-16), Abraham is shown lying flat on the ground out of fear and his sense of unworthiness in the presence of God. Using a reed pen, Rembrandt rendered the figures of God, the angels, and Abraham with rapid, spontaneous strokes. Abraham's thoroughly abject position has been effectively created out of a few touches of line; God's gesture of goodwill, as he says "Fear not, Abraham, I am thy protector," has been captured by a few coarse slashes. In addition to the content derived from the identities of the figures, the gestural qualities of the lines have an intensity that suggests a spirit of religious devotion.

Contrast Rembrandt's rough and intermittent strokes with Picasso's flowing, leisurely line in the portrait of the composer Igor Stravinsky (fig. 2-17). The fact that each drawing is firm, knowledgeable, and economical in its use of lines underscores their qualitative differences, which are due more to their individual personalities than to their different subject matters.

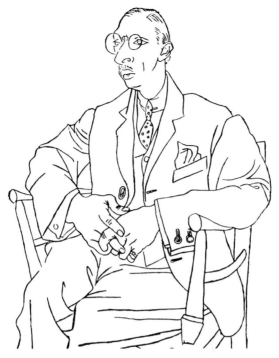

2-17   Pablo Picasso, *Portrait of Igor Stravinsky*, 1920.
Private collection.

*Texture*   The term texture is used to refer to the *surface* qualities of things. The best way to find out about the texture of something is by feeling, stroking, probing, and squeezing it. Our earliest experiences with the world around us involved the sense of touch more than the sense of sight. As we all know, infants learn about their environment through touching things and putting them in their mouths. As they grow older, however, they become more accustomed to learning about things by just looking—not only because handling objects can be dangerous, but because the senses of touch and taste often conflict with the adult sense of decorum. Thus, despite the advantage of touch over sight, most of our day-by-day information about texture comes by means of the latter. Yet the sight of certain textures still stimulates our sense of touch; texture is experienced vicariously.

Visually, information about texture is transmitted by the ways in which different materials affect the light that falls on their surfaces. A rough surface with bumps or pores will cast many little shadows, a low-lustre surface will absorb light, and a glossy one will reflect it. In other words, texture as perceived through the eyes

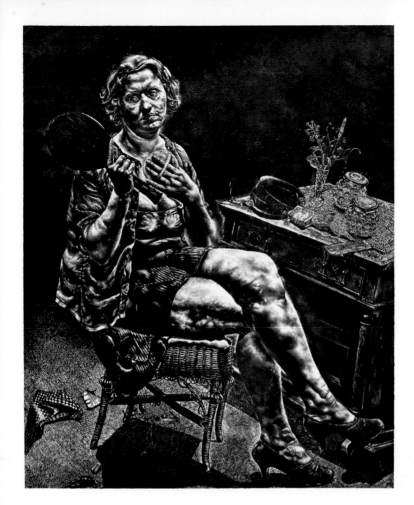

2-18
Ivan Albright,
*Into the World There Came
a Soul Called Ida,* 1929–30.
Oil on canvas, 56⅛'' x 47''.
The Art Institute of Chicago
(Collection of Mr.
and Mrs. Ivan Albright).

is essentially the same as the visual elements of color and shape. Just as a line can be considered simply a very thin shape, a texture can be thought of as a pattern of light and dark on a small scale. Indeed, texture can be considered as a function of scale. Viewed from nearby, the trunk and the spreading branches of a tree would be considered the shape, while the bark would be considered the texture. But viewed from an airplane, a whole tree becomes part of the texture of a landscape; from high above, the sight of tree-covered land resembles that of a thick carpet. On the other hand, the texture of bark at close range is seen to be made up of small shapes and patterns.

In painting, texture can take two different forms. In works that imitate reality, texture is usually simulated; that is, by means of light and dark patterns the artist creates the illusion of texture.

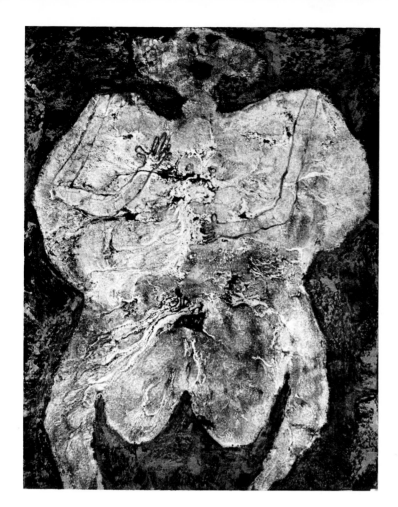

The other approach to texture has to do with the physical character of the art object itself—the paint, the canvas, or some material that is attached to the surface. Usually one or the other of these predominates, but either can have a decisive effect upon the meaning. The effect of texture is basic to two artists' treatments of a similar subject that employ radically different textural means. In Ivan Albright's *Into the World There Came a Soul Called Ida* (fig. 2-18), the simulated textures of a wicker chair, a vanity, cosmetic jars, clothing and, especially, middle-aged flesh do much of the work in suggesting the process of human aging and deterioration. In Jean Dubuffet's *Tree of Fluids* (fig. 2-19), it is the paint itself that seems to be deteriorating. Here the material existence of the art object participates symbolically in a statement about the spiritual existence of women.

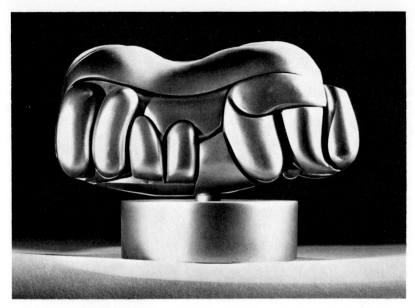

2-20   Miguel Berrocal, *Romeo and Juliet,* 1964. Bronze, 4¾″ x 8¼″ x 3½″.
Courtesy Albert Loeb Gallery, Paris.

Texture is even more fundamental in sculpture, and art historian Herbert Read fervently advocated the role of tactile values in its appreciation.

> For the sculptor, tactile values are not an illusion to be created on a two-dimensional plane: they constitute a reality to be conveyed directly, as existent mass. Sculpture is an art of *palpation*—an art that gives satisfaction in the touching and handling of objects. That, indeed, is the only way in which we can have direct sensations of the three-dimensional shape of an object.

Read goes on to lament the fact that visitors to a museum are not allowed to touch the art works. But even Read might concede that the human faculty of visual perception, together with previous experience and imagination, is enormously capable of appreciating the tactile values of a piece of sculpture without actually touching it. It would certainly be a pleasant experience to pick up and to fondle the Berrocal bronze (fig. 2-20). But even though we have never touched one, we have handled other metal objects, and just the sight of this sculpture, even in a photograph, can stimulate us to imagine its cool metallic feel, its weight, and perhaps even its smell.

**Organizing the Visual Elements**

All of the visual arts require the careful organization of the visual elements in order to create a successful work. These problems come under the heading of "design" or "composition." In the past century this aspect of art has become of increasing concern to the professional artist, leading to abstract works that focus almost entirely on questions of design. To the layman, design is of concern in so far as it aids his own perception and appreciation of art. It will be helpful, then, to investigate two fundamental concepts of organization as they can apply to painting: illusionistic and formal. In the first, the general idea is to imitate visual reality; in the second, the objective is to make the forms function together as a satisfying, harmonious whole. In the first, the physical surface, or picture plane, is treated like a window through which the viewer is intended to look into an imaginary space beyond the plane. In the second, the picture plane is treated as a physical fact; the shapes and colors are thought of as existing on the surface and moving the viewer's attention parallel with the plane, back and forth within a depth that is no thicker than the materials used. However, it should be pointed out that in most art these concepts are not completely separated. Meticulously realistic paintings are usually tightly organized in terms of the forms, while a great many abstract paintings show considerable spatial depth.

**Illusionistic Organization**

Seurat's *Bathing at Asnières* represents space in a variety of ways. Perhaps the most obvious is the chiaroscuro modeling of the figures with sun and shadow, which was commented on earlier. Then there is the *placement* of things higher or lower on the canvas, which contributes to a sensation of depth because we tend to think of things that are higher in a picture as being further back, as they are in our own vision. The consistent *overlapping* of individuals and objects also strengthens the impression of nearness and farness. Another means is *aerial perspective,* a coloring approach that suggests differences in atmospheric conditions. It is established here by the reduction of color contrasts—both in hue and value—and by the lowering of color intensity the further back the scene goes. Both the water and grass demonstrate another system known as *gradient of texture,* in which the "grain" of the material diminishes with distance. The little lozenge-shaped daubs of paint that Seurat used to indicate ripples of water or blades of grass become progressively smaller and more closely spaced in the background.

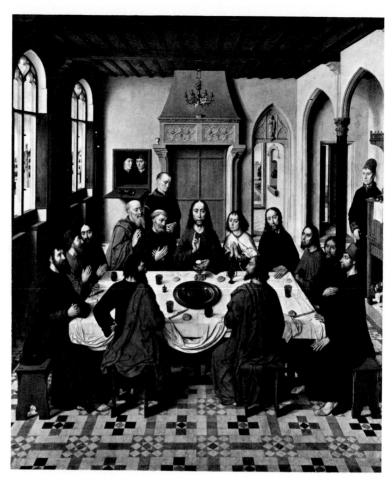

2-22 Dirk Bouts, *The Last Supper* (center panel), 1464–68.
Oil on wood, 6' x 5'. St. Peter's, Louvain.

The most useful system of spatial representation Seurat employed is that of *linear perspective,* which dictates the relative size of things according to their locations in space. This technique was not developed until the early fifteenth century, but it was widely used in nearly all painting until the beginning of the twentieth century. Its basic principles are most easily demonstrated with a set of drawings of railroad tracks. The simplest (and earliest) form of linear perspective is that in which all of the converging lines meet, or would meet if continued, at the same point on the horizon. In *single-point perspective* (fig. 2-21) there is a set of parallel lines,

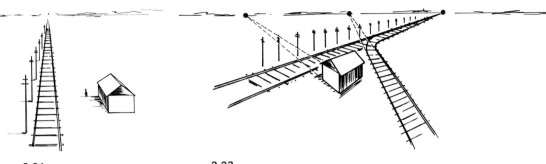

**2-21**
Single-point perspective.

**2-23**
Multiple-point perspective.

**2-24**
Single-point perspective from a low angle.

representing the ties of the track, and another set of lines, representing the rails, that converge at a point near the horizon known as the *vanishing point.* Because we have become accustomed to this system of representation in childhood, we are able to interpret these lines of ties and rails as actually being at right angles to each other, and, as long as the vanishing point is on the horizon, they will appear to us to be level with the plane of the ground. *Multiple-point perspective* is a slightly more complicated system that escapes the stage-set look of single-point perspective (fig. 2-22) by supplying additional vanishing points for other sets of lines. Any additional features, such as the tracks and ties of the spur line (fig. 2-23), will require a new set of vanishing points. The final illustration (fig. 2-24) demonstrates the effect of lowering the horizon (or eye level) line.

Although Seurat's painting presents a somewhat more complicated situation than that of the railroad lines, we can still see that the sizes of the people in the picture are progressively reduced according to their relative distances. The eye level is on a line somewhere just under the distant bridge line that is intersected by the head of the central figure. Specific vanishing points are difficult to locate, because the few linear features are almost all on the horizon.

*Formal*
*Organization* Certain principles govern the composition of works of art and are partially responsible for our feeling that a work is successful or not. Perhaps the first of these is *unity,* the artist's ability to make the visual elements and subject matter work well together. In a painting like *Bathing at Asnières,* with its apparently accidental subject matter, the variety was undoubtedly very challenging to the artist. Yet we sense the unity of the picture immediately.

Several of the principles of visual organization help to explain how the variety of Seurat's painting was brought under control and made to work as a unity. *Proximity,* the nearness of individual things making them seem to combine into a single unit, is a very important factor in Seurat's work. It exists, as we have seen earlier, on the most basic level, causing the individual brushstrokes to coalesce into a shimmering field of color, and it is also important in the composition of the figures and objects in the scene. The three boys on the right seem to be connected in a single, almost triangular, form that is repeated in the smaller triangles that result from the way one is sitting, another bending, a third holding his hands to his mouth; and the same is true of the clothed figures on the bank, who echo both the triangular module and the strong diagonal of the river's edge. This tendency is referred to as *similarity,* and it can exist in other visual elements as well as those of shape and direction. Color similarity is a conspicuous unifying device in *Bathing at Asnières.* Note how orange tones connect the swimmers, the dog, and the pillow, and how the light values, including those of the skin, clothing, and sails, pulsate across the whole surface. *Continuity* can be achieved by a line, a shape, or a series of units that connect to form a passage or a direction. A major element of continuity of *Bathing at Asnières* is the color blue, which forms the largest single shape. Another is the edge of the river bank, which, incidentally, is not broken by the large, seated bather in the center. The lighter value of his skin blends

in generally with the river, while the darker value of his trunks picks up and continues the contour of the river-bank edge. Commanding the whole painting is the shadowed head of the central bather, the *dominance* of which is established by its isolation from nearby features and by its location just above and to the right of center. Intersecting the line of objects on the shimmering horizon, the head acts as a link between foreground and background. As the major focal point, the bather is highly influential, both visually and psychologically, in the way we interpret the painting. His monumental stillness affects all the other aspects of the painting and underscores the quality of summer torpor.

## Summary

The visual process—the principal means by which we gain most of our knowledge of the world—is probably also the main vehicle of our pleasure and emotional stimulation. Imagine, if you can, what the world would be like without sight.

As was stated at the beginning of this chapter, seeing is an active process; but for most types of seeing, the activity is largely unconscious—so overlearned from childhood that it is an effortless routine. Yet some types of seeing—looking at art, for example—may require more than a little conscious effort. Much is made of the fact that it takes a lot of learning to make art; it is equally true that it requires learning to see art.

There is, of course, more to art than seeing: sensitivity, intellect, imagination, and reflection bring it all together. But after reflection we return to seeing with a more informed and renewed vision. The whole process of viewing art is a continual interaction between vision and meaning, each enriching the other.

# 3

## The
## Object

Apart from its subject matter and its emotional effect, a work of art must also be considered as a physical object. That is, it is created with physical elements that affect the work as much as the visual ones. A sculpture will not look the same in marble as in wood or bronze, not only because of the qualities peculiar to each material but because each requires the artist to work in a different way. And if we are to understand and enjoy works of art, then we must learn to appreciate the way materials are used.

The means with which art is created—the techniques and materials—are known as the medium. Oil paint is considered a medium, as are marble, wood, bronze, and television. For our purposes, it will be sufficient to cover only the most traditional media and a few of the more recent ones that constitute a useful and meaningful break with past ways of thinking about art.

**Plane-Surface Media**

Paintings, drawings, prints, posters, and pottery decorations are all examples of plane-surface art. The significant attribute of anything in this category is its flat, continuous surface (although it may bend around a form such as a vase). Painting is the most

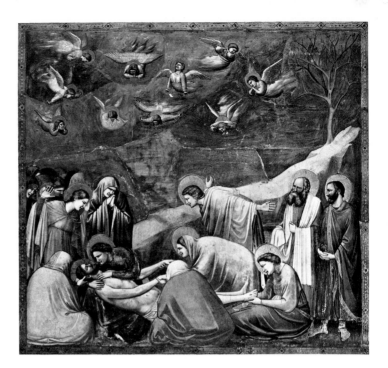

3-1
Giotto, *Lamentation,* 1305–06.
Fresco, 7'7'' x 7'9''.
Arena Chapel, Padua.

common form of plane-surface art and consists essentially of applying colors made of pigments mixed with a *vehicle* (a liquid such as water, or oil), to a surface of some kind (the *support*).

*Fresco*    To paint murals on the walls of a chapel in Padua, Italy, in the early 1300s, Giotto di Bondone employed the method of *fresco,* a popular technique in Europe during the Middle Ages and the Renaissance (fig. 3-1). True fresco consists of painting on fresh, wet plaster with pigments mixed with water. The advantage of working directly in the plaster is simply that it is more permanent; painting over dry plaster is likely to cause flaking. The thin layer of plaster intended for the paint must be applied day by day, and Giotto therefore had to plan ahead to ensure that the day's work would end at the edges of a figure or other prominent feature in the composition. He was unable to make corrections or repaint an area without removing the old plaster and redoing the unsatisfactory portion on a new base.

*Tempera*    For movable, smaller-scale works, such as altarpieces, artists in Giotto's day used wood as a support. They painted with *egg tempera,* a medium of pigment mixed with egg yolk and water. However, this also dried rapidly and did not blend easily, so that color mixing had to be accomplished by painting in short, fine brush-

strokes (*hatching*) that allowed the painting layer below to show through—a technique not unlike that which Seurat was to use.

*Oil*     By the 1400s, artists began to combine pigments with oil. When specially treated canvas was introduced as a support to replace wood, *oil painting* was universally adopted and overtook the popularity of both fresco and tempera. The mobility provided by a strong, elastic medium on a lightweight support accounted for the immediate acceptance (and enduring popularity) of oil on canvas. But the real breakthrough had to do with the flexibility of the oil medium itself. Unlike fresco, oil paint dries slowly enough that the artist may take up or leave off wherever he chooses and may change an area without having to start over. Unlike tempera, the proportion of pigment to liquid is not fixed. This allows greater control over degrees of transparency and thickness of paint layers and makes possible the subtlest variations of light and color. To catalogue the different ways oil can be used and the effects that can be obtained from its use would be virtually to recite the history of European painting from the sixteenth century to the present. By the early nineteenth century, the medium of oil had already been put to the service of many different effects, and French artist Eugene Delacroix used as many of these as he could—as well as some unusual effects of his own (colorplate 4). Dedicated to arousing the romantic imaginations of his time, Delacroix portrayed his exotic subjects in an impetuous, colorful style that at times was almost electrifying, and took great pains to keep the surface of his pictures alive with rich, thick strokes of paint.

*Acrylic*     Today the idea that paint and color have intrinsic dramatic powers is axiomatic, and experimentation with this aspect alone has occupied many artists. It has found its fullest expression in works by abstract painters such as Morris Louis (colorplate 5). Yet in spite of a fundamental belief in the expressive qualities of the paint itself, Louis's methods differed greatly from those of both Delacroix and many of his own contemporaries. Instead of oils, he used *acrylic paint,* one of the synthetic mediums developed since the Second World War. Acrylics can be used to imitate almost all the effects of oils, and they are more versatile and durable. Although their qualitative differences in surface appearance may be negligible to the average observer, to the artist their differences in "working" texture are often crucial. Oil offers far more resistance to the brush. Acrylics can be mixed with water and are much faster

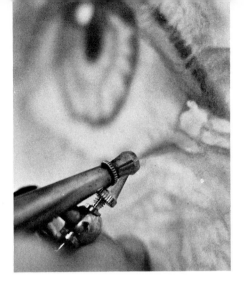

**3-2**
**Painting with an airbrush.**

drying, traits that can be considered either advantages or disadvantages depending on the artist and what he is trying to do. Louis turned the water-soluble characteristic of acrylic into an important aesthetic advantage by spilling the paint directly onto raw canvas—something he was unable to do with oils since oil decays cloth. (For oil paintings, canvas has to be treated by sizing—applying a material such as liquid glue to seal its surface—prior to the application of paint.) Louis's paint permeated the canvas, staining it rather than lying on the surface in layers of varying thicknesses.

*Airbrush*  Another modern technique that has enabled artists to achieve things that were previously impossible is one that was used by commercial artists for many years before its potential was recognized. The *airbrush* is a type of spraygun that can be adjusted from a narrow stream to a broad spray of paint. It differs from the paintbrush in that the instrument never touches the canvas—and consequently leaves an absolutely smooth, evenly shaded surface on the painting (fig. 3-2). The first group of artists to make serious use of it were the Photo-Realists of the late 1960s, most notably Chuck Close, who adapted it to an imitation of the color printing process. Working from photographs that separate the primary hues, Close re-creates each area of the face three different times to produce a full-color picture (colorplate 30).

*Woodcut*  Prints of all kinds are usually produced on paper, like drawings and watercolors, but they are distinct from other media in the plane-surface category in that they involve the production of numerous identical editions of a single work by means of partially mechanical methods. Not surprisingly, these techniques were

45  *N. Remke*

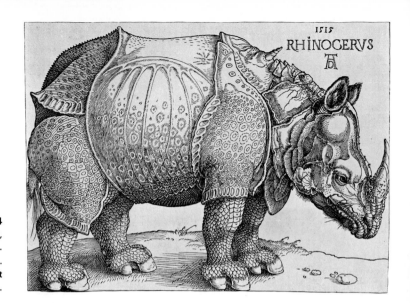

**3-4**
**Albrecht Dürer,**
*The Rhinoceros,* **1515.**
**Woodcut, 8⅜″ x 11⅝″.**
**The Metropolitan Museum of Art**
**(gift of Junius S. Morgan, 1919).**

begun at about the same time as book printing. The dissemination of knowledge was facilitated by the labors of artisans who translated drawings and paintings into the various printmaking media, which were then used to make hundreds of black-and-white reproductions. The technology of printmaking was also adapted by some artists as tools for personal expression.

The *woodcut* is the oldest of the major techniques, a form of *relief printing* (fig. 3-3) made by drawing an image on a block of wood and by cutting away the areas that are to remain white. After the image has been rubbed with ink, it can be printed under moderate pressure. Albrecht Dürer established a reputation in the sixteenth century for his extraordinary woodcuts. Today we are still awed by his mastery of the medium, by the precision and control that made possible such complex and fine-lined pictures (fig. 3-4).

**3-3**
**Relief printing.**

*Etching*
*and Aquatint*

*Intaglio printing* (fig. 3-5) is the opposite of relief printing. The image is cut into a metal or wooden surface and printed with ink that is rubbed into those lines. The material may be cut with special gouges, as in *engraving,* scratched with a needle, as in *drypoint,* or dissolved with acid, as in *etching.* In etching, the most popular of the three methods, the metal plate is covered with a wax-base material in which lines are made with a needle. When the plate is placed in an acid bath, the exposed parts are eaten away. Shadings can be achieved by covering some lines with varnish and allowing others to be ''bitten'' deeper in repeated immersions. More subtle tones can be obtained by bonding particles of resin

**3-5**
**Intaglio printing.**

to the plate surface before placing it in the acid, a technique called *aquatint*. In a Rembrandt etching the velvety blacks were a result of the denser, more deeply bitten masses of lines (fig. 3-6), while Goya's cloudy shadows were achieved with aquatint (fig. 3-7). The etching medium, which permits in-progress adjustments and encourages the accumulation of darker and richer accents, was admirably suited to the introspective styles of both these artists.

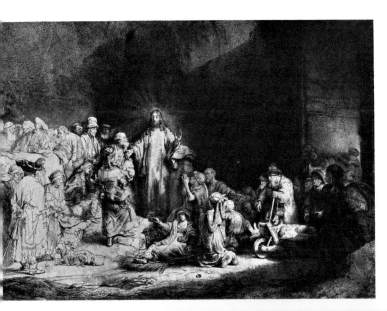

**3-6**
**Rembrandt van Rijn,**
*Christ Healing the Sick, c.* 1649.
**Etching and drypoint**
**(second state), 11″ x 15½″.**
**The Art Institute of Chicago**
**(The John H. Wrenn Memorial**
**Collection, bequest of Ethel Wrenn).**

**3-7**
**Francisco Goya,**
*Unbridled Folly,*
*c.* 1815–24.
**Etching and aquatint,**
**9¾″ x 13¾″.**
**Calcografía Nacional,**
**Madrid.**

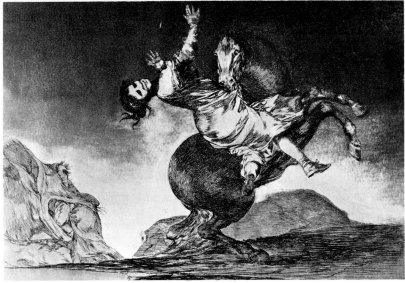

## Lithography

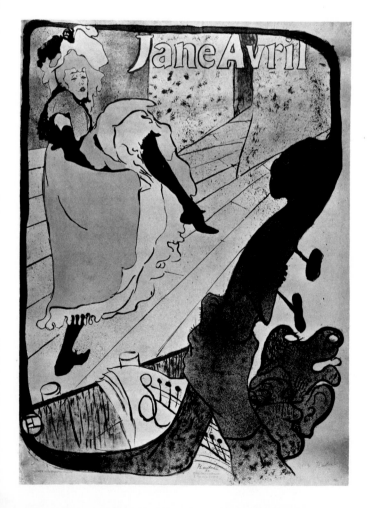

**3-8**
**Planographic**
**printing.**

*Lithography* is a *planographic* (fig. 3-8) system of printing. It involves drawing or painting directly onto a special form of limestone or a zinc or aluminum plate with a greasy crayon or liquid. The working surface is then treated with chemicals, so that the area with the image will resist water. During the printing process the stone is dampened, and the uncovered areas, being wet, will not accept the ink. Lithography allows more freedom and directness in the drawing phase, and a great variety of line, texture, and shading is possible. Henri de Toulouse-Lautrec, whose art emphasizes the spontaneous and witty, found lithography perfectly suited to his uninhibited approach. He also furthered the medium's possibilities through his own technical experiments and unorthodox style (fig. 3-9).

**3-9**
**Henri de Toulouse-Lautrec,**
*Jane Avril Jardin de Paris,* **1893.**
**Color lithographic poster, 48⅞" x 35".**
**The Museum of Modern Art, New York**
**(gift of A. Conger Goodyear).**

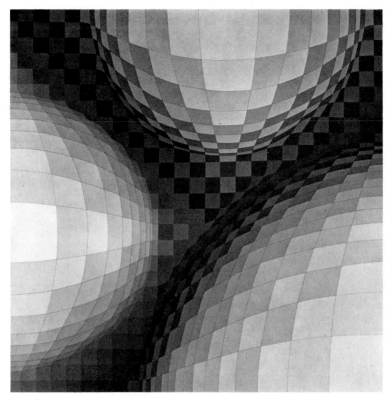

3-10  Victor Vasarely, *Triond,* 1973. Silkscreen, 31⅛″ x 31⅛″.
Victor Vasarely, Marne-sur-Annet.

*Silkscreen*  *Silkscreen,* a recently developed form of stencil printing, consists of silk, organdy, or similar open-meshed material stretched tightly over a frame. Parts of the screen can be blocked out by glue, plastic strips, or even photographic emulsions leaving the rest open for ink to pass through. Printing is accomplished by placing the screen on the surface to be printed and pushing the heavy ink across the mesh with a squeegee. The materials used in silkscreening are less expensive than wood blocks and copperplates, and the techniques used are simpler, faster, and more portable than etching or lithography. These are the principal reasons why silkscreen has become a popular medium, but the fact that it also lends itself very nicely to precision-edged shapes has proved an important attraction to artists like Victor Vasarely (fig. 3-10).

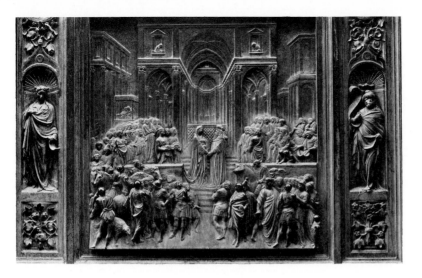

3-11
Lorenzo Ghiberti,
*The Meeting of Solomon
and the Queen of Sheba,*
detail of the
Gates of Paradise door,
Baptistry, Florence,
*c.* 1435. Gilt bronze,
31¼" x 31¼".

**Sculptural
Media**

There are a number of techniques that occupy a sort of twilight zone between the ordinary categories of painting and sculpture. They are definitely not flat, but at the same time they can be adequately viewed, like plane-surface works, from the front. Many twentieth-century works, as we will see, are ambiguous in their status as paintings or sculptures, but this condition is not a new one. There are ancient precedents—ceremonial masks, mummy cases, and carvings on everything from gravestones to canoes— that could qualify for this in-between category.

*Casting*

*Relief sculpture* consists of figures that project only slightly from the background. Although some, especially the *low relief* variety, are little more than bulging pictures, they have always been considered sculptures, because the materials used in their manufacture were nearly always the same as those used for traditional sculpture—wood, stone, or cast bronze. Ten panels of cast-bronze relief sculptures, mounted on the east doors of the Baptistry of Florence, comprise one of the most famous entrances in the world. Called the *Gates of Paradise,* they were made by Lorenzo Ghiberti in the early part of the fifteenth century. The method of casting bronze has remained basically unchanged since its invention thousands of years ago. Called *cire-perdue,* or *lost-wax* process, it consists of making an original sculpture, or a copy in wax, covering this with a heat-resistant material, and baking it. The wax melts and runs out, leaving a cavity that corresponds exactly to the model. The cavity is then filled with molten bronze to form the

sculpture. Taking a close look at one of the *Gates of Paradise* panels (fig. 3-11), we see that the greatest relief is in the lower portion, where some figures are almost in the round. As our eye travels upward, the relief becomes progressively shallower, until in the upper third it is very flat. There Ghiberti relied on the one-point perspective of painting to create an illusion of space rather than relying on the sculpture itself to create real space.

*Shaped Canvas*     In the shaped canvases of Lee Bontecou, the issues have primarily to do with the abstract problems of controlling spatial depth, both actual and illusionistic (fig. 3-12). Bontecou builds a metal arma-ture—much like the frame of a ship or an airplane—and over this stretches pieces of canvas or other materials. The relief pro-ceeds in steplike intervals to the rim of an abyss before plunging into a black void within the sculpture. Bontecou reinforces the sensation of depth by controlling the widths and the colorations of the intervals. Her constructions may refer to mysterious caverns, but they also suggest some kind of mechanical volcanoes or even the cowlings of jet engines.

3-12
Lee Bontecou,
*Untitled,* 1960.
Welded metal, canvas, wire,
55" x 58".
Private collection, New York.

3-13
Romare Bearden,
*Pittsburgh Memory,* 1964.
Collage, 9¼" x 11¾".
Courtesy Cordier & Ekstrom
Gallery, New York.

*Collage
and Assemblage*

In the late 1950s, a number of painters began to take extraordinary liberties with their medium. They violated its plane-surface character by attaching real objects such as stuffed birds, plaster casts, and clocks to it. One even turned his bed into a painting. These works were not bas-reliefs, nor even shaped canvases, for the forms were not built up from within. By 1961, this medium had become so well established that New York's Museum of Modern Art held an exhibition of this type of work, calling it *The Art of Assemblage.* As the name implies, this calls for assembling things together with glue, nails, rivets, or any other means.

Assemblage is the outgrowth of *collage,* a technique invented by Picasso and Braque shortly before the First World War. This medium, which essentially consists of pasting fragments of paper or other relatively flat materials against a flat surface, has become very popular. Changing the appearance of one image by adding fragments from others offers a pleasing, almost magical, sensation of power to the artist. In the hands of a man like Romare Bearden (fig. 3-13), it is a tremendously potent means of expression. He combines different facial features, bits of African masks, costumes of sharecropper and city blacks, indoor and outdoor elements of the ghetto—indeed, anything from the whole spectrum of black life in America—into his collages. The new combinations are part of a rhythm of design in which the variations of meaning are interwoven with those of the visual patterns. The final composition is so subtle and complicated that one is usually unaware of the hundreds of juxtapositions. It is an art form related to the docu-

mentary movie in which segments of film are spliced together to create a sequence that is different from the sum of the many smaller parts. Although some qualities of the news story are present in his collages, Bearden's multiple images aim not at reporting life but at revealing and summarizing the meaning of what it is to be black in modern America.

There is no limit to the kinds of material eligible to be incorporated in an assemblage or the ways that it can be put together. Indeed, many derive their strength from improbable associations where the artist has yanked an object out of a very unartistic context to put it into an art context. The assemblages of the early 1960s marked a change in art toward a revised association with the social environment—very often with a nod toward the throw-away commodity aspects of the modern world. The French artist Arman has capitalized on this fact both in his materials, which very often include discarded objects and even garbage, and in his compositions, which take the form of infinite repetitions of similar items—like the assembly lines that created them (fig. 3-14).

Because the works cited in this section protrude into the space beyond the picture plane (or are intruded on by space), it seems logical to treat them as sculpture. And indeed, the earliest works were just that. But the developments in our own century, even

3-14
Arman,
*End of Romanticism,* 1973.
Assemblage, 68'' x 48''.
Courtesy Andrew Crispo
Gallery, New York.

though they are related to new techniques and new materials that were first adopted by sculptors, evolved largely out of the practices of painting.

*Carving*　In-the-round sculpture exists in space and can be viewed from all directions. The most familiar version of sculpture is the self-contained, upright, free-standing figure that most people call a statue. It is no longer a surprise that many twentieth-century varieties of sculpture do not exactly fit the statue category. But before we get into the open, nonupright, or nonstanding versions of our own time let us look at an example of seventeenth-century sculpture.

Gianlorenzo Bernini's life-sized *David* (fig. 3-15), showing the hero as he is about to pivot and hurl the stone at Goliath, is carved out of a single block of marble. *Carving*—sometimes called the subtractive process—calls for removing unwanted material from a block of wood or stone with a knife, gouge, or chisel. Carving requires that the artist have a well-defined idea of what he wants before he begins and that he know exactly where to stop. Bernini probably began by making a small clay model and then having the shape roughly cut in the marble block by an assistant. Further cutting and later refinements, using progressively finer tools, were done by the artist. Unlike oil painting, carving in stone permits very little room for changes and in-process modifications. The mental anxiety and the physical exertion of chipping away at an obstinate block no doubt discourages many artists from working in this medium. Judging from his output, it appears that Bernini was rarely discouraged; indeed, looking at individual works, one gets the impression that marble carving was, for him, easy. Few other sculptors have been able to imbue their works with such a degree of realism, movement, and emotion. Bernini so carefully articulated and refined the textures of the flesh, hair, and cloth that one can easily forget that this figure was carved from stone. But the most innovative aspect of the work involved the way that Bernini made use of space. His *David* is not a static form that merely represents a Biblical figure but a fascinating study in motion and energy. His slender body is caught in the very act of hurling the sling, its position and balance suggesting a movement rather than a position, while the violent twisting of the body forces the viewer to move almost all the way around the sculpture in order to understand it.

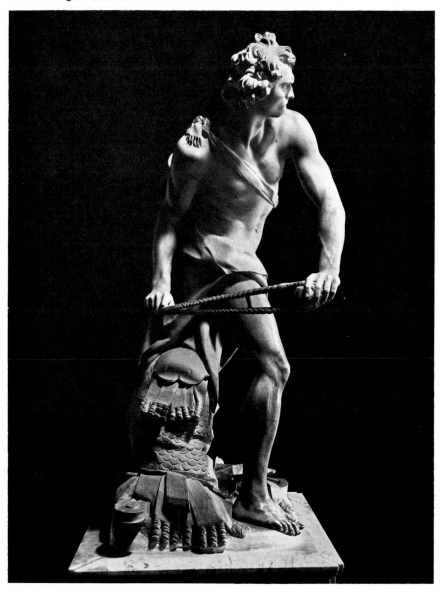

3-16
Constantin Brancusi,
*Mlle. Pogany, III,* 1931.
Marble, 19" high,
on limestone base 9¼".
Philadelphia Museum of Art
(The Louise and Walter Arensberg
Collection).

The marble bust of Mlle. Pogany (fig. 3-16) carved by Con-
stantin Brancusi some three hundred years later contrasts vividly
with Bernini's *David.* Rather than asserting itself spatially and
emotionally, the twisting lines of the Brancusi piece lead inward,
giving the impression that it has withdrawn modestly into its own
eggshell-like container. Its surface articulation is reduced to a few
clearly stated ridges that correspond to Mlle. Pogany's features
and accent the basic oval shape. The textural treatment is even
more economical, designed to bring out the quality of the marble
itself rather than imitate the appearance of flesh. Traditional mate-
rials and methods (and traditional subject matter) have been united
with modern notions of abstraction and minimalization.

3-17
Julio González,
*Head,* 1936.
Wrought iron, welded, 17¾'' high.
The Museum of Modern Art,
New York.

*Welding*    Julio González, another major sculptor of the early twentieth century, pioneered the technique of *welding*—a radical break with the classical conception of ''noble'' forms and materials. González made crude constructions of scrap iron, rods, and nails that contrast dramatically with the finely finished surfaces and the elegant forms of the marble works but are still valid and important works. The textures, the shapes, the movements of a work like González's *Head* (fig. 3-17) are stated in a completely modern sculptural language. Its most important aspect is its construction: it is not built up from a lump of clay or cut down from a mass of stone or wood but pieced together around empty space—an early example of *open sculpture.*

*Plastics*     Even in González's art of rough materials and stiff shapes, there is a lingering relationship with the human body. But the following generation of sculptors, like their counterparts in painting, were able to finally escape this attachment to biology and create works that were concerned entirely with such abstract problems as space, movement, and the character of the materials with which they were constructed. The open sculptures of Naum Gabo reflected the strong technological influence of the early twentieth century. Trained as an engineer and mathematician, he was able to appreciate the innate beauty of the forms of analytic geometry, and in the early 1920s he began to use these forms in transparent plastic sculptures. *Linear Construction* (fig. 3-18), one of his later works, combines a simple two-piece plastic frame with nylon thread to create a soft, gently curving image that forms a precise space while at the same time appearing open—a perfect union of art and technology.

3-18
Naum Gabo,
*Linear Construction,* 1950.
Plastic and nylon, 15″ high.
Collection of Mrs. George Heard Hamilton,
Williamstown, Massachusetts.

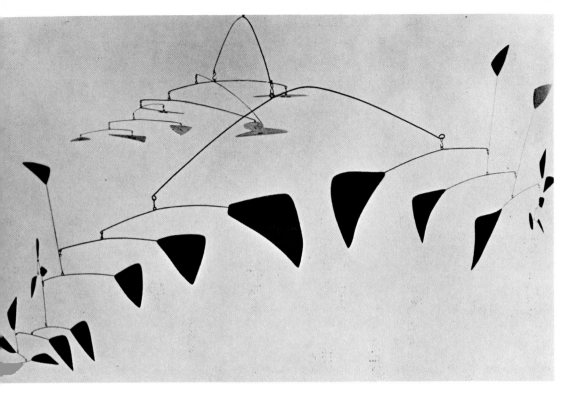

3-19 Alexander Calder, *Sumac*, 1961. Sheet metal, metal rods, wire, 49¾" x 94". Courtesy Perls Galleries, New York.

*Kinetic Sculpture*

Almost concurrent with the technological influence in art and the trend toward openness, sculpture's possibilities were also expanded to include movement. *Kinetic sculpture* is the name applied to those works that, through motors, wind, or other energy sources, escape the static state of ordinary sculpture. But even though kineticism was in large part inspired by machines, the first really successful works of this kind were not motorized at all. Alexander Calder's hanging *mobiles* (fig. 3-19) depend on a system of precise balances to make their light metal vanes respond to movements of the air. The result is a drifting and dipping of the abstract spots of color and the continual transformation of the overall form and volumes of the sculpture. Motorized kinetic sculpture was revived in the late fifties, but for all the technological means available to sculptors today, it has still not produced any series of outstanding works. Oddly enough, the most interesting of the artists in this area is one whose whimsical vision of the machine is anything but scientific. Jean Tinguely's works are constructed of odds and ends and have nothing of the polished disci-

3-20
Jean Tinguely,
*Homage to New York,* 1960.
Kinetic assemblage of machinery
fireworks, piano.
In the sculpture garden
of The Museum of Modern Art,
New York.

pline or the sense of purpose of a factory assembly line. His most symbolic construction of all was the huge *Homage to New York,* the ultimate purpose of which was to destroy itself—which it did, with fire, noise, and a fitting degree of confusion, in the garden of the Museum of Modern Art of that same city (fig. 3-20).

*The Range of New Materials*

Tony Smith's six-foot steel cube, *Die,* is about as abstract a three-dimensional form as anyone is likely to conceive (fig. 3-21). Its hard, flat sides and sharp edges are free of any biological associations—although its unusual scale suggests that it was meant to relate to human size. Nothing could be more in tune with modern technology: the artist was not even directly involved in the making of the sculpture but ordered it from a construction firm over the telephone. In some ways *Die* might appear to be a fulfillment of the movement toward pure abstraction that began with Gabo and the Constructivists, but it can also be seen as exactly the opposite. It can be considered a rejection of sculptural openness, of the emotional excitement of exploring the new range of machine-age forms, of the idealism implied in the Constructivists' goal of creating a new language for both fine and applied art. *Die* can only be understood as a pure, literal form.

At the opposite pole of mid-century sculpture—but ultimately very much related to it—are John de Andrea's literal imitations of the human form (fig. 3-22). By making his molds directly from the body, working with new materials like polyester resin and fiberglass, De Andrea is able to re-create incredibly accurate likenesses of actual people—right down to their goose bumps and

varicose veins. Rather than simply rejecting earlier twentieth-century notions about abstract form and space, he has cut himself off from recent art history to focus anew on the problems of verisimilitude in the light of the many technological innovations, new materials, and concepts of art that have evolved. Even Bernini, who was remarkably successful at making marble look like flesh, would be astounded by the possibilities that are now available to artists.

**3-21** *(left)*
**Tony Smith, *Die,* 1962. Steel, 6' x 6' x 6'.**
**Collection of Samuel Wagstaff, Jr.**

**3-22** *(right)*
**John de Andrea, *Standing Woman with Earrings,* 1973.**
**Polyester and fiberglass, polychromed, life-size cast.**
**Collection, Sidney Janis Gallery, New York.**

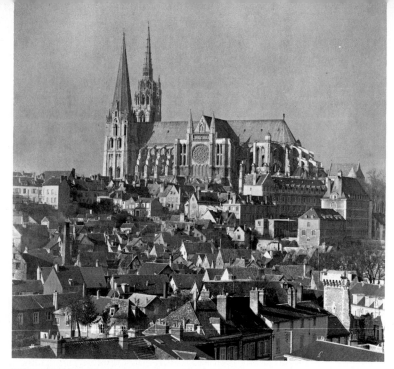

3-23   Chartres Cathedral, France, 1194–1507.

**Environmental Media**

All the categories reviewed so far comprise art works that are essentially *self-contained.* They can be adequately observed from a single direction or, by taking a few steps, from several directions. Works of art in the environmental category are intended to be experienced in an entirely different way. Some of them envelope the viewer on all, or nearly all, sides at once; others are so sprawled across a landscape that they can only be experienced by a journey across or through their constituent parts; and some are more modest, simply bridging two or more areas of a room at one time.

The term "environment," as it is now used in art, refers to particular kinds of contemporary art works that satisfy the above conditions. The relative popularity of this kind of art in recent times is due to the continual experimenting of painters and sculptors with new visual experiences, but it has some precedents in such other areas of the arts as theater, landscaping, and architecture. The inside of a church, for example, is designed for worship, but religion and aesthetics are certainly not mutually exclusive. To the thirteenth-century citizens of Chartres, France, their cathedral (fig. 3-23) was a symbol of the holy city of Jerusalem and a manifestation of the glory of God; beauty and splendor were therefore indispensable. A twentieth-century visitor entering the cathedral

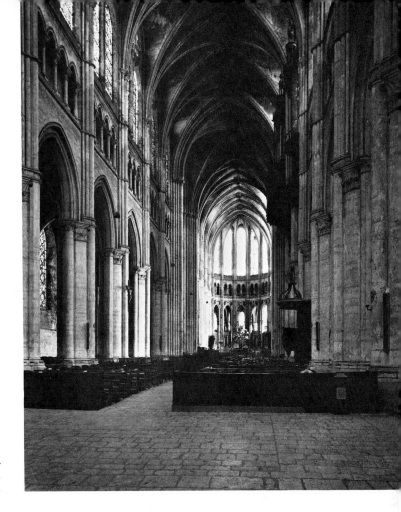

is affected by the miracle of soaring stone and the glory of light
and space. The daring thirteenth-century builders erected a lofty
structure with a masonry ceiling spanning 53 feet of the main part
of the church at a height of 118 feet from the floor (fig. 3-24).
Like an enormous open sculpture, a Gothic cathedral is a system
of interior volumes defined by massive piers and archways on the
main level and smaller arcades and columns on the upper levels.
The outer walls, especially the clerestory just below the ceiling,
are penetrated by large openings filled with stained glass that
transforms the sunlight (colorplate 6). The rays of intense color,
whether seen directly through the glass or indirectly as they pierce
the dark interior, are a significant part of the experience. It is an
experience that we cannot receive from ordinary painting and
sculpture, where color is only reflected from an opaque surface.

*Stained Glass*    Stained glass, an art and an industry that thrived during the medieval period, has been almost defunct ever since. When the glass was in a molten stage, the color was introduced by means of certain minerals. Pressed into sheets and allowed to cool, the glass was then cut into smaller pieces according to a previously prepared design. Details such as facial features were painted on with oxides and made permanent by firing in a kiln. The fragments were then joined together with lead strips by a technique called *leading.* Where possible, the leading also served the function of outlining figures and major details.

    Because the experience of their color depended so much on the shifting light of day, the images and their reflections in the church seemed less material than the sculptures and masonry. Indeed, this aspect of "dematerialization" was in keeping with thirteenth-century worship. Perhaps to obtain a fuller meaning of Chartres Cathedral as a religious and an artistic environment we should also imagine its cavernlike space filled with the chanting of a choir.

*Constructions*    Another precedent for environmental work was the *Merzbau,* a name given by German artist Kurt Schwitters to a series of structures he created. The first of these, begun in 1924, was one of the earliest assemblages, an entire room lined with all kinds of objects—rusty tin cans, newspaper, pieces of broken furniture. He called it *Cathedral of Erotic Misery* and filled it with secret panels that hid other objects or tiny scenes that reflected his own erotic misery and that of his times. Eventually, however, he replaced the chaotic collection of junk with abstract forms of wood that developed the equally interesting idea of affecting a viewer's sensations through the manipulation of space (fig. 3-25).

*Happenings*    *Happenings,* which are something like a cross between a temporary *Merzbau* and improvisational theater, attracted a number of painters and sculptors in the late fifties and early sixties and were influential in the intermixing of various art forms over the past decade. The first use of the term Happening appears to have been in a 1959 article by Allan Kaprow, in which he included a brief script for a related series of events called *18 Happenings in 6 Parts.* He later produced a version of this work (fig. 3-26) in a New York gallery, which he outfitted with plastic partitions, Christmas lights, slide projectors, tape recorders, and assemblages of junk. "Per-

3-25  Kurt Schwitters, *Merzbau,* 1924–37.
Mixed media (destroyed). Photo courtesy
Niedersächsisches Landesgalerie, Hanover.

3-26  Allan Kaprow, *18 Happenings in 6 Parts,* 1959.

formers'' bounced balls, spoke double talk, read poetry, played
musical instruments, painted on the walls, squeezed orange juice,
and executed other similar acts. The gallery patrons had to be
given instructions on how to move through this potpourri, becom-
ing in a sense performers themselves—a role that was developed
in future works.

Happenings differ from theater in a number of important ways,
although these are becoming more difficult to distinguish because
of the important influence that such works have had on experi-
mental theater. The spectator-participant is surrounded by the art
medium rather than confronted with a picturelike stage. Vision and
hearing are not the only senses addressed. The actors are not
distanced from the audience by fictitious roles. And most impor-
tant, there is no plot, no focused structuring of sequence. There
is nothing but a series of separate, often overlapping, seemingly
unrelated events. Despite the apparent randomness, however,
most Happenings are carefully scripted and rehearsed—though
unpredictable occurrences are accepted as integral parts of the
total experience.

*Light*    The environmental art of Dan Flavin is rather closely related to that of Chartres Cathedral, although he uses colored fluorescent light fixtures rather than stained glass (colorplate 7). His creation of an environment presupposes the use of a room or part of a room in which his lights change the character of a space with a single color or a subtly mixed combination of colors that can vary according to the texture of the walls, the size of the room, and other factors. He was not the first artist to have used real rather than reflected light as his medium, but none had ever tried to actually make it the very *substance* of a work.

*Earth Art*    For some artists, a canvas, a room, or even an entire building is not enough space—they set about rearranging the landscape itself. Michael Heizer, one of the principal figures of *Earth Art,* has done a number of pieces in the desert. His *Double Negative* (fig. 3-27) is an enormous rectilinear gash in the earth, divided by the edge of a canyon; a sculpture that consists of both real and imaginary (where the canyon eats away the earth it is cut from) space, a geometric shape constructed by man contrasted with an organic one created by nature. Although the work may appear no more complex than any other hole in the ground, it raises many questions about the traditional problems and techniques of sculpture. Among these are the fact that the use of a negative form makes the space itself the work, and that the scale is so immense that there is no way to comprehend it, even from an airplane. Another important point is that this work is far more vulnerable to the erosions of time and weather, so that it will disappear in a relatively short time. A hundred years from now all that will remain is the photograph that documents it.

## Architecture

From the standpoint of perception, architecture is related to the categories of both sculptural and environmental art. But from the standpoint of the architect's intentions, it differs notably from all other art. Architectural objects are utilitarian—places where people live, work, and congregate. They are projected into the realm of human affairs in intimate ways that other art seldom enjoys. Therefore, the form and substance of architecture, even more than the other arts, is closely affected by the values, needs, and technology of the society it serves.

The Gothic style of Chartres Cathedral was a culmination of

3-27 Michael Heizer, *Double Negative,* 1969–70. Two hundred thousand ton displacement in rhyolite and sandstone, 50' x 1500' x 30'. Collection of Virginia Dwan.

architectural developments nurtured not only by religion but by politics and engineering. More than a local church for the citizens of Chartres, the cathedral was the site of a bishopric, a major religious center rivaling other centers throughout the region of northern France. Since the importance of a cathedral town was generally measured by the majesty of its cathedral, civic pride stirred the people of Chartres to heroic efforts to erect a larger and higher structure. Underlying this was the religious enthusiasm for the soaring lines, color-saturated space, and other effects that were alluded to in the earlier discussion of the Gothic interior as environ-

ment. Translated into engineering terms, this meant achieving the maximum of space, height, and window opening with the available technology of *stone masonry,* that is, one block of stone placed on top of another.

*Masonry*    Gothic construction is based on the arch, which, in basic principle, consists of spanning a space or opening by means of wedge-shaped stones (fig. 3-28). Because of their shape, the stones press against one another and are prevented from falling. But the force of gravity is not countered, it is diverted outward as well as downward and travels down both sides of the arch. The same principle can be employed to create a vault, which is a kind of continuous arch (fig. 3-29). Used extensively for ceilings in earlier churches, *barrel vaults,* as they were sometimes called, had the disadvantage of requiring continuous support along their lengths. The ceiling

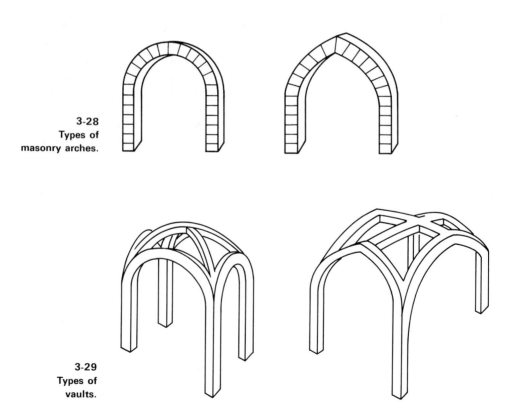

**3-28**
**Types of**
**masonry arches.**

**3-29**
**Types of**
**vaults.**

of Chartres employs *cross vaults,* formed by two intersecting barrel vaults, which permit all of the support to be localized at the four corners. A major contribution of Gothic builders was the *pointed arch,* which proved far more flexible than the older *round arch* in building vaults. As the angle of the arch could easily be changed, shorter, steeper arches and longer, more gradual arches could be combined to make rectangular vaults, allowing the architect a great deal more freedom in his design. The sharper angle also served to divert the weight it supported more directly toward the ground, thereby requiring less bracing on the sides. Another important contribution of Gothic architecture was the development of the flying buttress (fig. 3-30), an exterior stone rib that reinforces the vaults and walls at key points by absorbing some of the outward thrust of the vaulted ceiling.

By improving upon inherited methods of construction and adding some innovations of their own, Gothic builders were able to create skeletons of stone that provided far greater possibilities for space, height, and window opening than had previously been possible. Masonry construction is characterized by *load-carrying walls.* The Gothic builders were able to modify this by shifting some of the load to heavy piers and flying buttresses, but this practice had its limits. Although masonry construction continued into the nineteenth century, builders in the latter half of that century began to use alternative methods that challenged both the old principle of load-carrying walls and the painstaking practice of building stone by stone.

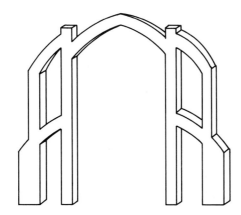

3-30
**Flying buttresses.**

3-31
Joseph Paxton,
Crystal Palace,
London, 1851.

*Iron*   To Londoners of 1851, the Crystal Palace was like a magical city (fig. 3-31). A single structure of iron and glass allowing the light of day to flood its vast interior, the Crystal Palace was the site of the Great Exhibition of London, a world's fair that featured industrial and agricultural products from several countries. Despite its size—a ground plan of over 800,000 square feet—it was built in less than six months. To accomplish such an engineering feat, its designer, Joseph Paxton, conceived of structural units that could be partly prefabricated. Planned around the largest standard sheet of glass (which at that time was only four feet square), the wood and iron members were manufactured in Birmingham and fitted together into a framework on the site in London (fig. 3-32).

3-32
Interior of
Crystal Palace,
London.

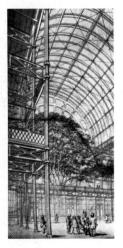

Although it was a remarkable tour de force—both as a technical accomplishment and as a spectacular sight—the Crystal Palace was not really considered architecture by the people of the time. It was, of course, a functional structure built for a particular job and suited for rapid construction (and perhaps equally rapid dismantling)—a kind of super circus tent. But the main reason it was not considered architecture was because it had been made of iron and glass. Other iron buildings of the nineteenth century had more permanent uses—railroad stations, warehouses, factories—but they too were looked on merely as functional "sheds." To be called architecture, a building had to use stone instead of a lightweight framework of iron posts and girders bolted together. Only a few observers had the foresight to realize that the Crystal Palace would inspire a revolution in architecture. Its principles of construction eventually came to be the basis of twentieth-century building.

*Wooden-Frame Construction*

In the nineteenth century two different building booms in Chicago were related in concept to the methods of construction used in the Crystal Palace. In the 1830s, the wooden *balloon frame* (fig. 3-33) was developed to answer the demand for a rapid means of building houses to keep pace with the growth of Chicago and other settlements all over the new continent. Two-by-four boards were nailed together to form a lightweight framework to support the exterior siding and interior walls. Today this type of building, referred to as studs-and-joists construction, is so commonplace that it is difficult to appreciate its once revolutionary importance. But prior to the balloon frame, wooden buildings were made with heavy timbers joined by a cumbersome process of inserting tenons into mortices (fig. 3-34). The new method, on the other hand, was not only lighter in weight, it capitalized on the standardization of parts to speed construction. Two-by-four boards and machine-produced nails could be converted to a building in two weeks by two men who were handy with saw and hammer.

**3-33  Balloon-frame construction.**

**3-34  Mortice and tenon construction.**

*Steel-Frame Construction*   In the last two decades of the nineteenth century another architectural revolution took place as a colony of high buildings rose over Chicago's downtown. These first *skyscrapers* were born of new industrial technologies, including steel-frame construction, the passenger elevator, and the need to provide office space in a commercial hub where real-estate costs were extremely high. It was the simple economics of using the free space of the sky rather than the costly space of a city block. The principle of construction was the same as that for the balloon frame: a skeletal framework—this time iron and steel rather than wood—was constructed prior to the addition of walls.

Early skyscrapers were sheathed with outer walls of stone. Even though the practical need for this kind of construction no longer existed, there seemed to be a psychological need to make a building appear heavy and solid. It was an addiction that continued to a greater or lesser degree until the early 1950s, when a number of buildings were constructed with their steel skeletons covered with a nonstructural skin of glass and metal. The freedom to create a simple geometric solid and sheathe it with any material for the "curtain wall" was inspired in large part by the architecture of Mies van der Rohe. His bronze and glass Seagram Building in New York (fig. 3-35), designed with Philip Johnson, is one of the classic examples of a style that has since become very prevalent in American cities. In the 1950s, the appearance of free-standing, shiny, and seemingly weightless structures like the Seagram Building was a liberating experience. Since then, unfortunately, the urban landscape has become cluttered with numerous unimaginative imitations.

*Ferroconcrete*   Construction in concrete is one of the more recent techniques to find a place in the modern world of architecture. This material, and the methods of construction connected with it, contrasts vividly with steel. A blend of cement, water, sand, and sometimes small stones is poured into molds that correspond to the shape required by the construction. When this blend has hardened, the molds are removed and the concrete retains the original shape. Unlike steel, which lends itself to the geometry of sharp angles and flat surfaces, concrete can assume almost any shape—even an organic one like a sculpture, a plant, or an animal form. By itself, however, concrete is weak in tensile strength, that is, the ability to withstand stress. (A slab of concrete spanning a given

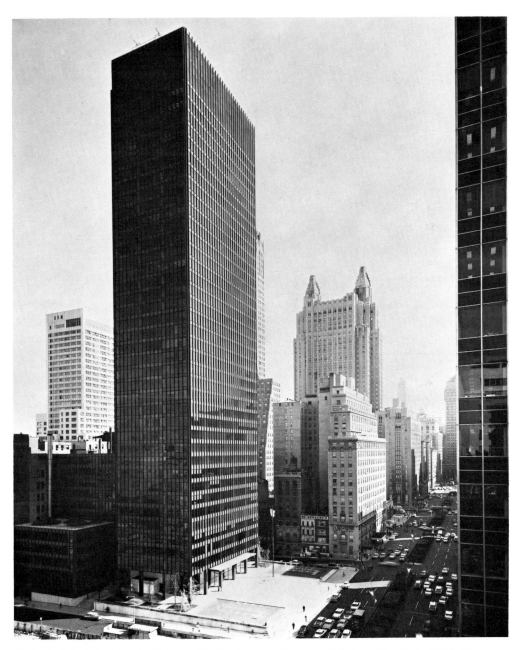

3-35　Ludwig Mies Van der Rohe and Philip Johnson, Seagram Building, New York, 1956–58.

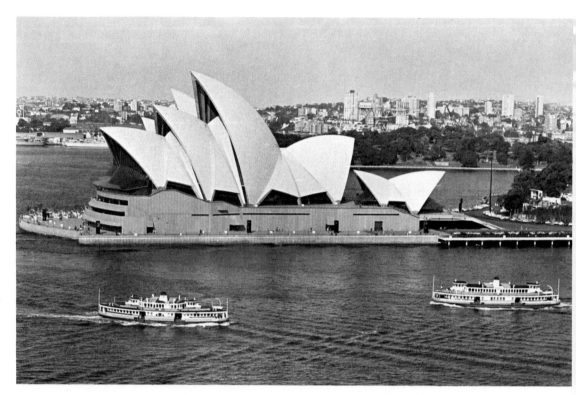

**3-36 Jorn Utzon, Sydney Opera House, Australia, 1959–72.**

area will not support the weight that the same thickness of steel will.) But this handicap can be counteracted by imbedding steel rods or cables in the concrete, a combination called *ferroconcrete* or *reinforced concrete.* The dual advantage of plasticity and strength makes ferroconcrete an extremely versatile medium. Jörn Utzon made excellent use of these qualities when he designed the curving vaults of the Sydney Opera House in Australia (fig. 3-36). One is reminded of gull wings, swelling sails, or breaking waves— all of which are appropriate to the site on a peninsula in Sydney's harbor. The repetition of the vaults, together with their slightly varied axes, gives the whole ensemble a sense of movement. With the highest shell rising nearly two hundred feet, the Opera House forms a striking landmark both for approaching ships and for the residents of the city.

3-37  Buckminster Fuller, United States Pavilion, EXPO 67, Montreal, 1967.

*Geodesic*  Buckminster Fuller's invention, the *geodesic dome,* like Utzon's
*Dome*  vaults, takes advantage of the inherent strength of shell con-
struction but uses a method of assembly related to that of Paxton's
Crystal Palace. Employing a simple but revolutionary construction
principle, Fuller's dome seems to be unlimited in its capacity for
interior space, possibly capable of spans even several miles wide.
Without the need for any interior supports, the American Pavilion
at EXPO 67 in Montreal (fig. 3-37) was slightly higher than the
Sydney Opera House—and its weight was only a fraction of that
building, being constructed of nothing more complicated than a
steel-pipe framework and panels of transparent acrylic. The geo-
desic dome also has features that are analogous to the balloon
frame of a century earlier. Just as that was based on the simple
principle of the grid, the geodesic dome employs a system of

3-38 Buckminster Fuller, detail of geodesic construction.

hexagonal pyramids constructed of triangles. The former, for its time, provided a lightweight but solid construction that could be erected quickly; the latter is the most rapid and efficient construction method to date. What remains to be seen is whether or not the geodesic shell will play a significant role in answering the social needs of the future as the balloon and steel frames did for the past and present.

**Summary**     The complexity of today's art seems to be unlimited. No set of categories can adequately cover the range or neatly sort out the variety. Over the past years the boundaries between the arts that once seemed so secure have been challenged and overrun by experimental artists bent on discovering new experiences in the combination of two or more areas. Such hybrids as assemblages, environments, and Happenings have gained respectability and must be added to painting, sculpture, and architecture. The traditional limitations concerning the materials of art have also been challenged. One can no longer say that a sculptor is an artist who works with marble, wood, or bronze, for anything that involves space is likely to be suitable, even water and air. Finally—and related to the above situations—the concept of the art object itself has been challenged. Performances, environments, and the use of perishable materials raise fundamental questions about art's relationship to its audience. Reconsideration of the uses of art has led some artists to conclude that the *idea* of a work of art may in itself be sufficient—eliminating the need for an object.

The lack of solid definitions does introduce an element of unpredictability, if not chaos, but this is the inevitable price of freedom. At the same time, it allows the artist to expand the possibilities of his craft and the viewer to enlarge his own experiences. The situation of art is symptomatic of our rapidly changing world, in which material progress and social change always seem to outrun human consciousness.

Artists who work with visual images, like those who use written or spoken words, interpret the human experience of the time and place in which they live. In a primitive society, where a group of people share a common history and set of beliefs, their conception of the world is interpreted by their art, their ceremonies, their ritual objects, and even the way in which they build and decorate their houses. In a society like that of contemporary America, where religious, educational, regional, and ethnic differences divide the population, such unity is impossible; the pluralism of beliefs and values is reflected in the pluralism of artistic expressions as well as that of life styles.

Nevertheless, certain themes basic to human society seem to be present in the expressions of all ages and cultures, whether primitive or modern, simple or complex. The forms in which these themes are expressed vary tremendously, but the fundamental questions of life—who are we? where do we come from? where are we going?—are eternal. Part II presents some of the answers that artists of different times and places have given to some of these questions and illustrate the variety of ways in which some of these basic human concerns are expressed in art.

# 4
# Images
# of
# Nature

"Almost every Englishman," Kenneth Clark once said, "if asked what he meant by 'beauty,' would begin to describe a landscape. . . ." The same might be said of a Japanese, or an American, or, in fact, almost any citizen of a modern society. To the average man, the art of painting is often identified with the landscape—this despite the fact that landscape painting is a vanishing species in the world of art.

This popular conception of art is continually reinforced by the endless number of reproductions of landscape paintings sold in department stores for the decoration of American living rooms. Perhaps the proliferation of these images in our culture has led to their self-cheapening and has reduced them to little more than pleasant ornaments. If this is so, it obscures the fact that landscape painting is a sophisticated product of art and human consciousness. It is the result of a long evolution of artistic changes linked to a history of changing human attitudes toward the natural environment. Varieties of human and cultural relationships to nature and their corresponding representations in art (not only in terms of landscape) are the subjects of this chapter.

**Paleolithic Painting**

Animals appear to have been the very first subject matter of art. So far as we know, the earliest image makers were members of a hunter-warrior society that existed more than fifteen thousand years ago. The Paleolithic (Old Stone Age) culture left in its painting and sculpture an artistic record of all the larger fauna—mammoths, bison, horses, rhinoceroses, boars, wolves, and reindeer—that inhabited Europe at the time. Ever since the discovery of this art around a century ago, observers have been impressed by the evidence it provides of an extraordinary level of artistic observation and image-forming ability.

Although some of the species painted on the walls of the caves near Lascaux in southern France may no longer exist, the hunter-artists made their images so vivid that we have no trouble recognizing them as various types of grazing animals (fig. 4-1). The

4-1 *Hall of Bulls,* Lascaux, *c.* 15,000–10,000 B.C. Dordogne, France.

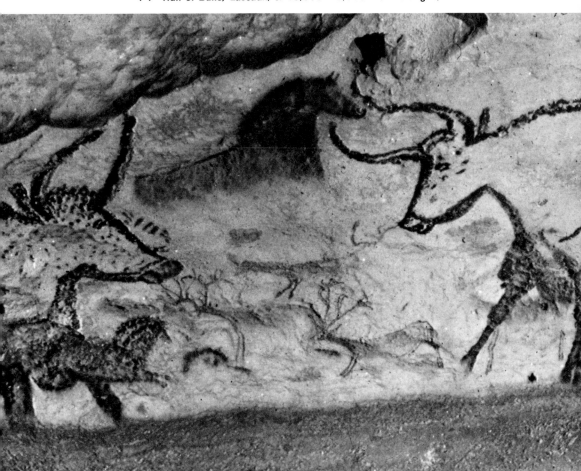

outlines and proportions seem to have been based on fairly accurate observations of the profile views of real beasts. Shown in a variety of lifelike postures, many of the images give the appearance of animals caught in the act of running. Their colors of dark reds, browns, and blacks—still visible after so many thousands of years—raise questions about what the artists used for paints and brushes. We can only guess at the answers. They may have mixed pigments of red ocher and manganese with animal fat, and then used reeds or animal tails for transferring this mixture to the walls. There is also reason to believe that some of the artists developed a prototype of the airbrush, a painting tool of the twentieth century. The images in the caves of Font-de-Gaume and Altamira (fig. 4-2) are even more lifelike than those in Lascaux. They are extremely convincing because of their shapes and details, but mostly because of their sense of volume, a chiaroscuro effect that may have been accomplished by spraying paint with a blowpipe.

There is a sharp contrast in levels of sophistication between the images of animals and the images of other subjects. Representations of people are like stick figures; the rare references to landscape features such as rocks, plants, and streams are more like schematic symbols than images. Likewise, the arrangements of the animals (with or without other images) reveal none of the sophisticated methods—overlapping, vertical placement, variations in size, and linear perspective—for showing spatial depth in a landscape picture. Indeed, few of the arrangements seem determined by any indentifiable logic; one animal overlaps another for no apparent reason other than being painted on the same space at a later time. Occasionally two or more animals are purposely juxtaposed to illustrate an event such as a chase or combat, but beyond this they are not related to what we would consider a pictorial setting. The intense realism of Paleolithic art is restricted almost entirely to the portrayal of the individual animal.

But if we speculate on the kind of lighting (or lack of it) that was available, we can guess that prehistoric people probably could not have viewed more than one painting at a time anyway. Imagine what it must have been like to see one of these beasts leap into view as a torch was waved in front of it. This intriguing mental image leads us to wonder about what an animal picture meant to these hunters. It requires quite a lot of imagination to piece together the few bits of evidence and guess the purpose and meaning of prehistoric art. The awkward locations of many of the

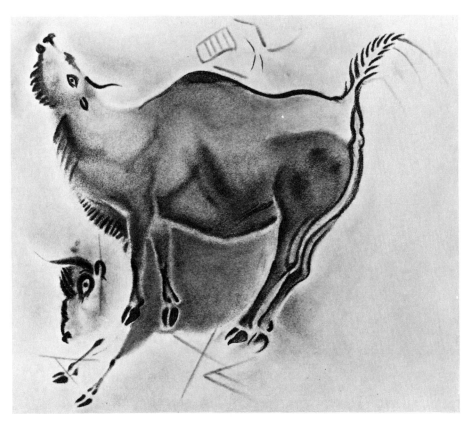

4-2 **Bellowing bison and fragments of another galloping bison,** Altamira, *c.* 15,000–10,000 B.C. Altamira, Spain.

murals and the poor ventilation of the various chambers disprove theories that these caves were used as art galleries or dwellings. This, plus the fact that many of the images of beasts show the marks —real or painted—of weapons, suggests that they did not serve purely aesthetic purposes.

The best guess is that the awkward locations served as privileged sanctuaries for religious rites and that the murals of beasts contained within served magical purposes. Religion and myth mirror the needs of a society. And animals, which to the Paleolithic hunters meant nothing less than survival, must inevitably have been at the center of their religion.

There is a parallel both in art and crafts between Paleolithic culture and the recently extinct society of African Bushmen (fig. 4-3). Totemism, a belief that animals are ancestrally or spiritually related to humans, thrived among the Bushmen, and their myths are laced with stories of people turning into animals and vice versa. Their sacred rites, accordingly, focused on animals. Sexual initiations were woven in with ritual killings of animals or symbolic killings performed by hunter-dancers dressed in animal costumes. The existence of illustrations of men-beasts on Paleolithic walls (fig. 4-4) further strengthens the parallel, suggesting that those prehistoric hunters, like the African Bushmen, performed animal rites and believed in a form of totemism.

In such societies distinctions were not made between the supernatural and the natural. Since Paleolithic man's world was

**4-3  Bushmen defending their herds from a band of Zulus, rock painting.**

**4-4**
*Sorcerer,*
Trois Frères,
*c.* 15,000–10,000 B.C.
2' high.
Ariège, France.

totally bound to animals, the art of the animal in this world must have assumed awesome significance. Its magic would not only have been sought to ensure success in the hunt but would have been part of the very structure of belief and social continuity. In a sense, these paintings were not images but real spirits occupying the same magical stage as the hunter-dancers.

**Egyptian Tomb Art**

The dead rather than the living were represented in most Egyptian art, for one of the principal uses of painting was the decoration of tombs. Here, too, art had a magic function. The image served to provide a home for the spirit of the deceased and to prevent the corruption of the body. The tomb of Ti, located at Saqqara, provides an excellent example of this custom. Ti, who lived around

2400 B.C., was an important bureaucrat, the overseer of the pyramids and the Sahura temple. Consequently, his remains were privileged to reside in a *mastaba* (a type of tomb) in a special burial ground for deceased officials.

One of Ti's earthly privileges was that of fishing and hunting in the marshes down by the Nile, and in order to perpetuate this pleasure in the hereafter he commissioned a major mural depicting it (fig. 4-5). Along with his own image, magical images for servants, boats, animals, and plants were also needed. Other painted reliefs in his mastaba illustrate the many needs of his rich estate in eternity: workers polish his statues, cooks and bakers prepare his food, craftsmen build boats for his favorite sport, and peasants harvest his grain and care for his cattle (fig. 4-6).

In order to guarantee that an image would be an adequate home for a soul, the Egyptian artist was compelled to follow certain rules. Ti's body, for example, which seems pinned in an upright position to the corrugated thicket of reeds, has its head, legs, and feet shown in profile while one eye and the trunk of the body are shown frontally. This formula, called *fractional representation,* was applied to all human figures, no matter what their activity. Had the artist shown the back rather than the front of the nobleman's head, or one of his arms hidden behind his body, or his feet hidden inside the boat, then, according to the rules of magic, he would have tragically omitted some of Ti's anatomy, leaving him literally without a face, two arms, or two feet. The artistic solution was to provide the most adequate and characteristic full view, not only of Ti, but also of the people and creatures that were to serve him forever.

The same type of thinking that considered anatomy a sum of the parts was applied to the organization of the picture. Although various elements of nature, people, and animals are logically connected (to an extent never achieved in Paleolithic art), they are not at all integrated in the realistic sense that we are accustomed to associate with landscape art. Divided into tidy zones, the relief clearly spells out the proper neighborhood of each figure. The aquatic animals are relegated to their own environment, which is symbolized by neat rows of vertical ripples. The scarcely broken line on top of the water is the base line for the boats. Overhead is another clear zone of fowl and smaller animals among the papyrus tops. Little if any overlapping is permitted, even where there are swarms of animals.

4-5  *Hippopotamus Hunt,* tomb of Ti, Saqqara, *c.* 2500 B.C.
Painted limestone relief, approx. 48″ high.

4-6 *Cattle Fording a River,* tomb of Ti, Saqqara, *c.* 2500 B.C. Painted limestone relief.

In the rigid structuring of this mural we can also perceive the symptoms of a highly organized food-gathering society (where hunting was pictured as a sport) that was physically and emotionally dependent on the Nile. Although the river and its banks provided many resources—fish and game, papyrus to write on, alluvial clay for pottery—the vital and abiding resource was the annual overflowing of the Nile that enriched the fertile valley. All Egyptian agriculture, hence Egyptian survival, was dependent on this event. So regular was the flooding—between July 19 and 21 at Heliopolis (now Cairo)—that the river imposed its rhythms on the life and thinking of the people. Thus the dependable fluctuations of the Nile, sanctified in myth and overlaid with the concentration of earthly authority, helped produce what was perhaps the most rigid and stable society ever seen on this planet. This enduring tenure was exemplified by Egypt's art—an art that changed very little over a period of three thousand years.

**Roman Wall Painting**

It is believed that Greek landscape painting developed out of Greek theater sets, the word "scenery" coming from the Greek word for "stage." Yet we can only guess about the origin and development of Greek landscape art from pottery painting or from written sources because almost no Greek painting still exists. We can,

however, obtain a secondhand reflection of the later forms of this art from Roman frescoes and mosaics that frequently were imitations of Greek works. Indeed, Greek artists were sometimes imported to Italy to decorate the walls of wealthy Romans' homes.

In a painting on a wall of a Pompeii villa (fig. 4-7), we see a few trees and buildings on a gentle hillside, a quietly romantic setting for strollers and a little herd of goats. This view of nature,

4-7  Wall painting transferred to panel, from the Villa of Agrippa Postumus, late first century B.C. Portion shown approx. 26'' high. Museo Nazionale, Naples.

as well as the feeling it inspires, represents an enormous leap from Egyptian art. The separate figures and objects are lighted by the sun; some even cast shadows. The temples and bases of monuments, unlike the Egyptian boat, expose two of their sides instead of one (although their oblique angles do not always create a consistent perspective). The people and animals are not restricted to their profile views but are free to stand or relax in any natural position. Everything—trees, architecture, creatures, and the ground on which they rest—is integrated into a single visual event. A pervasive light blends the elements by de-emphasizing edges and boundaries. But this integration is also achieved by some of the logic and controls of optical space. We interpret an Egyptian picture vertically or horizontally, like a floor plan, but we can view the Roman picture—because of overlapping, relative sizes, and other visual cues—in much the same way as we see real objects in space.

The Romans, delighted by the illusionistic potential of a more realistic form of painting, decorated their walls with numerous false architectural features such as colonnades, bays, and cornices, perhaps to tease their guests into seeing nonexistent courtyards and temples (fig. 4-8). Landscapes were often framed by false window mouldings to give the impression of seeing beyond the wall.

Paradoxically, the mental attitude that allows one to view an image as an illusion (or a dream) of a real scene is the product of a more scientific approach to reality. The awakening of the intellect that began with the Greeks, and to which the Romans were heirs, introduced scientific explanations not shared by other ancient cultures. Eventually this more objective attitude drove totemism out of nature. Image-making, liberated from taboos and its primitive magical function, was free to be used to represent natural appearances. But hand in hand with science and the art of appearances came an attitude of detachment from nature, signifying that the Greeks and Romans were no longer *participants* in but *witnesses* to her drama. The primitive hunters and the Egyptians were so much a part of nature that they were incapable of detachment—that is, of standing apart to view the world scientifically and artistically.

On holidays the traffic of our freeways, jammed with cars and campers, is headed mostly away from the city. The view of nature as being not only beautiful but an escape is in our day taken for

granted. Roman citizens, especially those who could afford wall paintings, seemed to have possessed a similar psychology. They, too, were town and city dwellers enjoying public services—water, sewage, markets, court houses, theaters, and public baths—that were remarkable for a preindustrial society. But despite the amenities, city dwelling then, as now, must have exerted a psychological pressure. The idea of ''opening up the wall'' to imaginary porticoes and parks was probably intended to satisfy a need to be in closer contact with nature—even though it was only an unreal paradise.

**4-8  Architectural wall painting from the bedroom of the Villa Boscoreale, first century B.C. Metropolitan Museum of Art, New York (Rogers Fund, 1903).**

## Chinese Landscape Painting

To the Chinese of the Sung Dynasty (960–1279) landscape art was much more than a stage prop. Nature itself was the protagonist of a drama in which humans were merely minor actors. By the tenth century, Chinese artists had translated their feeling for nature into a pictorial language that produced glowing images of landscape.

With only the austere tools of ink on paper, Tung Yuan evoked a sensation of boundless space in *Clear Day in the Valley* (colorplate 8). The faint indications of human life—the fisherman, strollers, and houses—are almost completely absorbed into the magnificent natural panorama. The artist did not evoke the sense of this vastness by means of any single identifiable vanishing point. Instead, through the sensitive control of ink diluted with water, he managed to suggest overlapping layers of rocky or forested hillsides and the misty spaces in between. In places, empty paper has been used to hint at the deepest areas of mist and the plane of the lake. These effects are not mere artistic devices; Tung Yuan's openness is also characteristic of the Oriental intellectual attitude that favors cooperation with, rather than subjugation of, nature. Also, by not forcing an image of nature on the viewer, the sense of realism is, if anything, enhanced. But *Clear Day in the Valley* is more than open space filled with vapors. The ink washes are given form by a structure of lines and figures. By the means of placing small trees and pavilions at the bottom of the picture, the feeling of distance and altitude suggested by the washes is increased. (The exciting sensation of potentially falling into the scene is due perhaps to this ''plunging'' perspective.) Drawn lines also complement the tonal areas in defining the craggy land formations and the textures of leaves and rocks.

In addition to providing realistic information, the lines create an intricate surface that is interwoven with shapes of various densities. This sensitivity to the subtleties of abstract rhythms, especially as demonstrated in their use of line, can be at least partially explained by the fact that Chinese artists received extensive training in handwriting, or *calligraphy*. Calligraphy was practiced with a brush and looked on as a fine art just as painting was. Chinese painting was nurtured by the freedom and fluency of Chinese script and by the cults that refined the art of calligraphy over the centuries.

Rather than directly copying a section of nature, a Chinese artist gathered impressions while walking. He absorbed his subject

matter from many angles, in the process savoring its aspects and mentally translating this information into the signs for trees, water, and mountains that he had learned from his masters. Everything was stored in his memory to break out later in an act of expression. Like a stage performer, the artist felt the necessity of mental preparation before the act. According to documents of the time, some Chinese artists depended on wine for this purpose. But the artist Kuo Hsi (fig. 4-9), who lived in the eleventh century, relied on a private ritual that was described by his son:

> Whenever he began to paint he opened all the windows, cleared his desk, burned incense on the right and left, washed his hands, and cleansed his ink-stone; and by doing so his spirit was calmed and his thought composed. Not until then did he begin to paint.

The absorption and filtering of reality before transferring it to paper was an artistic habit that was founded on a philosophy of life. The goal of the Chinese artist was to reveal the essentials of nature rather than to record its outward appearance. The twelfth-century Confucian philosopher Chu Hsi compared the ultimate knowing of anything to the act of peeling an orange; an artist who merely imitated outer appearances was one who stopped at the

4-9 Kuo Hsi, *Clearing Autumn Skies over Mountains and Valleys* (detail), eleventh century. Ink and light color, 8⅜" x 10¼". Freer Collection, Washington, D.C.

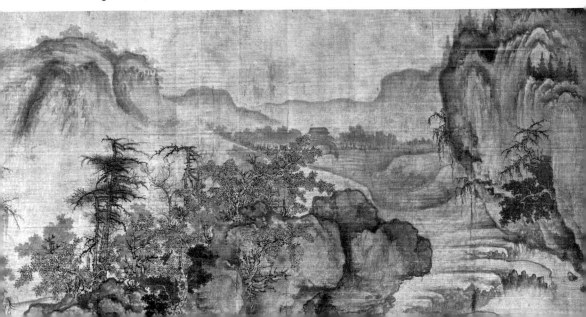

peel. The educated artist, like the Chinese philosopher who meditated on religion and philosophical subjects until they became engraved on his inner consciousness, studied nature from all angles until he could internalize its universal character. Central to this philosophy of art was the concept of *Ch'i*—life force, or energy. *Ch'i*, to which the artist had to attune himself, became not only the source of his creativity but the measure of the value of his work.

Ideas connecting man and nature run deep in Chinese thought. By the time of the Sung painters a cult of nature had arisen out of elements of all three of China's religions (Buddhism, Confucianism, and Taoism). Both Taoism and Ch'an Buddhism, the sect to which most painters and intellectuals belonged, involved the search for an escape from reality, an escape that took the form of a withdrawal to nature. This was motivated by more than purely religious insights and metaphysical speculation since at that time China was being divided by internal upheavals and barbarian attacks on its borders. Artists, however, made their livings from government salaries or the protection of rich patrons and were insulated from the mainstream of Chinese living, free to fulfill their wishes of withdrawal. Their art was not shared with the average Chinese but was circulated among a cultural elite. Love of nature and *Ch'i*, it seems, were a privilege of the wealthy.

**Christian Manuscripts**

At the time Tung Yuan and other Sung painters were glorifying nature, Christian artists in Europe were glorifying the gospels. *Christ's Entry into Jerusalem* (fig. 4-10) from the *Gospel Book of Otto III* is a fair example of medieval landscape at the time—which serves to show how far European art had retreated from Greco-Roman realism by the year 1000 A.D. Christian artists, totally committed to the spiritual world, translated their message of salvation by an art of symbols. Theologians had connected the concept of man's sinful body to that of his natural surroundings. The Christian orientation was essentially hostile toward nature and, by extension, toward artistic imitations of nature. Not that items from earthly nature were entirely excluded. Illustrations of animals, for example, were often used to decorate gospel texts, but they were turned into emblems for other meanings than themselves: the ox, the lion, and the eagle were among the symbols of the evangelists. Nature, downgraded in medieval Christian life, was used in art

4-10 *Christ's Entry into Jerusalem,* from the
*Gospel Book of Otto III, c.* 1000. Staatsbibliotek, Munich.

solely for the purpose of teaching the faithful about the mysteries of the church.

An anecdote about mountains illustrates the great difference between Chinese and Christian attitudes toward nature. The Alps, so attractive to travelers today, were not considered a fit subject matter for human attention in the Middle Ages. Petrarch, a famous

fourteenth-century scholar, talked his brother into accompanying him on a climb of Mt. Ventoux. According to history they were the first Europeans to scale a mountain just for the beauty of doing so. But when they reached the top, Petrarch read a passage from St. Augustine that made him feel guilty about enjoying himself and forgetting the needs of his immortal soul. "I turned my inward eye upon myself," he says, "and from that time not a syllable fell from my lips until we reached the bottom again."

**Leonardo**   Five hundred years after Tung Yuan's *Clear Day in the Valley* and the *Gospel Book of Otto III,* a Florentine artist named Leonardo da Vinci painted the portrait of the young wife of Francesco del Giocondo (fig. 4-11). Since then she has become the most famous woman in the Western world; her familiar smile has fascinated every generation. The fact that it was possible to make such a portrait

4-11
Leonardo da Vinci,
*Mona Lisa,* 1503–05.
Oil on panel, 30" x 21".
Louvre, Paris.

4-12
Giovanni di Paolo,
*Saint John in the Wilderness*
(detail), *c.* 1450.
Tempera on wood,
27″ x 14¼″.
The Art Institute of Chicago
(Collection of Mr. and Mrs.
Martin A. Ryerson).

in 1503 shows the vast distance that European art and intellectual life had come. Man's interest, as suggested by the expression in Mona Lisa's face, was shifting away from the mysteries of the Church and beginning to focus on the mysteries of himself. Even before Leonardo, artists had experimented with the problems of expressing the human spirit in more secular terms. Man's interest had also turned from the sky to the earth. And it is the form of the landscape behind Mona Lisa, as well as its newly discovered human meanings, to which we must now turn our attention.

As might be expected from Petrarch's experience, Europeans' historical lack of rapport with the land made it difficult at first for their artists to incorporate land features into their pictures. Early attempts, especially with mountains (fig. 4-12), were naive or fantastic (not unlike the papier maché concepts of moon scenery made in movies before Apollo 11). The mathematically minded Florentines perfected linear perspective in their search for a logical system to use in coping with the problem. This method worked well for representing a room or the shape of a building, but hills and valleys and forests and streams did not submit as readily to the controls of vanishing points and straight diminishing lines. Renaissance artists before Leonardo also seemed to have a difficult time fitting their people into continuous landscapes. Either the people were the wrong size, or the foreground was discontinuous with the background, or both.

4-13
Leonardo da Vinci,
detail of
the upper right hand
background of the
*Mona Lisa.*

Leonardo, who was a scientist as well as an artist, was more observant and less restricted to abstract formulas in his approach to landscapes than were his contemporaries. He solved the problem of reconciling his subject with the background by placing her on a high ledge overlooking a landscape (fig. 4-13). The networks of cliffsides and valleys, roads and river beds, jagged mountains and sky, join forces to make a single environment, one that is held together by a pervasive atmosphere. (Leonardo perfected the technique of *sfumato*—blurred outlines and smoky atmospheres that tend to fuse figures and objects.) If scientific research was the father of his successful landscape solutions, a powerful imagination was the mother. It is no accident that the geological forms behind Mona Lisa seem to throb like a living organism. Leonardo's belief,

expressed in his landscape, that a life force courses through all
things of the earth approximated that of the Sung concept of Ch'i.
Yet there is an unmistakable forbidding quality in Leonardo's
mountains and valleys that borders on hostility toward creature
life—a touch of the apocalypse that is totally absent in Chinese
art (fig. 4-14). Nature, as he once observed in his notebooks,
''often sends forth pestilential vapours and plagues upon the great
multiplications and congregations of animals, and especially upon
mankind.'' Some of the chill of medieval art survived the Renais-
sance thaw and lingered in Leonardo's landscapes.

4-14   Leonardo da Vinci, *Alpine Mountain Peaks*, 1510–11.
Red chalk on brick-red paper. Royal Library, Windsor Castle.
Reproduced by Gracious Permission of Her Majesty Queen Elizabeth II.

4-15　Nicholas Poussin, *Landscape with the Burial of Phocion*, 1648.
Oil on canvas, 47″ x 70½″. Louvre, Paris.

**Constable**　In contrast, the landscape of cool trees and distant meadows in *The Hay Wain* (colorplate 9) radiates serenity and optimism. The nineteenth-century countrysides of John Constable are partly indebted to earlier work by Dutch artists, an art of low horizons with scudding clouds and moving shadows, and partly to his studies of the tree-lined, classical stillness of French landscape paintings (fig. 4-15). But even though he was a thorough student of the techniques of other artists, he was also an honest observer of nature itself. Constable's dedication resulted in his extending the vocabulary of outdoor art to perhaps its finest manifestation in the Western world. His particular contribution was that of capturing the transient phenomena of nature's "dews, breezes, bloom and freshness" by means of brighter color, broken touches of paint,

and flecks of pure white applied with a palette knife (fig. 4-16). Such effects were not casual tricks; Constable's fresh vision was due to combining a direct contact with nature with continual experimentation in his medium. His belief that painting should be

4-16 John Constable, sketch for *The Lock,* 1826. Oil on canvas, 36'' x 28''. Royal Academy of Arts, London.

pursued as an inquiry into the laws of nature is reminiscent of Leonardo da Vinci's attitude. And as was the case with Leonardo, Constable's reliance on careful observation was enhanced by a reverent passion for his subject.

A variant of nature worship had infected all of Europe since the eighteenth century. On the continent Jean-Jacques Rousseau had challenged the hearts and minds of Europeans by championing the virtues of primitive simplicity over the vices of civilization. In England, the Romantic poetry of Wordsworth (which was read by Constable) extolled the spiritual revelations of nature in even its most humble aspects. Literature and art reflected an intellectual revolution that seemed to be bringing Europe around to an outlook like that of Taoist China—the common ground being a mystical feeling for nature. (One symptom of this shared state of mind was the mutual taste in China and nineteenth-century England for large, informal gardens.) Constable's temperament and personal religious views coincided perfectly with this cultural movement. The natural universe, in which the philosophers of the time believed the highest moral feelings were revealed, was considered to be the handiwork of God. And this handiwork extended to every last thing—mill dams, willows, old rotten planks, shiny posts— that Constable revered in the English countryside. It is no accident that his finest landscapes, like *The Hay Wain,* were painted in the East Anglian countryside around the river Stour where he grew up.

Ironically, the works of Constable, the English artist who most successfully expressed the moral, philosophical, and visual ideals of the people of his country at that time, were more popular in France than in his own land. English artistic tastes, which favored a more finished-looking and idealized product, had not as yet caught up with English spiritual values. But in France, *The Hay Wain* received a prize in the Salon of 1824 and profoundly influenced many French artists and art movements including the Impressionists, who based an entire style on the technique of breaking up color. But he had his greatest effect on other artists of the movement known as *Romanticism* (fig. 4-17). The extremes of Romantic painting either sank into sentimental depictions of rustic life or soared into extravagant visions of idealized nature. But Constable's complete respect for nature seems to have enforced an artistic honesty that helped him to resist the seductions that so tempted other artists of his generation.

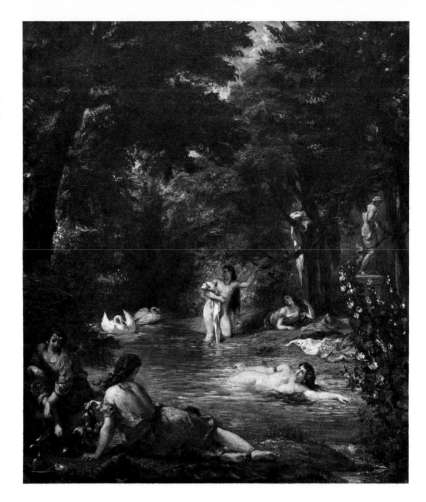

4-17
Eugène Delacroix
*Turkish Women Bathing,* 1854.
Oil on canvas, 36¼″ x 30½″.
Wadsworth Atheneum,
Hartford, Connecticut.
(Ella Gallup Sumner and Mary
Catlin Sumner Collection).

## After Constable

Landscape art and nature worship have declined since Constable's time. The French Impressionists, reacting against the excesses of Romanticism, purged the effects of that movement from their own art. At the same time they helped set in motion the separation of art from many of the social and spiritual values necessary to a landscape tradition. Nature, no longer felt to have any religious significance, became a source of color sensations and patterns, and a stage for portraying the newly wealthy, urban middle class. After the Impressionists, nature became less and less important even as a point of departure as preoccupation with color and the formal elements of art became a more central concern.

Perhaps it is possible to extol nature without realism or images of nature. Throbbing colors and vivid patterns can correspond to the ways that we experience the sensations of nature or act as

103

metaphors of creative energy: according to Robert Wolff, a twentieth-century teacher of design, "Nature is not the sight of the forest, it is the sap in the tree." In its most general forms, nature has been and still is a motivation for some abstract art, but a look at the whole story of art in our century would show that a concern for nature has been minor at best. As a matter of fact, an intentionally antinature attitude may be stronger. To the extent that modern art has reflected the prevailing intellectual climate of the twentieth century, it is clear that neither God nor nature are in vogue.

The general public, however, still likes to visit the countryside, favors exhilarating natural backgrounds in the movies, and hangs landscape pictures in their living rooms. But nature, despite the token sentimental recognition, has not benefited at the hands of the general public; instead, it has had its relevance diminished by buildings of concrete and steel and its very existence threatened by pollution. Meanwhile there is great potential in our time—in terms of both motives and means—for artists to deal with nature. The possibilities of ecological disaster may be reason enough for many to begin dramatizing an awareness of this prospect. For others, the possibilities of new images of nature may be the main inspiration. Before now, man's view of the world was limited not only by his eyes but by his position on the earth. One extreme is represented by da Vinci's well-known portrait, the other by Tung Yuan's distant view of mountains. Now the limits have been considerably extended, permitting him, with the help of an electron microscope, to get a look at the inner world of matter, and, with the help of space travel, to see his own planet from a separate vantage point.

Some artists are already dealing with nature but in ways very different from the oil-on-canvas methods of people like Constable. *Earth Art* calls for the artist to expand the scale of his work to that of his subject, using the land itself as his material. With such tools as picks, shovels, trench-hole diggers, and earth-moving equipment, Robert Smithson transformed large areas of the landscape into works of art (fig. 4-18). He created interesting shapes and textures on a grand scale. His work brings our imagination into a contact with nature that may cause us to discover fresh aspects and natural beauty where least expected. Thus, Smithson's function as an artist is not very different from that of such older landscape artists as Constable, da Vinci, and Tung Yuan.

4-18   Robert Smithson, *Spiral Jetty,* 1970. Black rock, slate crystals, earth, red water (algae), 1500′ long by approx. 15′ wide. Located in Great Salt Lake, Utah.

# 5

# Man
# Alters
# Nature

The Spanish city of Segovia is the site of many architectural treasures including a splendid Gothic cathedral, a storybook castle, and several old churches. One of its proudest monuments is the remains of a huge piece of city plumbing. El Puente (fig. 5-1), a double tiered Roman aqueduct, was built in the first century A.D. to support a large trough through which water could flow from the Sierra de Fuenfria mountains across a long valley to a Roman settlement.

This situation illustrates one of the principal ways something achieves the status of an architectural monument—by outliving its original purpose and becoming revered as a work of art. Can you imagine people nineteen hundred years from now admiring a segment of an interstate highway cloverleaf? Or tourists paying homage to the remains of high-tension towers? Looking back again to the Romans, one wonders if any citizens living in Segovia at the time complained about the aqueduct because it ruined their view.

In this chapter we will not be concerned about whether or not a man-made thing is as yet or ever will be called a work of art

**5-1    Roman aqueduct, Segovia, Spain,** *c.* **10** A.D.

(or a tourist attraction). We will instead observe the ways in which man's objects, new or old, affect man's environment. Rather than the shapes of monuments, the focus will be on the forms of living and their counterparts in man-made creations that will be called, loosely, architecture.

The twin considerations of *lived space* and *architectural space* will always be at the forefront of attention. Lived space refers to that which we physically occupy, move through, and use for various purposes, and in which we encounter and interact with other people and objects. But it is also the space that we are visually aware of and interpret with our minds and feelings. Architectural space consists of the solids and openings and places and paths that shape lived space.

An architectural writer, Christian Norberg Schultz, identifies some levels of lived space (what he refers to as "existential space") as: *landscape, urban, house,* and *thing.* These are convenient divisions with which to review some varieties of lived space and their counterparts in architectural space.

**Landscape Level**

The scope of space at the landscape level might be likened to that which can be pictured in a landscape painting or in a photograph from a tall building or a low-flying plane. It is big enough to take in a city and some of its surrounding topography. At this level the relationship between city and site can be examined.

*Metropolitan*

Historically, major settlements were formed on sites where a number of favorable natural features were found, especially waterways. A large bay and a fine harbor situated on the western coast of a new continent made up the potentials of an international city, San Francisco. With a little help from historical events—such as the '49 gold rush—the great city has lived up to the promise of its location. In addition to strategic location, the Bay Area has the natural endowments of a rich and fertile peninsula in a setting of sea water and foothills. San Francisco's natural site has the double blessing of a harbor for trade and a varied topography that gives it an aesthetic identity of its own (fig. 5-2).

**5-2
View of
Lombard Street,
San Francisco.**

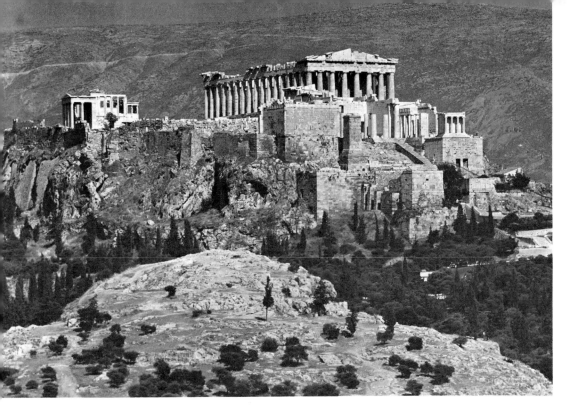

5-3 View of the Acropolis, Athens, Greece.

San Francisco's builders have both complemented and de-tracted from the natural beauty. The exceptional Golden Gate Bridge, which is the visual keynote of the area, and the historic personality of the waterfront and cable cars have contributed to San Francisco's reputation. However, the regularity of the street layout, unrelated to the natural contours, and the insistence on putting up tall buildings threaten to obscure some of the qualities that gave San Francisco her landscape identity in the first place.

Landscape in a modern city receives its most visible trans-formation in the city's spiritual center, the commercial district. There, the man-made monuments of office buildings, hotels, and department stores along with a network of elevated freeways and bridges change the original site into a metropolitan identity. In other times and places, the central or most prominent part of a city was transformed instead by architecture intended for religious purposes.

Probably the most venerated city landscape in the world is the Acropolis of Athens (fig. 5-3). To Athenians living in the fifth century before Christ, this hilltop was the spiritual focus of their

5-4  L'Aquila, Italy.

world—the showplace of their artistic glory and the rallying point of their civic and religious ceremonies. With the help of famous artisans from all over Greece, a great popular effort during the time of Pericles crowned the Acropolis with a sacred city overlooking the *agora,* or marketplace, of the city below. The hierarchy of sacred and profane was therefore confirmed by landscape elevation. The landscape's potential was further utilized in the city's ceremonies, in which processions starting in the agora wound their way up the rocky slopes, through the majestic gate of the Propylaea, and onto the exalted plateau of the Acropolis. One of the main legacies of Greek art and architecture is the concept of the heroic, and the heroic qualities of the gateways and temples on the Acropolis can best be understood in the context of their heroic landscape setting.

5-5   Safdie, David, Barott, and Boulva, *Habitat,* Montreal, 1967.

*Residential and Rural*   Less dramatic but equally important is the role of landscape in daily living, where attention is given to the selection of sites for family homes and their accomodation to the land (fig. 5-4). The organic relating of houses to a steeply sloped hillside produces a rich texture of spaces that are not found in the cities. The same variety of path, direction, and level is attempted in the experimental modular apartment building, Habitat, designed by Moshe Safdie—but without relying on a landscape (fig. 5-5).

Variety is not always a commodity of most suburban residences in America. The earth is leveled by bulldozers and overlaid with a grid of asphalt roads, and row after row of subdivided plots are topped with single-family dwellings. The whole idea, supposedly, is to provide city-oriented people with a little piece of real estate in the country.

**Urban Level**

Social interaction rather than interaction with the landscape is the focus at this level. The man-made environment has an effect on both our visual and social horizons. The physical elements of urban space that define our urban world are encountered in a complex network of history, habits, beliefs, and wishes.

*Village and Town*

There is a legend among the Dogon people of Africa about a thirsty man who was approached by a crocodile that led him to a pool where other crocodiles lived. There the man slaked his thirst and founded Bandiagra, capital of the Dogon people. Today the Dogons revere the crocodile as a tribal father, and water, which is still scarce, as a sacred bond of life. Bandiagra is not far from Timbuctu in the French Sudan and, along with other settlements of the Dogon people, has recently become an object of absorbing interest to sociologists and architects.

5-6  Dogon village in Mali, West Africa.

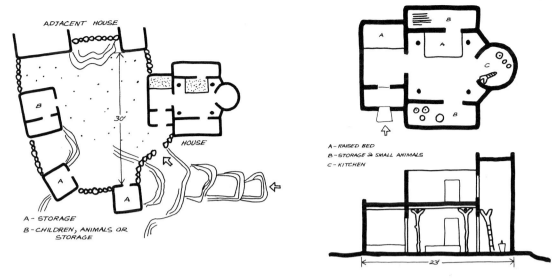

ADJACENT HOUSE

30'

HOUSE

A - STORAGE
B - CHILDREN, ANIMALS OR
      STORAGE

A - RAISED BED
B - STORAGE & SMALL ANIMALS
C - KITCHEN

23'

5-7   Plans of a Dogon house.

The hand-built architecture of the Dogon has the same sensuous qualities as primitive sculpture (fig. 5-6). And the organic clustering of their buildings makes pleasing levels and labyrinths that invite human curiosity. Symbol and tradition rather than geometry are the tenets of construction. A house is built in the image of a human being, with the entrance representing the vulva, the cooking area the lungs, and the kitchen itself the head. The proportions are based on the sexual symbols of 3 (male genitals) and 4 (female labia) multiplied by 2; thus a house is always 6 by 8 paces (fig. 5-7). This anthropomorphic symbolism is extended to the village as well. Individual family complexes are grouped to form various parts of the total village, which represents a man's body lying down in a north-south direction.

The symbolic interlocking of house parts, groups of houses, and village parts reflects a reciprocal interlocking in the social structure. Families of a village are linked by a complex patrilineal system that is recognized by marriage customs and a system of individual and collective ownership. A single Dogon is linked emotionally to a network of houses, and a network of houses is linked both socially and symbolically to the village. Unity is also expressed in the visible forms of objects—a woman's market basket, for example, resembles a granary shed—and the houses and courtyards harmonize with one another and with the landscape. Their architectural space is united with their lived space in all its aspects.

The land of the Dogons is not fertile; it is arid and unyielding, making hard work for the people. But, according to observers, the Dogon are remarkably happy. A sign of their content is an image of heaven that is almost identical to their life on earth, the only difference being that the fruit on the trees is a little larger and brighter so that the dead will know they are in paradise.

With the possible exception of Amish communities, nudist colonies, and some experimental communes, the vast majority of American living lacks the togetherness of Dogon villages. Even those who live in rural communities usually worship in different churches, favor private rather than collective property, and work at separate vocations (where commerce is regional as well as local); their teenage sons and daughters drive to larger towns for their fun, eventually go off to college somewhere else, and may never return. Small-town living, however, is marked by one condition that is similar to the Dogon and different from the rest of American living: the residents are acquainted with almost all of the other people who walk (or drive) in their streets.

*City Planning*    Jane Jacobs in her 1959 book, *The Death and Life of Great American Cities,* distinguishes cities from suburbs in that strangers are more common. Yet the cataclysmic growth of suburbs, even since 1959, has changed that picture. Growing alongside each other, many have united into vast, sprawling cities, remaining separate in name only. As if to verify their similarity to the big cities, suburbs are now exhibiting at least one tangible symptom formerly attributed to city living—a high crime rate. It is not our purpose here to discuss or even outline the many problems of urban living today, except to restate that social matters have a bearing on art. Indeed, with cities and suburbs it may also have come to be the other way around—art has had a bearing on their social problems.

Modern city planning goes back at least as far as Ebenezer Howard who, disliking what he saw and heard and smelled in London, proposed in 1898 to stop its growth and surround it with smaller cities combining the ''best of town and country.'' Howard's ''garden cities'' were to be encircled by agriculture, with industry, schools, and housing in planned preserves, and with culture and commerce at their centers. In essence, Howard's proposal was anticity, in both its rationale and effects. It helped to set in motion a growing body of thinking about urban living, especially in America, that favored decentralization—thinning out the city and

spreading the population across the land. The concept was furthered by two men, perhaps the most influential architects of the twentieth century, who became engrossed with their own grandiose conceptions of urban living that in one way or another reflected Howard's "garden cities."

American architect Frank Lloyd Wright, like Howard, was no lover of cities. "To look at the plan of a great city," he said, "is to look at something like the cross-section of a fibrous tumor." A dramatic and forceful person, Wright was a passionate promoter of decentralization; he equated centralization (symbolized by the evil skyscraper) with antidemocracy, anti-Christ, and the gravestone of capitalism. He was uncannily accurate about the future role of the automobile, predicting that it would increase by tenfold (in twenty-five years) and become a staple of American life. Wright included the car as an essential element of his utopian vision. The private citizen with a car was likened to a bird freed from a cage. According to Wright, he could "go where he may enjoy all that the centralized City ever gave him, plus the security, freedom, and beauty of the Good ground that will be his basis for an economic independence that is the only sure basis of Freedom." In 1934

**5-8**
**Frank Lloyd Wright, plan for**
***Broadacre City,*** **1934.**

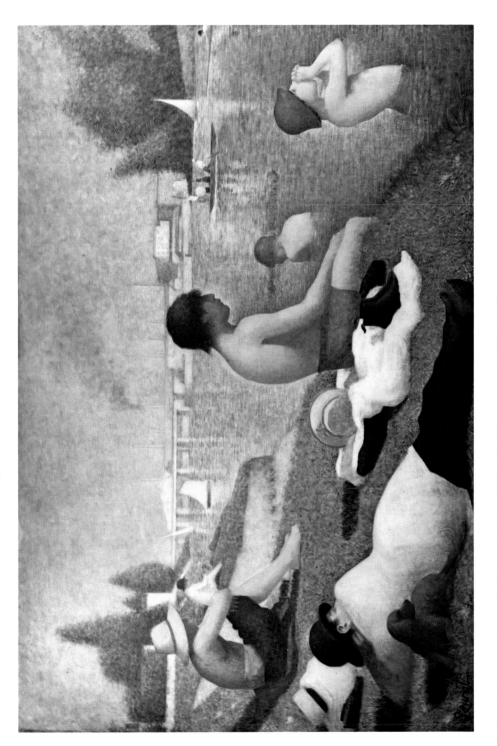

Plate 1   Georges Seurat, *Bathing at Asnières*, 1883–84. Oil on canvas, 6′ 7″ x 9′ 11″.
Reproduced by courtesy of the Trustees, The National Gallery, London.

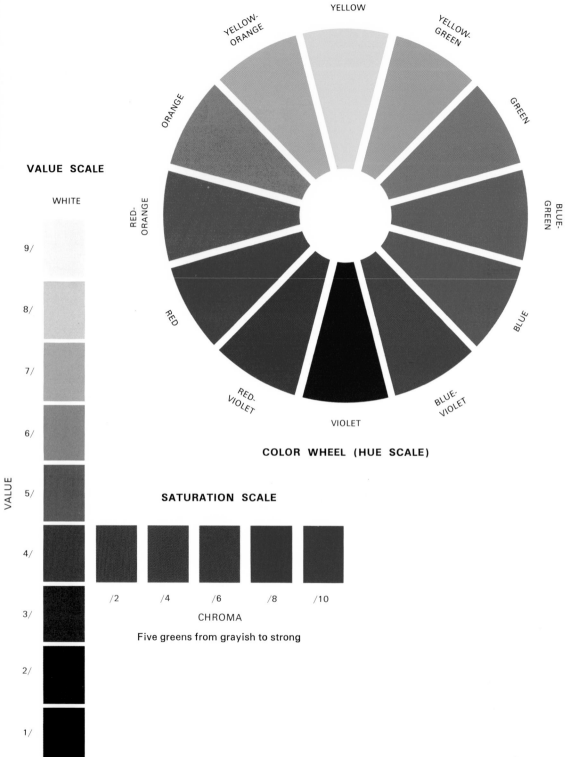

VALUE SCALE

WHITE

9/

8/

7/

6/

VALUE

5/

4/

3/

2/

1/

BLACK

YELLOW

YELLOW-
ORANGE

YELLOW-
GREEN

ORANGE

GREEN

RED-
ORANGE

BLUE-
GREEN

BLUE

RED

RED-
VIOLET

BLUE-
VIOLET

VIOLET

COLOR WHEEL (HUE SCALE)

SATURATION SCALE

/2          /4          /6          /8          /10

CHROMA

Five greens from grayish to strong

Plate 2

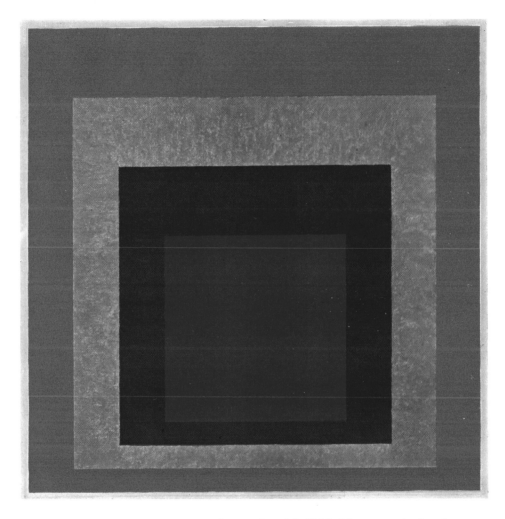

Plate 3   Joseph Albers, *Homage to the Square: Portal A,* 1953. Oil on masonite board,
35¼" x 35¼". Yale University Press, New Haven, Connecticut.

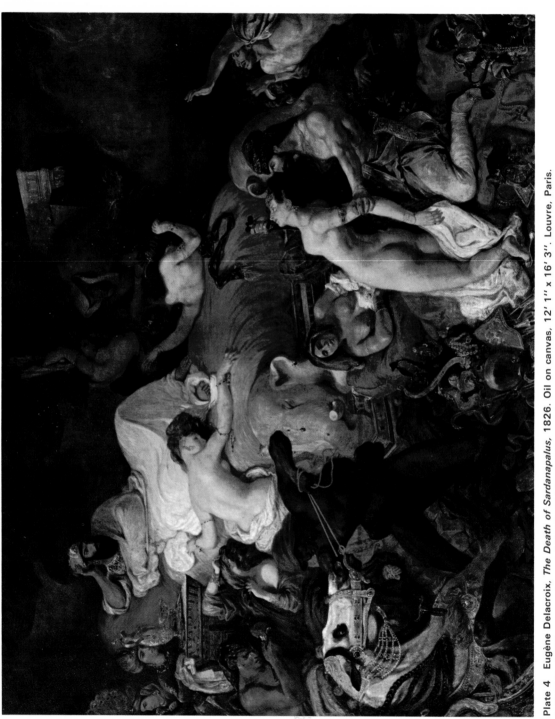

Plate 4  Eugène Delacroix. *The Death of Sardanapalus*, 1826. Oil on canvas, 12′ 1″ x 16′ 3″. Louvre, Paris.

Plate 5   Morris Louis, *Saraband*, 1959. Acrylic on canvas, 8' 4½" x 12' 5". Solomon R. Guggenheim Museum, New York.

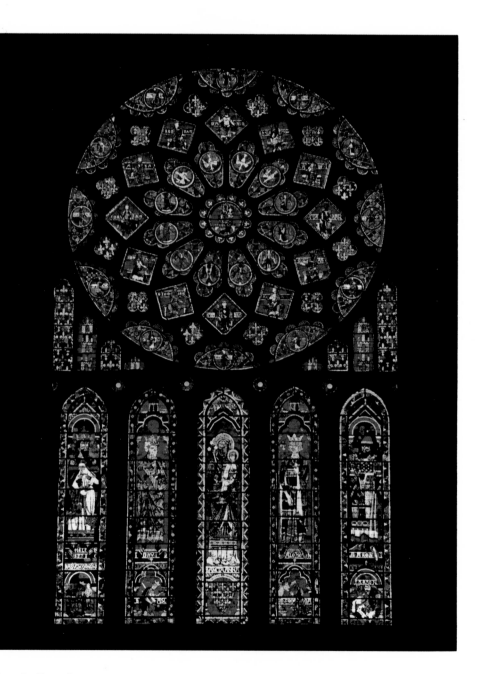

Plate 6 *Notre Dame,* rose window dedicated to the Virgin, *c.* 1230.
Stained glass, diam. of rose, 42' 8''. North transept, Chartres Cathedral, France.

Plate 7    Dan Flavin, *Untitled (To Donna) 5A,* 1971. Yellow, blue, and pink fluorescent light, 8' square across a corner. Courtesy Leo Castelli Gallery.

Plate 8    Tung Yuan, *Clear Day in the Valley* (detail), twelfth-thirteenth centuries. Handscroll, ink and slight colors on paper, 14¾" x 59¼". Museum of Fine Arts, Boston (Chinese and Japanese Special Fund, 12.903).

**Plate 9** John Constable, *The Hay Wain*, 1821. Oil on canvas, 51¼″ x 73″.
Reproduced by courtesy of the Trustees, The National Gallery, London.

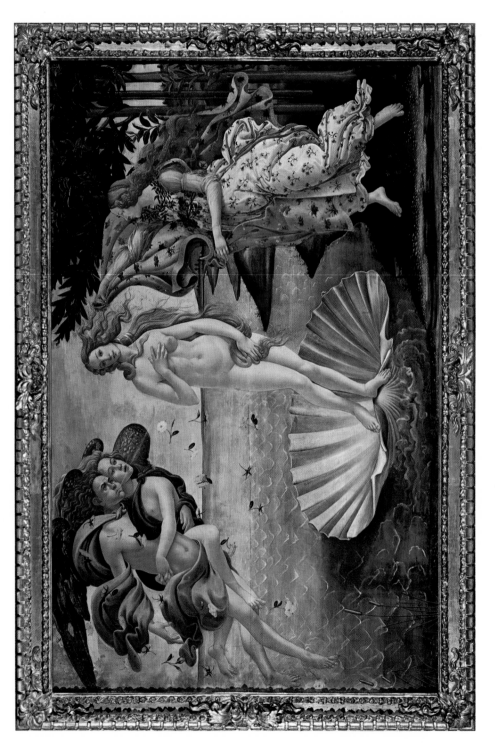

Plate 10   Sandro Botticelli, *The Birth of Venus, c.* 1480. Tempera on canvas, 5′ 8″ x 9′ 1″. Galleria degli Uffizi, Florence.

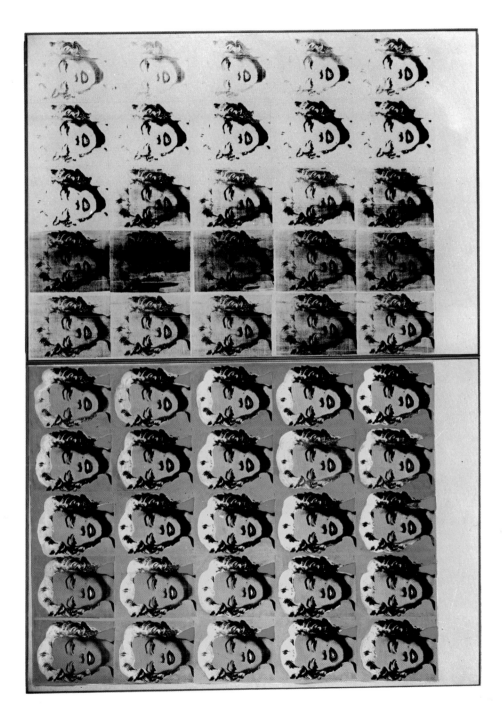

**Plate 11**  Andy Warhol. *Marilyn Monroe Diptych*, 1962. Oil on canvas, 6' 10'' x 9' 6''. Collection of Mr. and Mrs. Burton Tremaine, Meriden, Connecticut.

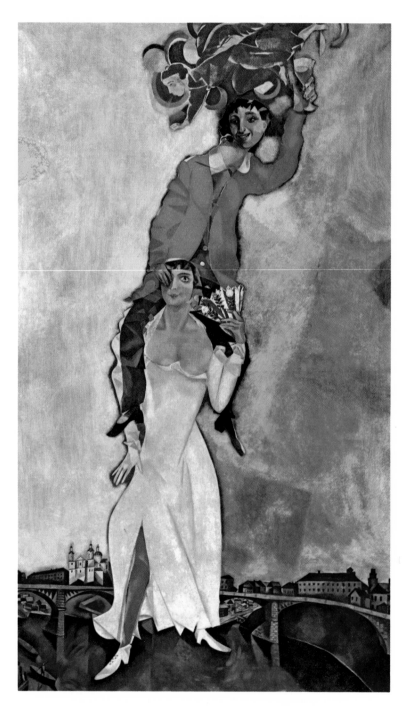

Plate 12   Marc Chagall, *Double Portrait with Wineglass*, 1917–18.
Oil on canvas, 7' 7¾'' x 4' 5½''.
Musée National d'Art Moderne, Paris.

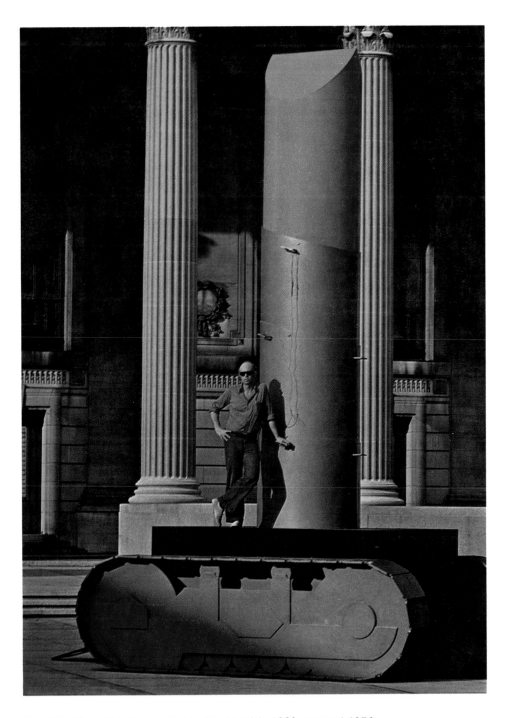

Plate 13   Claes Oldenburg with his *Yale Lipstick,* 1969, restored 1974.
Steel, aluminum, fiber glass, and paint, 24' high.

Plate 14 Barnett Newman, *Vir Heroicus Sublimus*, 1950–51. Oil on canvas, 7' 11⅜" x 17' 9¼". The Museum of Modern Art, New York (gift of Mr. and Mrs. Ben Heller, 1969).

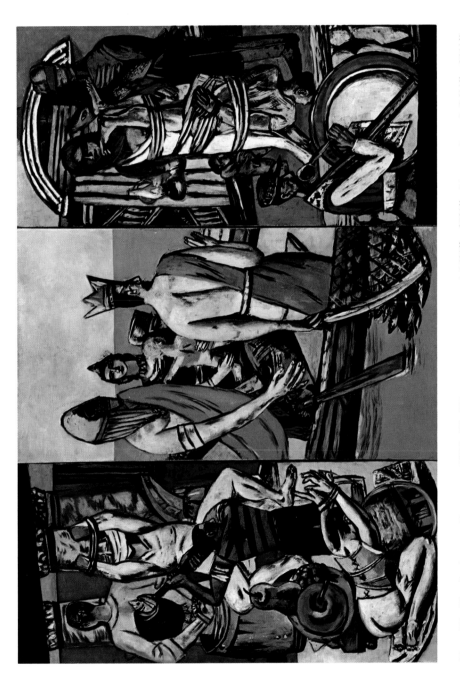

Plate 15  Max Beckmann, *Departure*, 1932–35. Oil on canvas, center panel 84³/₄″ x 45⁵/₈″, side panels each 84³/₄″ x 39¹/₄″. The Museum of Modern Art, New York.

Plate 16    Edward Hopper, *House by the Railroad,* 1925. Oil on canvas, 24" x 29".
The Museum of Modern Art, New York.

5-9  Frank Lloyd Wright, *Broadacre City* panorama showing air rotors, highway, gardens, football stadium, and apartment-office towers. © 1962 by The Frank Lloyd Wright Foundation.

he proposed a model for this beneficent "good ground." The *Broadacre City* plan—a sort of updated version of the garden city—gave recognition to and relied heavily on the automobile (figs. 5-8, 5-9).

Le Corbusier, a Swiss architect, was as enthusiastic about the city as Wright was opposed to it. Yet Le Corbusier did not like cities in their present state, which he perceived as "bulging with human detritus, with the hordes of people who came to them to try their luck, did not succeed, and are now all huddled together in crowded slums." He was really anticity in its status quo, hence

his solution was to clean the city out and supplant chaos with order (fig. 5-10). The *Ideal City* proposal (actually twelve years earlier than Wright's plan) would have created superblocks crisscrossed by super avenues, topped with skyscraper towers for working and living and surrounded by a "Great Park." Although it appalled disciples of the garden city concept, it was in fact a garden city on another scale—"vertical garden cities" in Le Corbusier's own words. Although his scheme called for twelve thousand inhabitants to an acre, high-rise quarters would only take up 5 percent of the ground (what better bow to green grass than a ratio like that). His dream also anticipated Wright's proposal in that it made ample provision for automobile thoroughfares and parking.

Le Corbusier's later versions of his *Ideal City* plan for the reconstructions of Paris and Moscow were never accepted, but his dream city has had immense influence on American city planners.

5-10   Le Corbusier, plan for *Ideal City* for Three Million People, 1922.

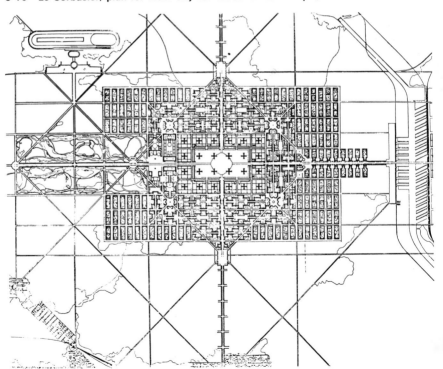

5-11   Alfred E. Smith Housing Project, New York.

In 1948 his towers and superblocks were embodied in New York's Alfred E. Smith Houses (fig. 5-11). His concept, in its basic essentials, underlies the thinking and planning of most urban renewal projects to this day. The clarity, simplicity, and glamorous visibility of Le Corbusier's drawing-board city, directly or indirectly, has captured the imaginations of architects, zoners, mayors, and even university regents. Frank Lloyd Wright's *Broadacre City,* meanwhile, has been translated (or, perhaps, vulgarized) into the spacious spread of suburbia. The capstone of the decentralization movement, what some regard as the world's largest suburb, is the immense city of Los Angeles.

It may be premature to pass judgment on the consequences of the two urban directions represented by the vision of these great architects. Although built on a much less grand scale than Le Corbusier's original conception, some of the high-rise complexes that have been designed to replace antiquated buildings or revitalize portions of the inner city have met with notable success. Chicago's Marina City solves the problem of car storage with eighteen

5-12
Bertrand Goldberg,
Marina City,
Chicago,
1964.

floors of parking facilities (fig. 5-12). The residents, mostly upper-middle-class professionals, are within walking distance of their jobs and have the benefit of the marina at their doorstep and Chicago's glittering shopping district a few blocks away. But for average families the removal of old housing to create new apartments has sometimes been disastrous. The dream of a vertical garden city has become the nightmare of a vertical slum. One of the most notorius examples is the Pruitt-Igo project in St. Louis, which, after only a few years of existence, became a super ghost city. Wright's horizontal orientation, on the other hand, aimed at dispersing the population across the countryside, received a big boost from a nationwide highway boom. A vast network of interstates, connectors, and throughways has helped thousands of families to realize their daydreams of green grass and clean air. But at the same time it has clogged the air of the cities with their commuter-car fumes. And the dream of suburban garden cities has often turned into the reality of expensive and inconvenient housing strips lined with roads that go nowhere and end nowhere.

5-13 The Galleria of Vittorio Emanuele, Milan.

A symbol, if not the source of the whole situation, is the automobile-clogged urban and suburban street. Both Wright and Le Corbusier saw the automobile as the means of modern man's salvation. "Our fast car," Le Corbusier said, "takes the special elevated motor track between the majestic skyscraper." But our fast car can just as easily zoom right off the throughway and on to the interstate that leads to Wright's *Broadacre City.*

*Planning
for Pedestrians*

Pedestrian thoroughfares are vital for genuine human interaction at the urban level. In a country famous for its public walkways, from winding medieval streets to spacious baroque squares, the Galleria in Milan, a covered street housing numerous shops and a permanent gallery of industrial products, is unequalled in its own way (fig. 5-13). The many famous city squares in Italy, such as St. Peter's in Rome and St. Mark's in Venice, have for the most part retained the ecclesiastical flavor of Italy's past. Milan, one of the richest commercial centers of Europe, is more like an American city than the others. But the Galleria is more than a shopping center; its arcades contain bars, cafes, and restaurants, and its marble streets are a place for dining and leisure as well as business. It is a square for informal seminars and a promenade for strolling, where artists and heroes of the entertainment world can mix without fanfare with ordinary people. Add a few pickpockets and prostitutes and several tourists, and the mixture is complete. But most of all, the Galleria is a focal point for the citizens of Milan.

Precedents for the Galleria go back to the extraordinary *fora* of Imperial Rome (fig. 5-14). Little remains today of Trajan's Forum (second century A.D.) except for parts of the large market on the east side of the square (fig. 5-15), but it was once an important center of the capital. In addition to being a place for shopping and

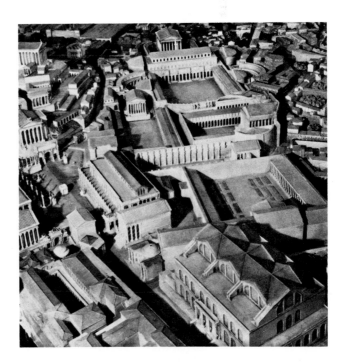

5-14
Reconstructed model
of Trajan's Forum,
second century A.D.
Museo della Civiltà Romana,
Rome.

5-15
Vaults of
Trajan's Market.

leisure, like the Galleria, a forum was a combination of civic center, financial exchange, sacred area, and sculpture gallery. Financiers met to do business, money-changers sat at their tables, and legal cases were tried in the covered basilica (an immense roofed building) or in an open tribunal where crowds of listeners could admire the legal eloquence.

Surprisingly, the automobile is responsible for a creation that could be considered a revival of the Forum of Trajan and a partial rival to the Galleria. Americans, who will drive just to mail a letter, are now being forced to stroll for their shopping because of a commercial solution to the car problem. Obviously serving fewer functions than a forum, an American shopping center is, nevertheless, a unified complex of retail stores, eating places, and malls for strolling; larger centers even have movie theatres, skating rinks, and sculpture courts. The Woodfield Shopping Center in Schaumburg, Illinois, even has a Greek amphitheatre (fig. 5-16). Some two hundred shops with brightly designed fronts face the main courts

and entry ways and announce their indentities to window-shoppers. Several balconies, crossovers, ramps, and staircases, together with gleaming sculptures, give the shopping center the appearance of a futuristic Emerald City. But for all its attractions, few people go there for the pleasure of social interaction; almost no one pauses to talk to another person. The shopping center is contingent on a suburban culture that derives its spiritual nourishment from the television screen. Its chrome and vinyl-coated surfaces and climate-controlled environment are an extension of the homogenous culture that surrounds it. Like the Galleria, it is peopled with strangers, but unlike the ultraurban Galleria, none of them are very different from the people next door.

5-16 Woodfield Shopping Center, Schaumburg, Illinois, 1971.

**5-17
Paley Park,
New York,
1967.**

The recent movement toward revitalizing old neighborhoods in the inner city offers a more varied texture of architectural spaces and encourages human contact (fig. 5-17). Sometimes this takes the form of cutting off traffic to unite one or more blocks and convert the street area into a place for pedestrians. Not just confined to the big cities, the solution of reserving streets for people— creating "pedestrian malls" in older shopping districts rather than building new shopping centers in residential districts—is being adopted in some smaller cities and towns as well.

**House Level**  The urban level is dominated by places and paths where people interact. The private spaces within the urban environment are classified as the house level. The essence of the house level is interior space, intimately proportioned by and related to the human being. It is a center of personal activity, a place someone goes to or comes from, and, most important, a place in which a man, woman, or child establishes a feeling of personal identity.

*Single-Family Dwelling*  The formal directness and material economy of Japanese art has long been an influence on some of the modern art in the West. And Western interest in Eastern art has been especially visible in the area of domestic architecture.

A dwarfish sense is apt to be the initial reaction of an American who first enters a Japanese house (fig. 5-18). The smaller scale, however, is due to social conditions and lack of space rather than to the somewhat smaller size of the average Japanese adult. On

5-18  Old Samurai's House, Miyagiken, Japan.

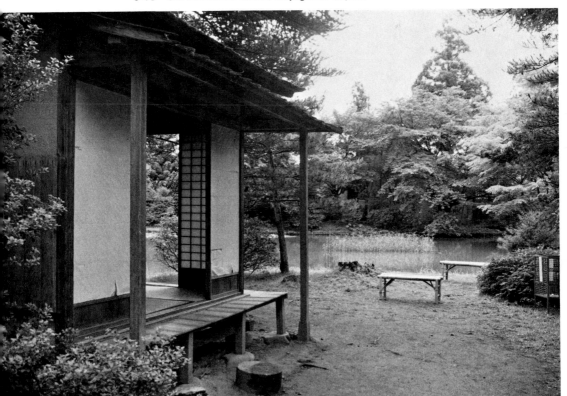

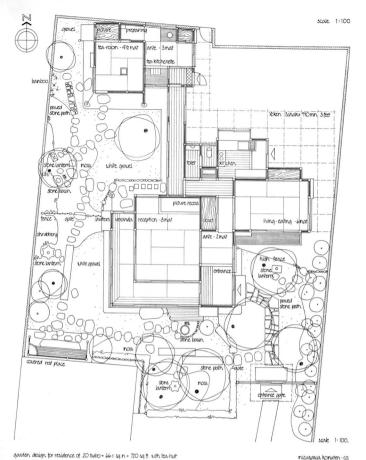

garden design for residence of 20 tsubo = 66.1 sq.m = 720 sq.ft. with tea-hut

mizusawa komuten · ca

scale 1:100.

**5-19**
**Plan of**
**a Japanese house.**

a chain of mountainous islands supporting a huge population, every habitable and arable bit of landscape has been put to human use. (The American landmarks of empty, weedy strips of land along highways or vacant lots and other patches of idle ground in the cities are simply unknown.) And the same radical economics applied to the countryside carries over into the design of Japanese houses. Architectural space in Japan is, perhaps more than anywhere else in the world, closely and economically related to the human body.

The basic ordering unit for a Japanese house is the *tatami,* a tightly woven rice-straw mat that is spread on the floor. Conveying the size and function of Japanese rooms, the meaning of these six-by-three-foot mats has so penetrated the Japanese language that the phrase, "four-and-a-half-mat novel" (suggesting an intimate nine-by-nine-foot-square room for a man and woman) is a familiar slang expression for a romantic book.

Japanese rooms, which serve different functions depending on the occasion, do not correspond to rooms in American homes (fig. 5-19). For one thing the nature and arrangement of rooms is profoundly affected by the Japanese custom of removing one's shoes before entering the house proper. The combined entrance hall and anteroom used for this purpose has thus become very important space, which in the smallest of houses may consist of 10 percent of the entire floor area. The area where one takes leave of the outside world by removing one's shoes symbolizes the first stage of shedding the indifference and estrangement of the outside and assuming the peace and harmony of the inside. The second stage of integration with the inner environment is in the adjoining anteroom. It is here that the wife welcomes her husband, and here that the host and guest meet and bow. Now a person is ready for full integration into the house. The anteroom is usually adjacent to all of the other rooms; however, a guest would be directed into the reception room. Roughly equivalent to an American living

**5-20  Inside the Old Samurai's House.**

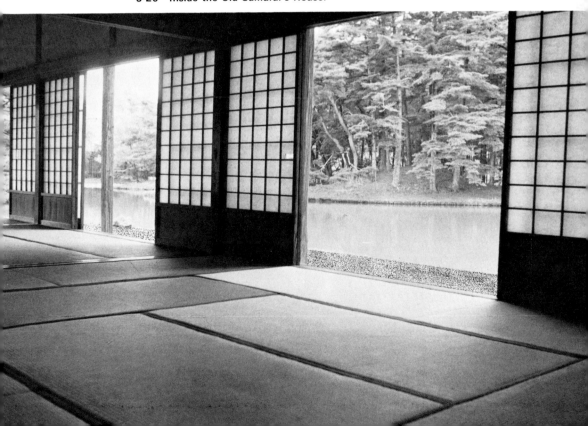

room, it is the most important space in a Japanese house (averaging at least eight mats in size). Containing a revered and ornamental alcove, called a *tokonoma*—a sort of private-home sanctuary—and bordered by a broad veranda that leads to a lovingly cultivated garden, this room is the spiritual core of the house.

Chief among the admired aspects of Japanese architecture is the outdoor-indoor relation and the concept of continuous or "flowing" space (fig. 5-20). A small garden, even under the limited conditions of city living, is considered a minimum requirement, and it is linked with the interior by a veranda that serves to visually and psychologically bridge the gap. In addition to the continuity between exterior and interior, the movable partitions and the modular coordination of rooms lends to the Japanese house a sense of uninterrupted flow between various interior spaces.

Yet any wholesale application of Japanese principles of architecture to Western architecture would be superficial. The differences in life style related to the custom of entering the home has already been mentioned; basic occidental attitudes toward physical comfort and hygiene require an assortment of furnishings that would suffocate a Japanese interior. Even more fundamental are the traditional differences in personal philosophy that always operate as underlying premises in domestic architecture. A Japanese interior, with its small scale and thin walls, is not conducive to the unfolding of individual personality. In the traditional Japanese manner the upright position is reserved only for walking from room to room. Clad in a kimono and adopting a sitting, kneeling, or squatting position, the Japanese man or woman personifies the humble and serene environment.

Frank Lloyd Wright successfully assimilated into his early homes some elements of architecture that could be attributed to Japanese inspiration (fig. 5-21). Ground-hugging horizontals accentuated by exaggerated overhangs, indoor-outdoor relationships occasioned by floor to ceiling glass, and the opening up of interior spaces are hallmarks of the Prairie Style that he conceived as early as the first decade of this century. But the elegant and romantic sensation of luxury is strictly American in spirit. Way beyond the pocketbook of the average American, the prairie house has nevertheless left its indelible mark (and thus a Japanese touch) on every suburban ranch house with its familiar overhanging eaves, picture window, and "scientific" floor plan. Meanwhile, the modern Japanese, who has assimilated many occidental habits, now has in his

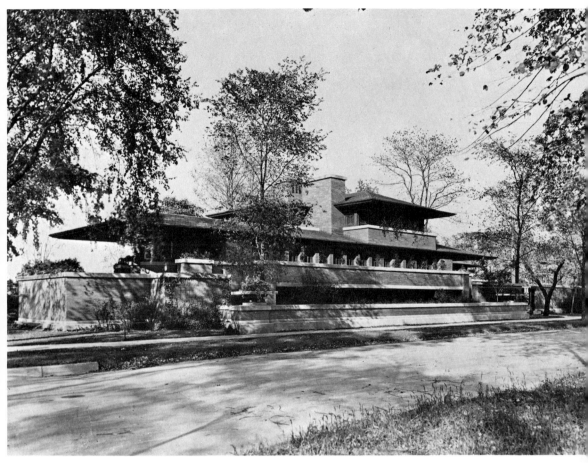

**5-21 Frank Lloyd Wright, Robie House, Chicago, 1909.**

home at least one ''Western room'' filled with comfortable over-stuffed furniture. And the same mechanical appliances stamped ''Made in Japan'' that are common in American homes are, of course, finding their way into Japanese interiors. The television set is replacing the tokonoma as a spiritual focal point. Nevertheless, the purity of the relation between architectural space and lived space that is the essence of the traditional Japanese house continues to provide lessons for home designers in both the East and the West.

5-22  I. M. Pei, Society Hill Towers, Philadelphia, 1964–1965.

*Concentrated-Family Dwelling*

The ideals of simplicity, flexibility, prefabrication, and modular coordination that are basic to Japanese architecture have been applied *vertically* by many architects in the West (fig. 5-22). Inspired by Le Corbusier's concept of the superblock, high-rise dwellings occupying open space have been offered as an architectural answer to the increasing demands of urban growth. On the other hand, the single-family dwelling is too expensive for most Americans, let alone other people of the world. And if its $45,000 ranch house on an 80 by 150 foot lot was multiplied to keep up with a population that increases by 2 percent every year, the whole world might soon be suburbanized. Clearly, there is a need for a form of concentrated living that meets the demands for the humane housing of large numbers of people on smaller surface areas.

The solution for multiple dwellings is certainly not confined to the modern apartment house. A review of other cultures and times reveals that concentrated living in preindustrial societies was and still is the rule rather than the exception and that it has been practiced in a variety of forms. Pueblo Bonito in Chaco Canyon, New Mexico, was the site of a housing settlement for over twelve hundred people of the Pueblo Indian culture that flourished around 1100 A.D. (fig. 5-23). A semicircular building complex that rose to four stories contained around eight hundred rooms. The large rooms—around 180 square feet and 6 to 10 feet high—were linked by large rectangular doorways and were open to the plaza from the outside.

5-23   Pueblo Bonito, Chaco Canyon, New Mexico.

5-24　Low-rise housing units, Bern, Switzerland.

New architectural means can be applied to high-density living without resort to multistory apartments. Under the general heading of "urban low-rise group housing" a variety of very interesting complexes that are terraced, staggered, linked, and patioed are being built today, especially in Europe (fig. 5-24). Surprisingly it

was found that low-rise urban housing is almost as economical both with regard to site requirements and cost of construction as massive apartments. Yet they retain many of the advantages of detached single-family dwellings. Indeed, many of the attractive qualities of garden-house existence have been captured in these high-density urban projects.

High-density housing, especially in the less industrialized parts of the world, is becoming a serious object of study to the architects of urbanized industrial countries. Furthermore it is recognized that concentrated living, rather than simply being a means of saving space, can be an end in itself. Given the proper conditions, high-density living can sustain a political and intellectual maturity, uncommon in low-density suburbs, that nourishes rather than impoverishes the quality of life.

## Thing Level

Theoretically, anything from a breadbasket to a phone booth can qualify at this level. And, like breadbaskets and phone booths, most *things* are associated with specific functions and thus tend to have a maximum of precise form and identity. Unlike phone booths, however, the majority of items at the thing level are not big enough to surround us completely.

Very often things serve as focal points of interest, especially at the house level. The Japanese, in particular, are sensitive to the role of things in a system of highly refined interrelationships. Creating a Japanese garden is both contemplative and exacting. Stones, the main feature, are selected by size, color, and texture and carefully placed according to symbolic and aesthetic rules. The placing of other features, such as stone vessels and lanterns, to accomodate the best line of sight from the reception room may require days of experimenting.

But things do not always serve to enliven pleasing or unpleasing panoramas. Most are so intimately bound to our daily customs and behavior as to be almost invisible. Compare, for example, the conspicuous difference in dining style between an American family and a traditional Japanese family. The role of things—the tatami instead of tables and chairs, chopsticks and bowls instead of silverware and plates—helps in establishing two different worlds for the same biological function.

Serving the other extreme of this biological function is a repertory of things toward which Americans have ambivalent attitudes.

5-25
Contemporary
American
bathroom.

The interior design of the private bathroom has come to receive much attention, perhaps replacing the private car as the family status symbol (fig. 5-25). Carpeting, ceramic tile, marble tops, and expensive fixtures are a few of the indulgences with which a modern family endows this center. Yet it is a questionable honor, since modern attitudes also decree that a straightforward name cannot

be given one of its principal purposes. Public toilets (latrines) are either nonexistent or carefully hidden, and a visitor who is not familiar with the local folkways or close to his own hotel may be in trouble. In ancient Rome, by contrast, such problems did not exist, because latrines were conveniently and openly located for the use of the general public (fig. 5-26).

*Industrial*
*Design*

In primitive societies the distinction between industry and art is comparatively nonexistent. Tools, pottery, woven goods, and other crafted objects are made in the household either by members of the family or artisans who are directly serving the needs of a small group. Utility—whether practical, ritualistic, or superstitious—is always an aspect of primitive goods; most tribal societies do not have museums to show off "useless" things like art. But the effectiveness of any item in the eyes and mind of a tribal client is inescapably dependent on how it looks. Thus style or some form of artistic ordering is imposed on every useful object.

5-26   Roman latrine.

In Europe, before the Industrial Revolution, the distinction between art and utility created few problems since both art and luxurious products were identified with privilege. The ordinary citizen was lucky to acquire merely the necessities of life, which were of no account in terms of artistic value. But as a consequence of the Industrial Revolution and the introduction of mass production, a crisis occurred in the concept of design. Not only were the blacksmith and the candlestick maker replaced by the machine but so also was the artist-craftsman. The machine's ability to pour out an endless series of identical copies tended to obliterate not only the uniqueness of the product but also the previous association that goods had with inherited class. In addition, the monotony and predictability of machine products eliminated the sense of humanity that was implied by handmade products. Early designers

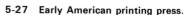

5-27   Early American printing press.

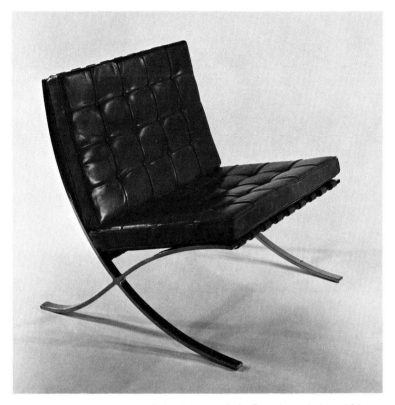

5-28   Ludwig Mies van der Rohe, Lounge chair (Barcelona chair), 1929. Chrome-plated, steel bars, leather, 29½" high. Collection, The Museum of Modern Art, New York (gift of the manufacturer, Knoll Associates, Inc.).

of industrial goods, whether through habit or conscious intent to restore old associations, continued to imitate the outer appearances of handmade products, resulting in cosmetic ornamentation that concealed rather than revealed the nature of an object. Such practices often produced monstrosities (fig. 5-27).

One of the most important contributions of twentieth-century artists and designers was the creation of a human perspective for accepting the reality of the machine. One of the principal centers for this was the Bauhaus, a German art school. The Bauhaus promoted a philosophy of design that dealt frankly with technology and sought to discover the artistic potentials of industrial commodities. Some of their efforts produced classics of design that have sustained their appeal, managing even to transcend changes in fashion (fig. 5-28). The essentials of the Bauhaus philosophy have dominated the serious practice of industrial design. Our everyday world is filled with products of Bauhaus-oriented industrial

5-29

design, seen in the crisp shapes of things from refrigerators to Xerox copiers. A holdout, however, remains in certain areas of American homes that are persistently decorated and furnished in "Homestead," "Mediterranean," and other pseudo-period motifs and therefore resist the basic Bauhaus principle of design honesty. All that one has to do to observe this design schizophrenia and to discover the ritual distinctions that Americans make between different domains of life is to thumb through any furniture catalogue (fig. 5-29). Things made for the utility room, the business end of the kitchen, and the office are highly admired for their sleek look of efficiency. But those things, whether sofas or stereo consoles, that go into the bedroom or living room—the areas that are spiritually important to the private life—are usually admired for exactly the opposite, that of *not* appearing efficient. In spite of technology and the lessons of the Bauhaus, the need for human identification with things seems to be eternal. Industrial design does not necessarily preclude making things that evoke human feeling, but the task of reconciling efficiency and emotional needs is an art requiring more than a commitment to the slide rule.

**Summary**    This essay, which presented a few examples of man's constant altering of his environment and briefly explored some of the historical and social contexts in which these have occurred, was intended to stimulate thinking about the human consequences of various acts. In general, man's creative manifestations in the past were more in keeping with local needs and conceptions. Today, new technologies and the rapid transformation of the physical environment tend to bypass human sentiments. It is only a slight exaggeration to suggest that parking lots would be installed on the Acropolis if it were in an American city. The question is: How do such actions affect human lives?

# 6

# Men
# and
# Women

In our English language Man with a capital "M" is intended to stand for a grand concept of the human race, both male and female. But at the same time phrases like *Early Man, Man and his Art,* and so on, summon up mental images of *men* rather than women, as if all the important things that have happened were performed by a race of males. In art, images of Man often turn out to be images of men. Pictures and sculptures of males rather than females are used to portray a society or symbolize its noblest ideals—a practice that is reflected in our public monuments, postage stamps, and pocket money.

Something can be (and is being) done about such usage in the English language. Words like "frontiersperson" to refer to the men *and* women who won the West can replace the old, male-dominated terms. But images are less abstract than language. Imagine creating a picture of a "frontiersperson" without making a clear choice between male or female. This problem brings us face to face with the obvious—the eternal division of the human race. Originally, according to Greek myth, a race of individuals

who were half-men, half-women populated the world. However, they became so proud that they rebelled against the gods, where-upon Zeus punished them by splitting each person in half and scattering the halves all over the world. Ever since, each half has been searching for the other half, a yearning for completion that we call love.

Art works that focus in particular on the distinction between the two halves of humanity do not necessarily imply that one half is more noble than the other. Indeed, by stressing the qualities of maleness and femaleness, this art strongly implies the *incompleteness* of the union of man and woman caused by their division. In the first part of this chapter we will look at images of men and women taken separately—images that particularly embody those respective sexual virtues that attract one half of humanity to the other half. In the second part we will look at images of men and women together, the fulfillment of that attraction. The examples in the first part will all be from the Western tradition, not because Greece, Rome, and modern Europe were more sexually inclined than the rest of the world, but because a principal thread in Western art consisted of the development of the depiction of the human body for expressing artistic content, including that of human sexuality. This focus will, in a sense, be like a history of a cultural sex typing, where the aesthetic object has played a role in creating a set of standards for the sexual object.

**Men**  In our culture, physical beauty is usually associated more with the female body than with the male body. The ancient Greeks, however, were preoccupied with male beauty and developed a cult around idealized portraits of the god Apollo. Sexual interest was not the primary impulse for creating these statues, but sexual connotations are present in the religious legends about the god, and pleasurable instincts are reflected in his images.

Greek interest in competitive athletics, particularly the Olympic games, was one of the origins of this sculpture. At least as early as the sixth century B.C., athletes competed at these events in the nude. A stereotyped notion exists today that nakedness, the "natural" state of people, occurs only in primitive societies. But nudity to the Greeks, who by this time were emerging as an important Mediterranean civilization, was a factor setting them apart from the surrounding "barbarians." The nude body, far from being

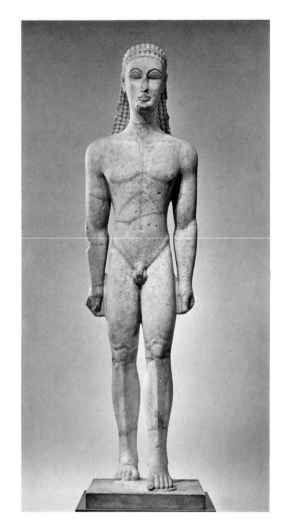

**6-1**
*Kouros, c.* 615–600 B.C.
Marble, 7'2'' high.
Metropolitan Museum of Art,
New York
(Fletcher Fund, 1932).

considered scandalous, became an expression of the essentially humane concern in Greek philosophy. Early sculptures of nude males, which could be statues either of Apollo or athletes (Kouroi), display an alert self-confidence characteristic both of young athletes and a young culture (fig. 6-1). But they also have a ramrod stiffness, a result of the influence of Egyptian sculpture, that diminishes their naturalism. The qualities of monumentality and immo-

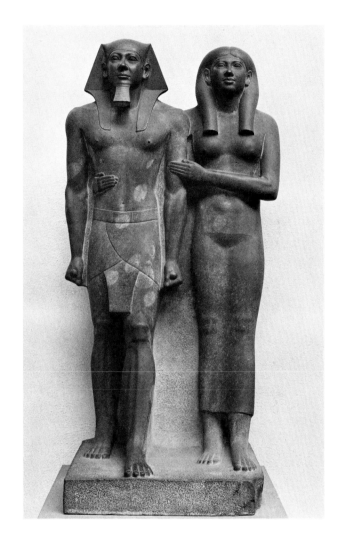

6-2
*Mycerinus and Queen,*
from Giza, *c.* 2500 B.C.
Slate, 4'8" high.
Museum of Fine Arts, Boston
(Harvard-M.F.A. Expedition).

bility, which are so admired in Egyptian statuary (fig. 6-2), are worn somewhat awkwardly by the Greek statues of athletes.

In the early part of the fifth century, the Greeks began an extraordinary progress in art and philosophy that was to set them apart from all of the other ancient civilizations bordering the Mediterranean. The aesthetic instinct that put the human alertness in the Kouros of the previous century endowed later sculptures with a

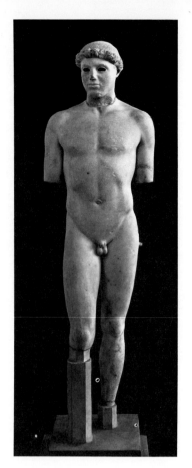

6-3
*Kritios Boy,*
*c.* 480 B.C.
Marble,
approx. 34'' high.
Acropolis Museum,
Athens.

hitherto unknown human realism and beauty exemplified by the
480 B.C. *Kritios Boy* (fig. 6-3). Kenneth Clark, who has made a
significant contribution in his study of nudity in art, says of this
statue:

> Here for the first time we feel passionate pleasure in the
> human body . . . for the delicate eagerness with which the
> sculptor's eye has followed every muscle or watched the skin
> stretch and relax as it passes over a bone could not have
> been achieved without a heightened sensuality.

(''Sensuality'' refers to the pleasure of the senses and sometimes
connotes sexual pleasure or suggestiveness.) Greek art progressed
rapidly at this time in developing models of male beauty in bronze
and stone that gave tangible form to their idealistic and humanistic
concepts of man.

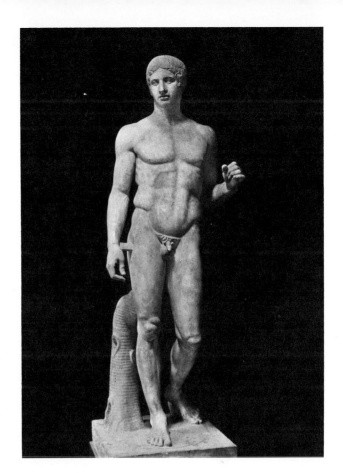

6-4
Polykleitos,
*Doryphoros (Spear Carrier),*
original *c.* 450 B.C.
Roman copy, marble,
6'6" high.
Museo Nazionale,
Naples.

By mid-century, a scant generation later, Polykleitos had sculpted his famous *Spear Carrier,* known to us only by a marble copy (fig. 6-4). Looking at this image of an athlete with our twentieth-century eyes, which are saturated with a visual idea of the human figure based on photography, movies, television, and even realistic statuary in public parks, we may not be too impressed with either its artistic or perceptual contribution. But let us look at the casual stance of the image. The slight step taken by the *Spear Carrier* was as important to Western art as the step taken by the first astronaut on the moon's surface was to science. The position of the feet and the effect it has on the posture and whole character of the body is a moon's distance away from the zombielike walk of Egyptian or earlier Greek statues. The slant of the shoulders (downward slightly to the statue's right) countered by an opposite slant to the hips is caused by placing the center of the figure's weight on the right foot. This is a stylization of the

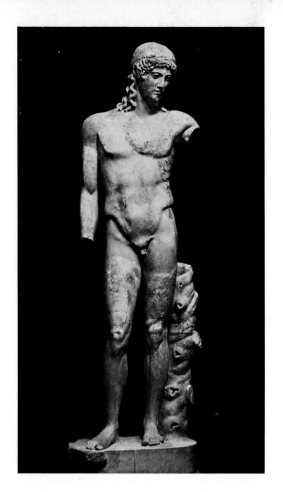

6-5
Style of Phidias,
*Apollo of the Tiber,*
original *c.* 470 B.C.
Roman copy,
marble, 7'2⅝" high.
Museo Nazionale Romano,
Rome.

human body that flows through art history down to our own time in every life-drawing class. This swing of the hips, called *déhanchement,* is a very natural way to stand or casually walk. (Nevertheless, it can also be a symbol, almost a cliché in the stance of a woman, for provoking sexual desire.) Polykleitos was quite methodical about his art. He developed a code of proportions and movements for the ideal male body, and it is reflected in this copy of his statue. Although it looks natural enough at first glance, the naturalism is actually modified by the artist's concept of perfection. The incisive clarity of shapes in the chest, stomach, groin, and legs is so dominant that they also tend to interrupt a smoothly flowing vision of the whole.

It was the achievement of the most famous of Greek sculptors of that time to project into bronze what many considered the finest archetype of Apollo. The Apollo statues of Phidias, the sculptor

for the Parthenon, survive only in the form of marble copies. Taller and more graceful than the *Spear Carrier,* the *Apollo of the Tiber* (fig. 6-5) accentuates the beauty and sensuality that was underplayed by Polykleitos. The *déhanchement* is there, and so are the conventions of defining muscles and tendons around the chest, pelvis, and knees, but none of these elements are allowed to stop our gaze and obstruct the sensation of supple grace. This statue symbolizes the Greek virtue of balance—between emotion and intellect, naturalism and idealism, and, to a degree, between male and female. This tension between polar opposites was not maintained by succeeding generations of Greek artists. Male images tended more and more to lose the aspect of this controlling intellect, becoming excessively elegant, almost effeminate, as in the *Apollo Belvedere* (fig. 6-6).

**6-6**
*Apollo Belvedere,*
original *c.* 330 B.C.
Roman copy,
marble, 7'4" high.
Vatican Museum,
Rome.

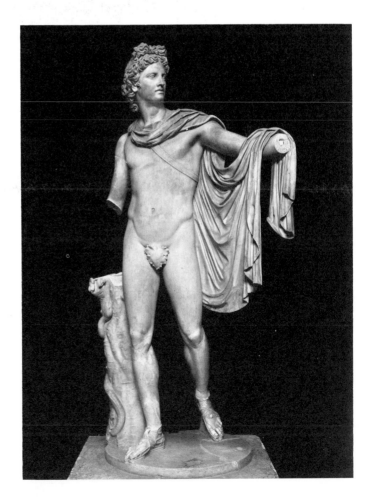

The Romans, who were the inheritors and the assimilators of Greek culture, added little to the male nude, being content with reiterations and variations of the themes already invented by the Greeks. Believing that it enhanced their divinity, Roman rulers had their portrait heads placed on top of ideal nude bodies. Despite the lapse of taste and the loss of an earlier vitality, the practice of sculpting male nudes did survive through Roman times.

The interest in the naked body that started with the Greeks has never completely disappeared from Western consciousness and has something to do, at least indirectly, with our present day concepts of the naked body's beauty. But at one time this thread of consciousness in Western history became very thin. After the Roman world was overturned by the new order of Christianity, images of nudes fell into disfavor for around a thousand years. Except for the legend of Adam and Eve, Christian theology of the Middle Ages had little need for references to nudity, and then only to exemplify the sins of the body rather than its virtues. Many, but not all, pagan statues were destroyed.

## The Renaissance

In the fourteenth and fifteenth centuries, the artists of the Renaissance rediscovered Greek and Roman sculpture, and once again the naked body appeared in art. But the passion for male beauty, when applied to the heroic figures of the Old and New Testaments instead of the gods of Mt. Olympus, underwent a striking transformation.

Michelangelo's treatments of monumental themes were expressed in equally imposing sculptures and murals that frequently involved nudity. Probably more than any artist since Polykleitos, Michelangelo extended the possibilities of the male body. Considering the human body divine, his percepts added a new experience of masculine beauty, but beauty alone is only a part of the total content of his sculpture. The thirteen-foot-high statue of *David* (fig. 6-7), carved for the city of Florence in the early years of the sixteenth century, shows the young man in the moments before battle, his head turned toward the approaching Goliath. We can certainly see something of the *Spear Carrier* in the stance and overall proportions of the *David,* for Michelangelo was an enthusiastic student of the antique statues that could be found everywhere in his native Italy. But after looking at the defiant head held in place by a column of muscle, our eyes move down across a torso that barely conceals a storm of tensions underneath. We see that

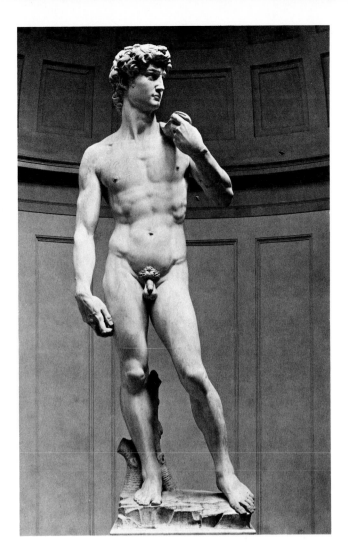

6-7
Michelangelo,
*David,*
1501–04.
Marble,
approximately 18' high,
including base.
Galleria dell´ Accademia,
Florence.

although David's form resembles the *Spear Carrier's,* his intensity
is an expressive world away from the latter's classical calm. As
far as male nudity itself goes, Michelangelo and other artists of the
Renaissance (and the Baroque period that followed) added immeas-
urably to its expressive possibilities but not appreciably in the
direction of idealized beauty. We must remember that the later
Europeans did not practice nude rituals, such as the Greek games,
and did not value nudity in males outside of art. Thus, to European
artists, male nudity was useful for its metaphorical value in reli-
gious and mythological subjects whereas, to the fifth-century B.C.
Greeks, male nudity in itself was a religious value.

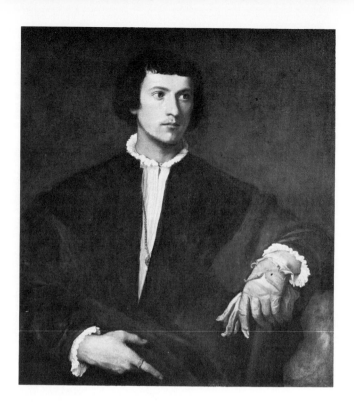

6-8
Titian,
*Man with the Glove,*
*c.* 1519.
Oil on canvas,
39'' x 35''.
Louvre, Paris.

*Later Images*   Models of male beauty since the Greeks are more likely found in portraits of men who are fully clothed. Titian's painting *Man with the Glove* (fig. 6-8) is an example of a young courtier who was handsome by sixteenth-century Venetian standards as well as, coincidentally, our own. His bearing, his face, even his long hair add up to an image of youthful manliness that we can easily understand. By contrast, Rigaud's portrait of Louis XIV (fig. 6-9) is, to our eyes, laughable—especially when we are told that it is a flattering portrait of the proud seventeenth-century monarch. What perhaps strikes us as most preposterous is the image of a pompous king, his middle-aged face framed by a large wig and his body covered with a mountain of ermine-lined robes, being supported by a pair of slender, almost feminine legs. But this judgment merely exposes our own parochial ignorance. In those days graceful legs were a symbol of *masculine* beauty; legs of women, on the other hand, were hidden from public view by floor-length garments. Only in very recent times have legs become a focal point of feminine sexuality.

Since Michelangelo, special images of masculinity have not occupied a dominant place in art; on the other hand, nude images of women as the custodians of beauty, sex, and love have become

more and more commonplace. To be sure, there have been certain living and legendary men who have represented qualities of male attractiveness. In our own century in America, for example, we can identify cinema, music, and television celebrities who have enlarged the concept of masculinity. From Clark Gable to Robert Redford, we can list a host of names, but this fact—that we have names of *individuals*—points up the difference. It is to actual personalities, their talent, and the legends built around their public and private lives that sexual attraction is attributed rather than their resemblance to a physical ideal. Anonymous images of men, such as "Mr. April" and "Mr. Orange State" or even "Spear Carrier" and "Apollo" (who was not a mortal), are not common in the art of our own day.

**6-9**
**Hyacinthe Rigaud,**
*Louis XIV,*
**1701.**
**Oil on canvas,**
**9'1⅞'' x 5'10⅞''.**
**Louvre, Paris.**

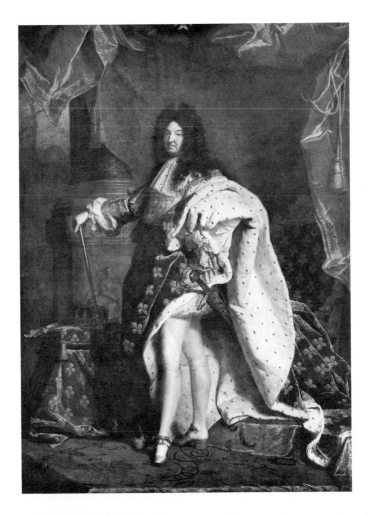

**Women**   Given our present-day situation, in which the physiological merits of the female body are pointed out daily in all popular media, and where the power of sexual attraction is virtually synonymous with the female face, breasts, and legs, it may require some stretching of the imagination to understand the attitudes of earlier ages. For that matter, if the position of women in our society continues to improve as rapidly as it has in the past few years, today's attitudes may themselves soon seem inexplicable.

*The Ancient Greeks*   In ancient Greece, while images of Apollos and young athletes were characteristically left undraped, images of women remained fully clothed. By the fifth century B.C., when Polykleitos and Phidias were refining their masterpieces of nude males, statues of women were, at their most revealing, clothed in a loose-fitting garment called a *chiton*. We should not, of course, take this to mean that women were not considered sexually attractive; the biological impulse was surely as strong then as it is now. But the desire to make images of a perfected ideal of the feminine body was not nearly as strong as it was to depict the male counterpart. By the fourth century, however, statues of nude women were beginning to be made for the sake of experiencing their ideal nudity. Appropriately, female beauty developed around the cult of *Aphrodite,* the love goddess, and her Roman equivalent, *Venus.* Statues of these and other nude figures of women became increasingly popular in the Greek (and Roman) world.

The first significant Aphrodite statue was created by the fourth-century Greek master Praxiteles for the people on the island of Cnidos (fig. 6-10). By this time the problems of representing the human body had been already worked out by earlier artists through work on male nudes. But the posture of *déhanchement,* Polykleitos's legacy, takes on a particularly voluptuous character when applied to the feminine body. The outside arch of the right hip, as well as the smaller inside arch underneath the arm pit, is much fuller, more pronounced, and its smooth line is less broken by bone and muscle. The S curve of the female body, to which the word ''sinuous'' is often applied, becomes a familiar symbol of desire. Praxiteles was well suited to sculpt Aphrodite; even his statues of men have a sinuous quality, and with it a delicate modeling of the surface that almost gives an experience of flesh. Unfortunately, Praxiteles' *Aphrodite* is known to use only through Roman copies.

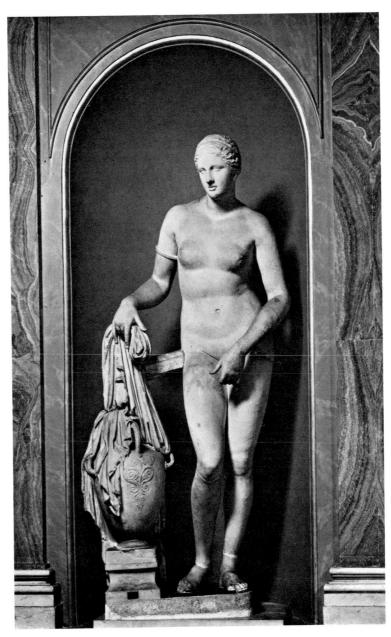

6-10    After Praxiteles, *Cnidian Aphrodite,* original *c.* 330 B.C.
Roman copy, marble. Vatican Museum, Rome.

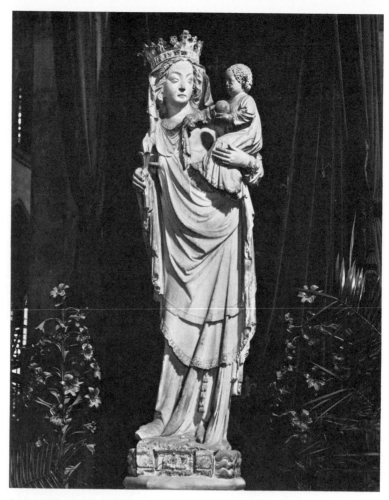

6-11 *The Virgin of Paris,* **early fourteenth century.
Cathedral of Notre Dame, Paris.**

*The Virgin
of Paris*

The basic formula established by Praxiteles was scarcely varied
in any major way through the rest of the Greek and Roman periods.
And, just as was the case with nude images of men, the Christian
world prior to the Renaissance professed little interest in naked
women except in instances where there was a need to symbolize
fleshly lusts. In one culture the body had been a focus of religious
veneration; in the other it was, at times, antireligious. However,
in the twelfth and thirteenth centuries, at the height of medieval
civilization, women took on greater importance and new meaning
in the arts and letters. The age of chivalry flowered and was given
expression in poetry and romances, and the cult of the Virgin Mary

appeared in the Church. The worship of the Virgin helped to offset the notion of Eve, the Temptress, that had dominated thinking during the earlier days of the Middle Ages. Mary in Heaven had her earthly counterpart in the medieval lady of the court who achieved a position of honor and even power in the masculine world of knighthood and the Crusades. But images of women, whether those of the royal courts or the Virgin Mary, were depicted fully clothed; their femininity being protected by layers of chastity. Yet their beauty peers through; even a seductive S-curve posture is present in the *Virgin of Paris* as she holds the baby Jesus (fig. 6-11). But aside from this apparently accidental similarity in pose, the comparison between Aphrodite and the Virgin Mary images ends. Not that the *Virgin of Paris* is opposed to Aphrodite on strictly Christian grounds; she is as much a chic ornament of the court in this image as she is the mother of Christ. But the Greek *Aphrodite* is a goddess of beauty who accepts her body openly, unselfconsciously, and pleasurably. The *Virgin of Paris* is a more spiritual lady whose beauty speaks of an eternal beatitude that, with the help of the soaring lines of her dress, even seems to imbue the stone.

*The Birth of Venus*
As the feudal system of the Middle Ages gave way to another form of society based on the new city-states, the influence of the Church was weakened, and artists began to work instead for the wealthy noblemen who held political power. Men like Lorenzo de' Medici of Florence cultivated the study of the past, inspiring a rediscovery of the myths, poetry, and sculpture of the Greeks. And with this, inevitably, came an admiration for the Greek portrayal of the nude. But it was not an easy matter for the artists of the fifteenth century to bridge the gap between the goddess of love and the Christian concept of Mary. A medieval attitude persisted toward the image of the naked female even when images of naked men had come to be sanctioned as symbols or even as representations of religious heroes like David.

Sandro Botticelli, one of the Medici circle, achieved a blend of the styles of Gothic Europe and ancient Greece in his versions of the naked female body. As was mentioned earlier, other Italian Renaissance artists before Botticelli had rediscovered the Classical art of Greece and Rome, but most had put this knowledge to the service of sculpting or painting images of men to express the flavor of their new-found rugged individualism in a burgeoning, middle-

class trading society. A great deal of fifteenth-century art, whether dealing with religious subjects or the nobility, seems to stress the attributes of powerful masculinity. With little to go on, therefore, in terms of precedent for painting the female nude in a classical theme, Botticelli created one of the more comely versions of Venus/Aphrodite in art history (colorplate 10). Initially inspired by an Italian poet, Botticelli's version of the love goddess's birth reaches back over twenty centuries to the original hymn to Aphrodite by the early Greek poet, Homer:

. . . where the moist breath of Zephyros blowing
Out of the west bore her over the surge of the loud-roaring deep
In soft foam. The gold-filleted Hours
Welcomed her gladly and clothed her in ambrosial garments . . .
And around her delicate throat and silvery breasts
Hung necklaces inlaid with gold, . . .*

Venus's pose was probably based on that of the Venus de Medici, a classical marble statue now in the Uffizi Gallery. Botticelli achieved, remarkably for his time, a comfortable, confident version of nudity and, in addition, an image of a nubile woman who is desirable yet dignified. To this extent his achievement is true to the spirit of Greek female nudity, but it is not very Greek in many other respects. None of the figures, including Venus, is standing solidly on the ground (or the shell). Even allowing for allegorical license and the need to illustrate a fancy of someone born of the sea, Botticelli's Venus is more like the lightweight figures of angels and saints that populate Gothic Christian art than the solidly physical types of the Classical marbles (fig. 6-12). The ornate delicacies that are easily appreciated in repeated details like the waves, the leaves, and the sinuous strands of hair are extended by the decorative treatment of the billowing drapery. But for the nudity, it could almost be a medieval tapestry.

On a different level, Botticelli's contribution to the popular conception of feminine beauty coincides with present tastes. The solemn dignity of her expression, of course, differs from the cloying come-ons seen in our advertising, but (at the risk of sacrilege) if we were to put a bikini on her, she would easily qualify as a fashion model.

*Reprinted from *The Homeric Hymns, A Verse Translation* by Thelma Sargent. By permission of W. W. Norton & Company, Inc. Copyright © 1973 by W. W. Norton & Company, Inc.

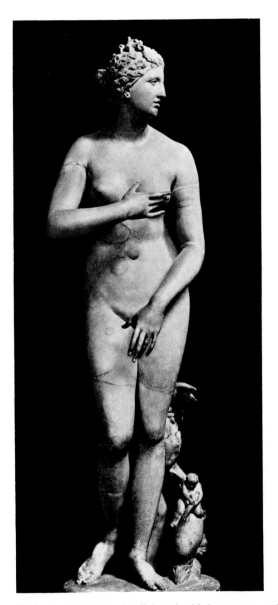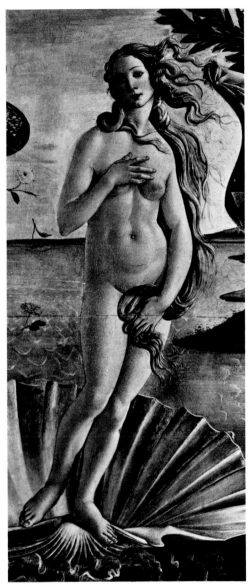

6-12 (*left*) *Venus de Medici,* early third century B.C. Roman copy, marble, 5'½'' high.
Galleria degli Uffizi, Florence.

(*right*) Sandro Botticelli, *The Birth of Venus* (detail), *c.* 1480. Tempera on canvas, 5'8'' x 9'1''.
Galleria degli Uffizi, Florence.

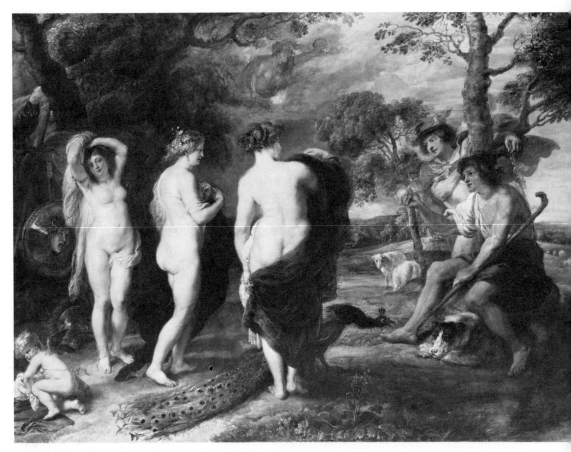

6-13  Peter Paul Rubens, *The Judgment of Paris, c.* 1636. Oil on canvas, 57" x 75".
National Gallery, London.

*Rubens*  It is doubtful that the abundant nudes painted by Peter Paul
Rubens could make it through the door of a model agency. The
ensemble of female flesh in his painting *The Judgment of Paris*
(fig. 6-13), based on a classical theme, gives us an alternative
experience of femininity to the cool elegance of the Renaissance
seen in *The Birth of Venus.* Painted a century and a half after
Botticelli's canvas by a Baroque artist living in Flanders (now
Belgium) in Northern Europe, Rubens's painting raises an interest-
ing question about the effects of local popular tastes on art. Are

his nudes an expression of Germanic preferences for hearty, healthy farm women? Indeed, the central figure is Rubens's second wife. A partial answer is that art is always created through the filter of experiences that are an aggregate of personal and cultural values. In Rubens's case, however, it would be inaccurate to claim that his preferences in models were entirely conditioned by the time and place in which he lived. Rubens was an aristocrat, a painter for the courts, and even a successful statesman on the ambassadorial level. His values and aspirations in art were molded by a firm knowledge of art history; the use of classical subject matter is evidence of this. As far as the female nude is concerned, the main art-historical influence on Rubens was the tradition of heavy Venuses developed by the sixteenth-century Venetian painters, especially Titian (fig. 6-14).

Still, Rubens's images bring a new vitality to the Western concept of femaleness, an unrestrained praise of life-giving abundance. His nudes are physically desirable, at least as much as the Greek Aphrodites, but they are also clearly intended for childbirth and motherhood. In Rubens's art we probably get one of our best glimpses of a major type—the eternal earth mother.

6-14   Titian, *Venus of Urbino, c.* 1538. Oil on canvas, 47¼'' x 65''. Galleria degli Uffizi, Florence.

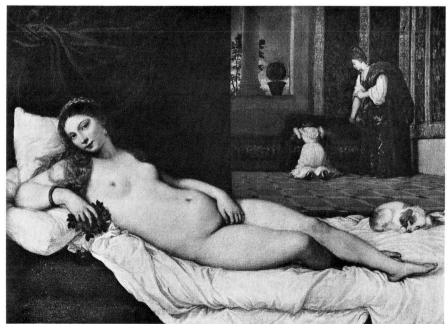

*Victorian Images*      Nude images continued to appear in art, managing to survive even
the nineteenth-century Victorian period, in which fear of the body
was at a peak—when the sight of an ankle was considered to
be provocative and the use of the word ''leg'' was held to be
indecent. In fact, the art of the time was replete with sexually
provocative displays of Turkish harems, Roman slave markets, and
decadent orgies. So long as the nudes in a work were sufficiently
classical and the subject matter recognizably aimed at teaching
history or moral lessons, the most voyeuristic scene was guaran-
teed public approval, if not great popularity. The biggest success
of the American section of the Crystal Palace exhibition in London
in 1851 was Hiram Powers's *The Greek Slave* (fig. 6-15). Her
body, a denatured version of the centuries-old Venus legacy, was
probably not as suggestive as the fact of her being in chains.

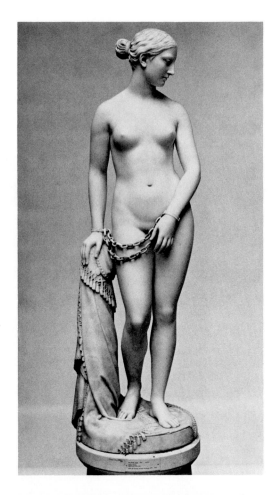

6-15
Hiram Powers,
*The Greek Slave,*
1846.
Marble, life-sized.
Corcoran Gallery of Art,
Washington, D.C.

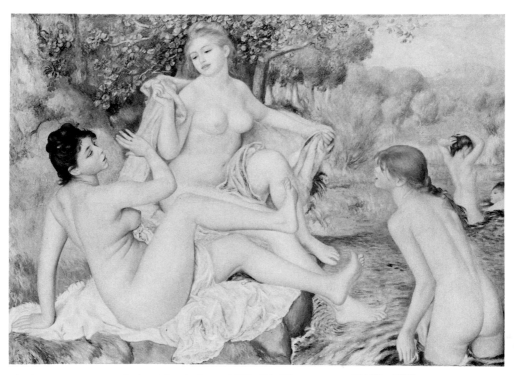

6-16 Pierre Auguste Renoir, *The Bathers,* 1885–87. Oil on canvas, 3'10" x 5'7".
Philadelphia Museum of Art (Mr. and Mrs. Carroll S. Tyson Collection).

*Renoir*     The vapidity of Powers's marble statue can be contrasted with the warmth of the paintings of nudes by the French artist Auguste Renoir (fig. 6-16), whose sweet and unaffected young women are softer and more voluptuous than those of Rubens. Renoir was a member of a group of rebellious late nineteenth-century painters, the Impressionists, who were more interested in seeking new ways of rendering visual experience in paint than in courting the conservative tastes of the period. But unlike many of his fellow Impressionists, Renoir was also very interested in the female nude, especially in adapting the traditional treatment of the nude to the new style of painting. Out of a fortunate blend of artistic endeavor and sunny temperament, Renoir contributed to and extended the tradition of Venus with his wholesome concept of hearty, healthy women—perhaps the latest, truly vital, version of that tradition.

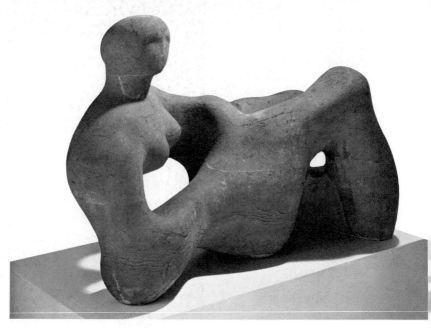

6-17  Henry Moore, *Recumbent Figure,* 1938. Stone, 4'4" long.
The Tate Gallery, London.

*The Twentieth
Century*

We could not say that Henry Moore's art was designed to expand
the concept of the body beautiful, yet his work is very sexual in
the metaphorical sense. Rather than imitations of the female
body's appearance, he makes semiabstract shapes that suggest
generalized female qualities. In his earliest variations of the reclin-
ing figure (fig. 6-17), Moore experimented with holes and the
opening up of sculpture, an awareness of negative space that is
fundamental to the meaning in his work. The hole refers to the
vagina and to caverns in the earth, while the openness of the forms
suggests acceptance and love. The reclining mode contributes to
this concept of woman as vessel, suggesting receptivity toward
the male, but it also signifies a view of female psychology that
is centered on *being* rather than *doing,* a view that is further signi-
fied by the fact that Moore's sculptural forms tend to reveal the
qualities of the material out of which they are made, whether
wood, bronze, or stone. By closely identifying the attributes of
woman with his medium of creation, he implied something very
fundamental about "Mankind." Unlike our language, which is
slanted to make us think of Mankind in terms of men, Moore's
sculpture equates the very essence of creation and being with
feminine qualities. More than just an image of woman, it is an
affirmation of life itself.

Negative statements predominate in the serious art of the twentieth century, not about the feminine principle necessarily, but about images of female beauty or the archetype of Venus itself. The work of Picasso and Matisse at the beginning of the century illustrates the ambivalent attitude toward traditional imagery that had begun to develop in the late 1800s. Picasso's reaction was one of willful violence, shattering the rules of composition as well as the conventions of the nude (fig. 6-18); Matisse's response was one of "drying up" the nude rather than destroying it (fig. 6-19). By turning the figure into just another compositional element that was completely subordinate to his artistic intentions, Matisse helped to overthrow both realism in art and the jaded tradition of Venus at the same time. But it must be understood that this was more a revolt against art and old-fashioned tastes than against women or human sexuality.

6-18  (*left*) Pablo Picasso, *Dancer,* 1907. Oil on canvas, 4′11″ x 3′3¼″. Collection Walter P. Chrysler, Jr., New York.

6-19  (*right*) Henri Matisse, *Le Luxe, II,* 1907–08. Distemper on canvas, 82½″ x 54¾″. Statens Museum for Kunst, Copenhagen (Rumps Collection).

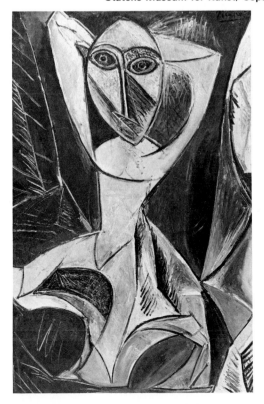

6-20  Tom Wesselmann, *Great American Nude No. 99,* 1968. Oil on canvas, 60" x 81". Collection Morton G. Neumann, Chicago.

*Pop Art*  More recently, Pop Artists like Andy Warhol and Tom Wesselmann have created satirical versions of the modern Venus archetype (or perhaps one should say "stereotype"). With cold indifference— and equally cold insight—Warhol took the ideal woman off her pedestal and put her on the supermarket shelf, as interchangeable as a row of soup cans or any other marketable commodity (color-plate 11). The judgment implied in this act, not only about the status of women but about the dehumanization that occurs in a mass-media, mass-production world, is more devastating than the violence in Picasso's forms. Wesselmann's long series of Great American Nudes, featureless women set in assemblage environments of products that advertising has made "essential" to today's life, comments on this from another viewpoint, emphasizing the bland sexuality of the cellophane-wrapped Venus (fig. 6-20).

Yet it is largely among the cliché images of popular culture that the traditional concept of Venus survives. Born Aphrodite, arriving naked from the sea, she quickly took the stage center of artistic nudity from Apollo. And when her role in art became compromised—if not obliterated—by the formal upheavals of twentieth-century painting, she was reborn from the sea of mass media, arriving naked in the centerfold of *Playboy* magazine and enacting the fantasies of the adult American male. Although realistic painting and sculpture have lately returned to prominence in the galleries, sexuality is no longer as marked nor as one sided as it once was. The artist, reflecting a new attitude toward women, has abandoned the sex object in favor of the art object, and nudity, when it is portrayed, is dealt with in a matter-of-fact way, as in the case of John de Andrea (fig. 3-22).

Notions of ideal proportions or appearance are perhaps essential to the development of any culture or historical period, but they can also become a trap that produces mindless rituals like the Miss America pageant, or dehumanized, demeaning roles such as those of the airline stewardess and the topless waitress. Inherent in the act of idealization is the fact that it will restrict our attention to themes that will soon become shallow and played out, stunting our awareness and preventing the evolution of new and better standards.

6-21

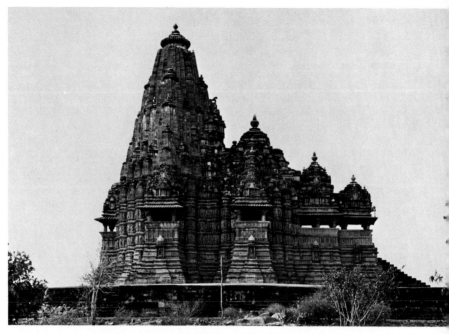

6-22    Kandarya Mahadeva Temple, Khajuraho, India, tenth-eleventh centuries.

**Man and Woman**

To go no further than to show artistic conceptions of men and women separately would be literally incomplete. The union of a man and woman is, after all, the fulfillment of the promise implied by their separateness. The rest of this chapter will complete the theme by surveying a few examples that deal with the content of love between man and woman, the first example being from an art tradition outside of the West.

*Indian Temple Art*

One of the most noteworthy—and unusual—expressions of the male-female relationship is to be found in the Khajuraho temples of northwest India, which were constructed in the tenth century A.D. by a people called the Chandels. The major temple of the group, Kandarya Mahadeva, is a luxurious beehive of a building, capped with a vast series of conical structures and covered with a profusion of detail (fig. 6-22). The visual energy of the walls of the temple suggests that the builders intended it to reflect the primal energy of life, the energy of creation and love.

While the organic is proclaimed in the rounded forms that dominate the temple, it is stated even more specifically in the biological terms that the Indians of the time used to refer to their architecture: the door was the mouth, the dome the head, and

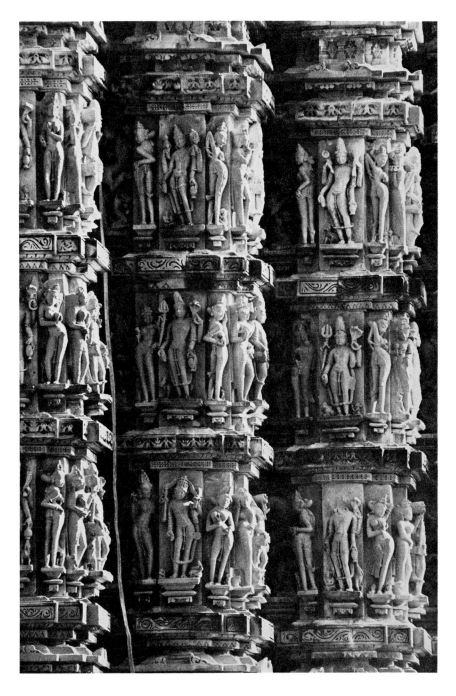

words like neck, feet, and thigh also had their corresponding parts. Inside there is a long pillar that extends into the top of the dome, a combination intended to symbolize the male and female organs.

But it was on the outside walls of the temple that the enthusiastic sexuality of the Chandels found its most explicit expression (fig. 6-23). Sculptures of gods and goddesses, saints and mortals, decorated the niches and bands around the turrets, some carved in high relief, others fully round—and nearly all engaged in one form or another of sexual activity. The majority of the figures are *apsaras,* heavenly courtesan-nymphs, who occur either singly or in conjunction with a male figure, and who may in fact be representations of the *devadasis,* women who served as attendants to the temple's deity and as public dancers and musicians (fig. 6-24). Many of the figures had their secular counterparts in the courts, representing actual princes and their wives and courtesans, a fact that calls to mind a parallel with Europe of the same period: the Royal Portals of Chartres Cathedral in France, so called because the Old Testament figures carved alongside the doors were patterned after the kings and queens of France (fig. 6-25). But the comparison only serves to demonstrate the vivid difference in outlook between the two faiths. The stiff, formal figures on the cathedral were clearly intended to de-emphasize the body, whereas the sensuous creatures that populate the temple were sculpted with greatly exaggerated sexual attributes. Their ritualized postures and gestures create a sensation of movement, and the jewelry and flimsy scarves that cling to the curves of their bodies accentuate the eroticism of their acts (fig. 6-26).

Unlike the Greek sculptors of Aphrodite or the Renaissance painters of nudes, the Indian artists did not use live models in developing their works. Instead, they employed earlier prototypes as a basis and evolved their conventions for the human body more out of religious-sexual philosophy than from the observation of anatomical structure. Much of the imagery was inspired by literary sources, such as the myth of the creation of woman, in which Twashtri, the Divine Artificer, took the roundness of the moon, the clinging of tendrils, the trembling of grass, the glances of deer, and many other qualities and compounded them all to make woman. Accordingly, the chests of young maidens are apt to be adorned with a pair of breasts that resemble wine-palm fruits. The figures of the men are likewise free of the dictates of strict anatomi-

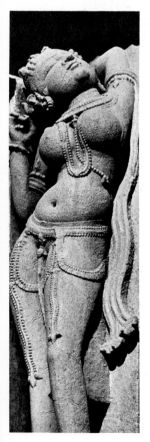

6-24  Apsara.

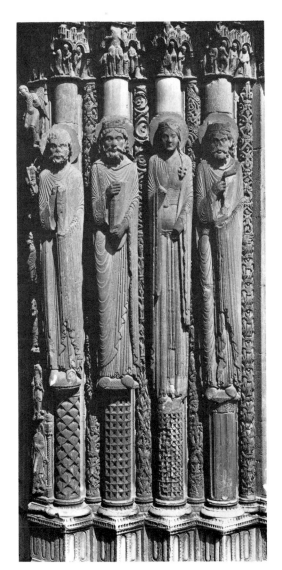

6-25   (*left*) **Detail of the Royal Portals, Chartres Cathedral, twelfth century.**

6-26   (*right*) **Detail of the Kandarya Mahadeva Temple, tenth-eleventh centuries.**

cal reality, and both men and women seem to have smoothly
flowing body envelopes that ignore the displacement of muscle
over bone structure. They have volume without seeming to have
weight, and their movements deny the sterner mechanics of the
real body. Instead, it is an emancipated anatomy of supple rhythms
that easily evokes the sensations of erotic love.

In the Christian world, in both philosophy and religion, habits of thinking and conduct have long been guided by the concept of a division between mind and body. And most of the time the body comes out second best. It is treated as something to be ashamed of rather than proud of, a tradition that reaches back as far as the allegory of Adam and Eve (fig. 6-27). Only in very recent times has the Western world come to accept the depiction of sexual activity as a possible, if not a proper, subject matter for art. Yet the forthright celebration of human sexuality was completely in keeping with the beliefs of Hinduism, a central aim of which is union with the Self. Achievement of this state can take many routes, including that of human sexuality, and a major theme of the religion revolves around the life-giving energies: the male-female principle. At times the female aspect, Shakti, is emphasized; at other times it is the male aspect, often personified by Siva, that is stressed. But the principle of wholeness always prevails, necessitating the union of male and female. In certain rites, sexual intercourse itself is considered a divine act whereby the participants become like Siva and Shakti or god and goddess. Physical sensation and idea are fused, obliterating the divisions between mind and body, heaven and earth.

6-27
Jacopo della Quercia,
*The Expulsion from the Garden of Eden*,
c. 1430.
Istrian stone, 34" x 27".
Main portal,
San Petronio, Bologna.

*Marc Chagall*     In the work of the twentieth-century painter Marc Chagall, the expression of unconditional love between a man and a woman is even stronger than in the Khajuraho sculptures, but it exists in a strictly monogamous context. Chagall and his wife Bella first met in Vitebsk, Russia, their mutual hometown, when he was about twenty-two. The daughter of a wealthy Vitebsk jeweller, Bella Rosenfeld was an emancipated young woman studying in Moscow. Marc, oldest son of a large family of a laborer, was a sensitive, shy, and somewhat eccentric young man studying art in St. Petersburg. Though the two were from widely separated social classes there existed between them such a harmony, or compatible chemistry (Chagall, himself, frequently uses the metaphor of chemistry to characterize relationships in art or people), that theirs was a truly ideal match.

Bella, perhaps to prove that she was beautiful, posed in the nude for her new boyfriend. Chagall delighted in this enterprise but was so overwhelmed by his potential fiancée that he did not use the opportunity for making advances. Although Marc and Bella were clearly infatuated with each other they were not to be married for another five years, for in 1910 Chagall left for Paris to continue his studies.

The meeting between the young Russian artist and the City of Light had the same chemistry as that earlier encounter with Bella. Chagall was ecstatic over the world's most cosmopolitan city, the center of art during the early part of our century. As though predestined, the awkward Russian emigrant gravitated to the best and the most progressive elements who were at the time revolutionizing the world of art. By 1914 he had already established a reputation, and that year he exhibited in Berlin before returning to Russia.

Despite objections from both families, especially the Rosenfelds, Marc and Bella were married in 1915. Chagall painted several works on the subject of love shortly before and after his marriage. In *Double Portrait with Wineglass* (colorplate 12) the fantasy come true is shown with Marc literally intoxicated with happiness supported on the shoulders of his wife with their newborn child hovering angel-like over both. Logical scale and the forces of gravity are sacrificed to express their private happiness. Floating figures are common in Chagall's works; in this one they specifically symbolize the flight of lovers, the buoyancy of the human spirit when it is blessed with marital happiness.

6-28 Marc Chagall, *To My Wife,* 1933–44. Oil on canvas, 51⅝" x 76⅜".
Musée National d'Art Moderne, Paris.

In 1944, while the couple was in America, Bella suddenly
died. *To My Wife* (fig. 6-28), a painting that he finished at that
time, thus became a summation of their life together. Into it
Chagall brought many elements familiar to much of his art work,
elements that derive intimately from his fantasies and private ex-
periences. The houses of Vitebsk are surrounded by a goat, fiddle
players, a horn player, an angel, and a clock as well as the couple
themselves. There can be little doubt that many of these images
echo Chagall's early years in a family of Hasidic Jews, a mystical
sect whose followers lived in communion with God by rejoicing,
singing, and dancing rather than praying.

But dominating the picture is the image of Bella, resplendently
nude—the dearest memory of all to the sorrowing Chagall. Above
her body is a bouquet of lilacs, a motif he had used in earlier works
about lovers, but having here an added connotation of mourning;
above the bouquet is the inscription *à ma femme,* to my wife. Just
left of center the couple is shown in wedding garments under a
red canopy, but the unmitigated joy of holy matrimony is now
overlaid with a funereal sadness.

Chagall's art is an extension of his private world, a world that freely united the real and unreal, the present and past, the sacred and profane. At times it seems to show a remarkable kinship with the stone sculptures of Kandarya Mahadeva, but the passion of Chagall's visual poetry was dedicated to the love of a single person, and to the physical and spiritual celebration found in a genuine monogamous union.

*Oskar Kokoschka*

A contemporary of Chagall, Oskar Kokoschka, painted *The Tempest* (fig. 6-29) in 1914, at almost the same time as *Double Portrait with Wineglass*. And like Chagall's painting, it is a young man's artistic response to a personal experience with love. Several other parallels suggest themselves on looking at the painting. The pair of lovers in *The Tempest* seems to be floating; in point of fact the German title is *Die Windsbraut*—literally, "the bride of the wind"—which would be an apt metaphor for Bella, whose figure floats in so many of Chagall's works. And like the earlier Chagall painting, *The Tempest* is a double portrait of Kokoschka and a particular woman.

6-29   Oskar Kokoschka, *The Tempest,* 1914. Oil on canvas, 71¼" x 87". Kunstmuseum, Basel.

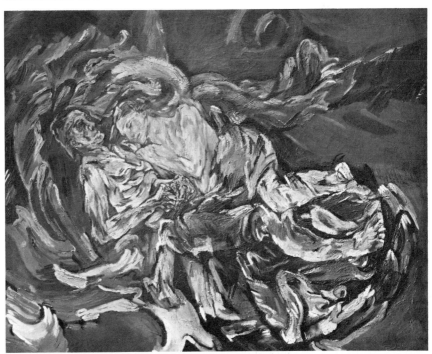

Kokoschka's three-year love affair with Alma Mahler—daughter of an artist, widow of a famous composer, and one of the most beautiful women in Vienna—nearly destroyed him. The double trauma of passionate romance and high society was too much for a tender ego; love, hate, ecstacy, fear, and above all, disillusionment were mingled in the relationship that was broken up by the First World War. Kokoschka's poetry during the period refers to the turmoil—mindful of the color and forms in his painting—that threatened to engulf his identity and creativity.

We could speak of both Chagall's *Wineglass* and Kokoschka's *Tempest* as being emotional. The Chagall is intoxicated with joy, the Kokoschka, as its English title suggests, is very agitated. But the kinds of passion presented to us in the two pictures are quite different. The spirit of *The Tempest,* though active, is heavy and turbid, like a gathering storm that has not yet released its fury. Where Chagall's lovers seem as emancipated from the pull of gravity as a wind-liberated kite, Kokoschka's couple is neither airborne nor firmly on the ground. Looking at the man's face in *The Tempest* we see neither joy nor satisfaction but the glazed expression of someone who might be deep in thought. In both of the Chagall paintings the love of a man for a woman is without reservations, while Kokoschka's work contains, at best, an ambivalent attitude toward sexual love—more feverish than truly passionate, more desperate than happy, restless rather than satisfied. The theme of Chagall's *To My Wife* has to do with loss, the artist's loss brought about by the physical death of his beloved wife; *The Tempest* also hints at this, but it is the loss of a love relationship between Alma and the tormented Kokoschka.

## Summary

Of all the subject matter available to the artist, perhaps none has proved more universally and consistently appealing than the human body. Whether as an ideal form or as the portrait of a particular person, it has always been viewed and treated differently by the artists of every age. Simply looking at the way in which it was painted or sculpted can tell us as much about the age as all the objects, clothing, postures, and expressions recorded therein. Style and content together also describe the attitudes held toward men and women, telling us whether the people of a given time believed that a man should be athletic or elegant, or if a woman was considered a piece of decorative property or an object

of worship. The relationship between man and woman is often expressed indirectly in these works, but it has much less frequently been the subject matter of art. To be sure, a hidden trove of sexually explicit works produced by artists great and small does exist, but these works are rarely meant to be more than stimulating. Only on rare occasions—such as the Indian temple carvings—has sex been treated in a transcendental way, and then only in countries and periods in which no shame is attached to it. Western art, needless to say, has had little of this since Christianity became the dominant form of religion. Only in the twentieth century has it become possible for artists like Chagall and Kokoschka to come to terms with the sexual and emotional ties between men and women, and to express them with joy or sorrow or whatever emotion they evoke.

# 7

# The
# Hero

A myth is commonly thought to be a form of tall tale, a pure fantasy with a cast of supernatural characters. But a lot depends on who is looking at it. The members of the society that produced the myth may take it seriously as an account of historical events or an authentic interpretation of their beliefs and moral obligations, and investigation often reveals that myths are based somewhat on fact, that they are a sort of veiled history of real events. Moreover, the content of a particular myth may correspond to real beliefs and feelings. Just as a dream can reveal subconscious aspects of an individual's personality, a myth can be an indirect reflection of the personality of a society.

It is not easy to be completely objective when one examines one's own personality. Likewise, it is hard to separate myth from reality when analyzing the folk expressions of our own society. Yet, in spite of the conviction that our interpretations of the world are based on science rather than myth, we also tend to color history and facts with our own collective outlook.

This chapter will only deal with one aspect of myth—the role of the hero. Next to the gods themselves, heroes are the most

7-1 Theseus killing the Minotaur, detail of painting by Epictetos, amphora, Corinth, sixth century B.C. Terra cotta, 4¼" high. British Museum, London.

important figures in the myths of any society, and they are often nearly as powerful as gods. The hero is inevitably a person of greater abilities than the rest of society, one who is able to meet a crisis and overcome great dangers. He frequently relies not on physical strength alone but employs a special weapon like the sling that David used to fell Goliath or the magic sword of King Arthur, a fact that tends to underscore either his cleverness or his holy mission. By studying the heroes of a given society, we can discover a great deal about the people who made them myths, for heroes invariably embody the ideals of that society.

**The Hero in Legend**

The story of Theseus and the Minotaur is one of the more popular and exciting legends of the ancient Greeks, and it has come down to us not only in words but in pictures. A number of the pots and jars of the Archaic period (approximately 700–500 B.C.) were painted with scenes from this and other legends, and from them we can piece together something of the story.

The Minotaur was the offspring of a bull and Pasiphaë, the queen of Crete. Her husband, King Minos, embarrassed by the existence of this monster, ordered a large labyrinth built in which to keep him hidden. The Minotaur was fed with young men and

women who were sent each year as tribute from the city-state of Athens. Theseus, determined to stop this slaughter, volunteered to be a member of the tribute group so that he might be able to slay the monster. On his arrival in Crete he began to court Ariadne, the daughter of King Minos. She promised to find a means of escape from the labyrinth if Theseus would take her away from Crete and marry her. The weapon she gave him was nothing more than a skein of linen thread, but by unwinding it as he entered the complex passageways, Theseus was able to find his way out again. A painting on a sixth-century jar from Corinth dramatically records his killing of the Minotaur (fig. 7-1), and another picture on a *krater* (a bowl used for mixing wine and water) of about the same period shows the return of the young Athenians (fig. 7-2). Their arrival at the island of Delos is clearly a joyous occasion, delightfully captured in the actions of the figures who have started to leap from the boat even before it touches shore (just below the boat we can even see one who decided to swim).

The krater was painted by an artist named Kleitias, who used a mixture of pigment and liquid clay called *engobe.* When the krater was "fired" (put in a high-temperature oven and turned from clay into ceramic, the same process used today in the manufacture of chinaware) the engobe turned black. The unpainted portions turned red, the natural color of fired clay. Most of the details—such as the facial features and lines indicating the folds of clothing—were made by simply scratching through the wet engobe to the lighter color of the clay underneath. This technique was known as *black-figure painting.*

7-2 *The François Vase,* detail, Theseus reaching the island of Delos. Painting by Kleitias, krater by Ergotimos, Chiusi, *c.* 570 B.C. Terra cotta, detail 2¼" high. Museo Archeologico, Florence.

7-3 *The Toreador Fresco,* Knossos, *c.* 1500 B.C. Fresco, approx. 32″ high, including border. Archeological Museum, Herakleion.

For centuries historians thought that the legends illustrated by these pictures were pure fantasies, tailored completely from the cloth of imagination to suit the ancient Greeks' religion. But after the late nineteenth-century German archeologist Heinrich Schliemann used Homer's *Iliad* to locate the site of the legendary city of Troy, people began taking a different look at the historical basis of Greek mythology. At the turn of the century an English archeologist, Arthur Evans, suspecting that the kingdom of Minos might have actually existed, began digging on the island of Crete. Evidence from a palace that was discovered provided a likely historical setting for the tale of the Minotaur.

It is now clear that this palace near the city of Knossos was once the center of a brilliant civilization that dominated the Aegean world before the Greeks became the principal power in that area. It is quite possible that cities such as Athens came under the influence of the Minoans, and that the citizens of these cities at times were forced to provide hostages for the lords of Knossos. A mural in the palace (fig. 7-3) suggests that the inhabitants of Knossos may have entertained themselves by watching a sport involving youthful acrobats and wild bulls. Moreover, a look at

**7-4**
**Plan of the**
**palace at Knossos.**

the complicated floor plan of the palace (fig. 7-4) reveals that outsiders might well have considered it a labyrinth.

According to Thucydides, a fifth-century B.C. Greek historian, Theseus was an early king of the city-state of Athens who wisely consolidated the surrounding communities to spur the growth of the young city, which provided an intellectual and social order that transfigured the life of its citizens. Whether or not Theseus was a real person, the Minotaur adventure indirectly refers to the rising power and genius of the early Greeks, who not only began to extend their power in the Aegean but began to provide an alternative society to that of the other ancient civilizations. The killing of the Minotaur may well symbolize the freeing of men's souls from the ignorance of barbarian culture. And no picture embodies the joy of freedom better than the boat scene pictured on the krater by Kleitias.

There is a parallel between legendary Greece and legendary America in that the latter, also dedicated to freedom and self-determination, struggled against obstacles to become a continental power. The glory of this struggle has been symbolized over and over in the movie genre of the western. Movies in America are great vehicles of myth: what seems so plausible in movies turns out, on closer inspection, to be the stuff of society's dreams.

The movie *Rio Bravo* (fig. 7-5) follows the basic pattern of hero legends. A sheriff (John Wayne) dedicates himself to avenging the murder of an old friend. When the showdown—in which Wayne and his men are surrounded—occurs late in the film, a special weapon far more powerful than Theseus's string saves

them. A wagon full of dynamite left behind by the wagon train is discovered by the small band of heroes. The enemy surrenders after the fourth stick.

In addition to the hero plot, *Rio Bravo* exhibits other similarities to ancient myths. The heroes undergo several rituals of purification, or tests of character, in order to gain the respect of Wayne, who as a father figure is reminiscent of the legendary King Arthur or the Greek god Zeus. In this setting, however, Wayne symbolizes the invincibility of the American frontier.

The character and plot stereotypes of *Rio Bravo* can be recognized in countless movie versions that bear little resemblance to the lives of the overworked, dirty, and small-statured laborers—the real cowhands—of the nineteenth century. But the main point is that *Rio Bravo* is an authentic version of the American myth of the Old West, and as such it tells us something about the way Americans think of themselves.

7-5   John Wayne and Walter Brennan in *Rio Bravo*.

The character of this myth owes quite a bit to early twentieth-century illustrators like Charles M. Russell, whose paintings helped to establish an image of the Old West that has persisted ever since. Most of Russell's paintings were products of memory—the artist's memory of his own and other people's experiences in the Montana Territory where he had lived after migrating there as a youth. He was seventeen and on his first cattle drive when he witnessed the scene in *The Toll Collectors* (fig. 7-6). After crossing the Yellow-stone River, they encountered members of the Crow Reservation who demanded a dollar a head for the privilege of sending cattle through their land. It must have made an impression on the young Russell; the artist retained this experience for over thirty years

7-6  Charles M. Russell, *The Toll Collectors,* 1913. Oil on canvas, 24" x 36".
The MacKay Collection, Montana Historical Society.

before painting it. But *The Toll Collectors* is more than an account of a single incident; it is also an expression of the artist's long familiarity and feeling for the land. He skillfully rendered all the features—the sagebrush knoll in the foreground, the river gorge, and the buttes beyond—that were to become the stock-in-trade of every technicolor western.

The striking landscape that Russell's paintings helped to popularize is more than just the western half of a certain continent; to Americans it is a state of mind. The openness of the horizon and the untamed landscape provided images for the myths of freedom and rugged individualism. What does not seem to have been translated into the myth is the artist's sympathy toward the Indian—personally and artistically. While spending an entire winter with the Blackfoot Indian tribe, he developed an admiration for the Indian that lasted the rest of his life. Russell paid tribute to his ''red brothers'' by depicting their exploits more than those of whites, an attitude that was not popular among whites at the time. His favorite subject was the buffalo hunt, which he probably knew only from detailed descriptions by his Indian friends. Although Russell was much closer to the scene than Hollywood, most of his portrayals of the West, like those of the movies, are reconstructions—the early shaping of the myth that, with the distancing effect of time, focuses less and less on the reality and more and more on the collective dream of a country's people.

**The Hero as Symbol of Present Struggle**

A hero image is very often created out of contemporary models to crystallize the meanings and the purposes of a current crisis. The rapid cultural growth of fifteenth-century Italy set in motion intellectual and political conflicts that we today might call an example of ''future shock.'' Feudalism, an economic system based on inherited wealth and land ownership, was giving way to the pressures of commerce and banking; power was shifting from fortified enclaves in the country to the commerical hubs of the cities. In the wake of these changes came political chaos, as the newly powerful city-states began to compete for influence and territories. Venice, for example, struggled mightily to protect her claims to the lands surrounding her Adriatic seaport from predatory neighbors. She became, for a period of time, the greatest maritime state in the Western world, a power in European politics, and the center of intense cultural activity.

7-7  Andrea del Verrocchio, *Bartolomeo Colleoni, c.* 1483–88. Bronze, approx. 13′ high. Campo dei Santi Giovanni e Paolo, Venice.

In 1479, the city government decided to erect a monument to Bartolomeo Colleoni, a professional captain of armies who was recognized as a hero in Venice's successful struggle against her enemies (fig. 7-7). The contract for the monument eventually went to Andrea del Verrocchio, a sculptor from that other famous city-state, Florence. Whether or not Colleoni actually looked like this when he rode a horse will never be known. But we do know that Verrocchio created a new concept of the hero image. The com-

position of horse and rider was a considerable advance in the art of this kind of monument over that of earlier examples, which had been modeled more on the classical calm of Roman statues (fig. 7-8). In Verrocchio's interpretation, one is conscious of the energy of the horse and rider, the tension that accompanies those moments before entering battle. Verrocchio brought out the qualities of ferocity and commanding presence and succeeded in symbolizing the aggressive individuality that was one of the principal attributes of the Italian Renaissance. But at the same time—in the grim and staring face of Colleoni—he inadvertently hints at the price paid for this kind of fame (fig. 7-9).

Some five hundred years later, the scale of military struggle, far surpassing that of a few warring city-states, involved nation-

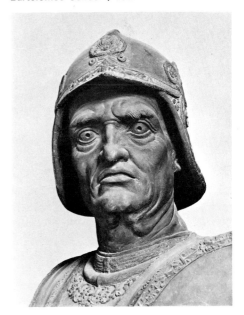

7-9 Andrea del Verrocchio, *Bartolomeo Colleoni*, detail.

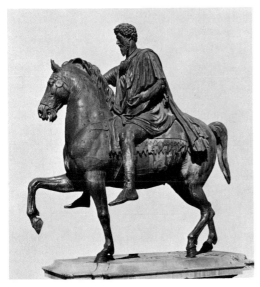

7-8 Equestrian statue of Marcus Aurelius, *c.* A.D. 165. Bronze, over life-size. Capitoline Hill (Campidoglio), Rome.

7-10 Milton Caniff, *Terry and the Pirates,* 1943. Reprinted by permission of the Chicago Tribune-New York News Syndicate, Copyright (1970–1974). World Rights Reserved.

states all over the planet, and, in the Second World War, one of the most critical roles belonged to the United States of America. The comic-strip artist Milton Caniff, author of the comic-strip *Terry and the Pirates,* created a contemporary hero for the occasion (fig. 7-10). Terry, a young and merry drifter in the 1930s, literally grew up to join the Army Air Corps in order to defend his country in the 1940s. As such he was the perfect symbol of the informal, fun-loving American youth who, when called upon, accepted military discipline and assumed the role of citizen soldier—a military type that never completely lost his civilian identity. Caniff gave Terry and his buddies—who were fighting it out with the Japanese in the Pacific—a free-wheeling slang that served as an antidote to the occupation of military hero.

But the drawings he penned were even more effective than the dialogue. For the daily comics, Caniff was restricted to the use of black and white. And rather than breaking it up into grays by means of little diagonal lines he chose to use it straight. Yet, without the help of in-between values, he was able to achieve an enormous variety of detail and texture along with a blunt but effective form of chiaroscuro. And, taking a cue from the movies he made the frames of his strip visually interesting by employing unusual ''camera angles.'' Caniff created perhaps the most exciting and plausible looking scenes of warfare that ever appeared on the pages of comics during the Second World War.

Outside of such popular arts as the movies, specifically heroic statements for public consumption have almost disappeared in our day. Since the Second World War heroic subject matter in the form of paintings, statues, and murals has become very rare in highly developed countries like America. The intellectual community, to

which most of the artists and a large part of their audience belong, often does not take heroes—real or symbolic—very seriously any more. Moreover, artists in a modern democracy do not need to depend on the governing powers, in whose interest it is to maintain images of heroism and self-sacrifice. Indeed, today's artist is far more likely to be critical of his government.

This attitude toward heroes is not always held, however, by minority groups in the United States. The outdoor murals called "Freedom Walls" that adorn ghetto buildings in some of our cities often reflect the special role that heroes play for oppressed peoples. William Walker's *Wall of Peace, Understanding, and the Unification of Man* (fig. 7-11) is a bitterly ironic mural filled with militant youths, grim faces, and guns painted in chaotic designs that are further disrupted by the

7-11
William Walker,
*Wall of Peace, Understanding,
and the Unification of Man,*
1970.
Chicago, Illinois.

189

7-12
William Walker,
*Wall of Peace, Understanding,
and the Unification of Man,*
detail showing black leaders.

forms of the antiquated wall itself. At the bottom (fig. 7-12) stands a group of Black leaders, all painted larger than life size, whose strong and orderly images help to offset the violence above. In the center stands the conservatively dressed Dr. Martin Luther King, Jr., holding a Bible. On the left is Malcolm X, dressed in an Islamic robe and holding the Koran. The Reverends Jesse Jackson and Ralph Abernathy are among the others who make up this company. Since both King and Malcolm X were dead when the mural was painted in 1970, their images are clearly symbolic of the ideologies they represented. But despite their differences, they are depicted as forming part of a united front, an example for the black community.

**Countermyth**    One of the characteristics of contemporary Western art that has contributed to the decline of the hero is the conception of the work of art as being more important than its subject matter. The heroic image of the artist—who struggles against overwhelming conditions to create art—usually overshadows whatever subject matter his painting or sculpture might have, and if an abstract monument in a public place glorifies anyone in particular, it is likely to be the artist who produced it.

A rare example of the treatment of the hero in avant-garde art is Claes Oldenburg's project for a monument to Adlai Stevenson, former U.N. delegate and statesman (fig. 7-13). Unlike his usual monuments, which are gigantic and ironic, *Fallen Hat* was intended to be small and unobtrusive—as modest as the man himself. "I think the Stevenson of legend," says Oldenburg, "would have preferred this to something grandiose. . . . The hat is bronze and set into one of the twenty-four-inch paving stones, making it necessary for a passerby to watch his step, slow and be curious since the sidewalks are narrow." The *Fallen Hat* makes gravity a metaphor for death and a fedora the symbol of an unpretentious citizen-statesman.

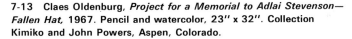

**7-13   Claes Oldenburg, *Project for a Memorial to Adlai Stevenson—Fallen Hat,* 1967. Pencil and watercolor, 23″ x 32″. Collection Kimiko and John Powers, Aspen, Colorado.**

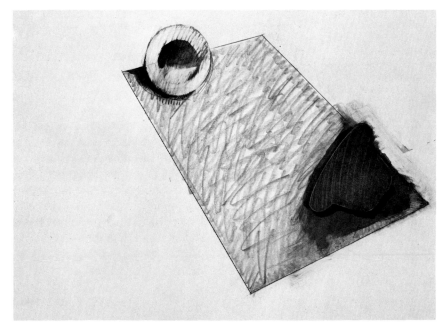

7-14  Claes Oldenburg, *Yale Lipstick,* 1969. Steel, aluminum, fiberglass, and paint, 24' high. Hewitt Quadrangle, Yale University, New Haven, Connecticut.

The term "monumental" is usually applied to works of art that are larger than life size in both physical scale and theme. It obviously applies to the thirteen-foot-high statue of Colleoni (which is further dramatized by being placed on a high pedestal), but it can also be used to describe abstract works that have an imposing look and a feeling of permanence. The simple memorial to Stevenson, because of its small scale and humble location, would hardly be considered monumental. On the other hand, Oldenburg has proposed many other projects that are of such gigantic size that they could only be considered monumental—except that their

subject matter is not at all conducive to a sense of grandeur. They are intentionally antiheroic, absurd transformations of everyday objects that mock the very concept of monumentality. Among the many projects for which Oldenburg has prepared sketches and scale models are a mammoth oscillating fan to replace the *Statue of Liberty* in New York harbor, a pair of gigantic toilet floats to be located in the Thames River in London, and a series of colossal pieces of partially eaten Knäckebröd (Swedish bread) turned on end for an island west of Stockholm.

Not too surprisingly, most of Oldenburg's monuments never get any further than the proposal stage. But a few of the somewhat less ambitious conceptions have actually been built. The twenty-four-foot *Yale Lipstick* (fig. 7-14, colorplate 13) monument was a low-budget project that Oldenburg, with the help of students, worked on without fee. The lipstick portion, originally consisting of an inflatable plastic bladder—so that it could be limp or inflated to fit the occasion—was later replaced with metal for technical reasons. The contradictory elements of the image present confusing multiple impressions: the lipstick tube is a feminine object with a form that is suggestively masculine, while the addition of tank treads leads us to realize that this ordinarily most peaceful of weapons bears a certain resemblance to a cannon. Oldenburg's visual games were well suited to the confusion of the times. Placed on the Yale campus in May 1969, the sculpture soon became a focal point of controversy that had more to do with the highly emotional political issues of the day than with art. It became a victim of graffiti and radical posters, and Oldenburg finally had it removed. It was not returned to Yale until 1974.

The elements of countermyth have been utilized more bluntly by other artists. Several works in which an image of the American flag has been incorporated have provoked court cases, even though the artistic protest was directed not at the flag itself but at immoral deeds that were allegedly committed in the name of the flag. Expressions such as these reflect the social and political agonies of recent American history. Nor are countermyth expressions limited to art. Some comics and movies have also responded to recent events and corresponding changes in attitudes. What has to be the most revealing single line in American comics was uttered by Pogo: ''We have met the enemy, and he is us.'' During the generation of Terry and the Pirates it would have been beyond imagination to even suggest that Americans could become critical

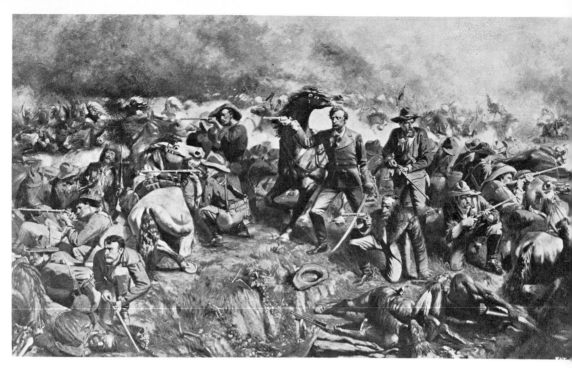

7-15　Anonymous, *Custer's Last Stand*, 1876. Library of Congress, Washington, D.C.

of their own government's role in a foreign war. But this attitude does not stop with an unpopular war of the 1960s. The inversion in the interpretation of good and evil has sent a shock wave backwards into history. Consider for example the symbolic stature of George Armstrong Custer.

Rather than one of the proudest moments in American military history, General Custer's legendary "Last Stand" (fig. 7-15) now appears to have been the product of selfish political desires and a reluctance to share the glory with other units of the Seventh Cavalry. The movie *Little Big Man* (fig. 7-16) demonstrates a radical shift in the mythology of America's history, heroes, and values. The American Indian, once considered the savage human obstacle to be overcome in the taming of the frontier, is seen as a victim of politics and technology, and Custer is accused of systematic genocide.

Depending on how one views these examples of countermyth, they could be considered perverse, or the opposite, moralistic— bringing an audience face to face with symbols that have already been corrupted. The process of mythological decline can be seen in civilizations as early as the ancient Greeks. By the fifth century

B.C. the poet Euripides was employing myth satirically and play-fully, and in later Greece and Imperial Rome the ancient gods were reduced to family mascots and their legends to favorite tall tales. But Greco-Roman mythology, some of which went back to the days of Homer, underwent several centuries of erosion before finally succumbing to the new order of Christianity.

**Summary**    Heroes have played a key role in the moral and political orientation of every society from the earliest civilizations to our own day, embodying the ideals and the dreams of each group of people. Some heroes, like Theseus, may have been real people whose actions were inflated to the level of legends. Others, like the mercenary Colleoni, were elevated to inspire the group with their exploits. Yet others, like the invincible sheriff of the western, were invented to fulfill the emotional needs of a particular society. But no matter what form they take, heroes have always held a very special place in the arts, the richness of their character providing the artist with an opportunity to rise above mere portraiture to a more dramatic level of expression.

7-16    Scene from the motion picture *Little Big Man,* 1970.

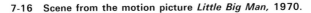

# 8

# The
# Religious
# Dimension

Viewed in the cultural settings of many different times and places, the main function of art throughout the ages is seen to be religious. Sometimes the art objects themselves have been considered magical, as is the case, for example, with fetish objects. At other times, art has been used as a principal means of communicating religious ideas. And in our own time, art has even become something of a substitute for religion.

Although the forms of art and the details of religion vary from culture to culture, there are major themes of belief that seem to be fairly common to all. The story of the Old Testament follows a pattern that is discernible in all myths. A supernatural power forms the universe and sets in motion a cycle that starts with the creation of the seas, lands, and their inhabitants. Later, man provokes the displeasure of the supernatural force and brings about the destruction of the world through cosmic holocaust. Only a redeemer-hero can intercede to save those who are worthy. But, in order to earn their salvation, the survivors are often compelled to pay the strictest homage. The cycle is impossible to alter; man cannot resist supernatural force.

8-1　View of Teotihuacán, Mexico, *c.* 510–660 A.D.

Present in all of the myths are the themes of obedience and disobedience, of good and evil. Continually tempted, man strays from strict obedience and brings about his suffering at the hands of an angry god. But he may also be plagued by a host of other supernatural forces—sometimes known as evil spirits—whose actions are not necessarily based on a sense of justice.

In this chapter we will review some examples of art that are based on particular systems of belief and some that are not. But all reflect the religious dimension by expressing either a major theme of myth or the mystery at the heart of life.

## Themes of Creation

A concept of creation can probably be found in the myths and the art of every culture in the world. But there have been very different interpretations of the concept in the art of such disparate places as Mexico before Columbus, Italy of the sixteenth century, and America of the 1950s.

### Nahuan

In the pre-Columbian Nahuan civilization of Mexico, where people were firmly convinced of the need to be in constant touch with their gods, they reproduced thousands of images and symbols of the beings to whom all authority over life and death was empowered and placed them on the outsides and insides of temples.

In the ruins of the ancient city of Teotihuacán (fig. 8-1) stands a pyramid-shaped temple dedicated to Quetzalcoatl, chief deity of the Nahuan pantheon. His fierce visage together with that of Tláloc, god of rain, is repeated over and over on the stepped

197

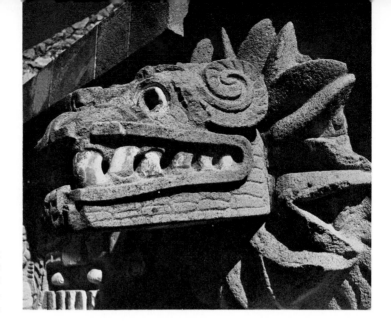

8-2
Feathered Serpent
on the pyramid
of Quetzalcoatl,
*c.* 500 A.D.

sides of the temple. We can see in these stone masks (fig. 8-2) the characteristics that are implied in his name: quetzal, a brilliantly plumed bird, and coatl, a snake. The dual symbol synthesized the concepts of matter and spirit—the snake was equated with earth and fertility, and the bird with heaven and spirituality. Thus, Quetzalcoatl was the main god of creation and the sustainer of life.

But in order to create life, he had to destroy life. After various abortive creations, he exterminated every living human being, a deed that is reminiscent of the biblical flood. He then created them anew out of a pliable substance made from a mixture of the dust of pulverized bones and blood from his own penis. In return, the people were expected to feed Quetzalcoatl and the other gods, so the Nahuans systematically practiced the ritual of human sacrifice. It was a grim arrangement of mutual dependence in which human sacrifices were made not out of cruelty or as punishment but out of religious fervor because they served to nourish the gods and produce unity between them and the people.

No one knows for sure who were the builders of Teotihuacán. Our only clue is the fact that they shared a common belief with the other Nahuan and Mayan cultures of Central America. The later Aztecs believed that the city was built by giants, so magnificent were the numerous temples, palaces, and broad avenues. Modern scholars indicate that it thrived in the second and third century A.D. with a population of nearly one million people.

*The Sistine Chapel Ceiling*

Over a period of four years Michelangelo Buonarroti, lying on his back atop scaffolding, painted a fresco of more than seven hundred square yards on the ceiling of the Sistine Chapel (fig. 8-3). The visual product alone represents an extraordinary feat, but the concept and the scope of the ideas are equally overpowering. Using the story of Genesis as his theme, Michelangelo constructed a towering drama of the Christian version of the Creation.

The intellectual life of the Italian Renaissance was partially motivated by a rediscovery of the cultural life of ancient Greece, especially the writings of Plato. The Church easily assimilated this pagan influence into a new spirit of Christian humanism, with

**8-3**
**Interior of the Sistine Chapel, Vatican, Rome.**

8-4  Michelangelo, *Creation of the Sun and the Moon,*
detail of fresco from the Sistine ceiling, 1508–12.

*Neoplatonism* becoming a cultural force in arts and letters. In the
city of Rome, the former capital of a vast empire, this new spirit
of the times began to take on monumental proportions, thanks
to the grandiose visions of a series of ambitious popes.

Michelangelo's talent was equal to expressing these powerful
new ideas in paint. The Sistine Chapel ceiling is almost a textbook
on this fusion of paganism and Judeo-Christian theology.

The God who rages through the Creation panels is the fearful
Hebrew God of the Old Testament. Shown in two positions in the
panel called *The Creation of the Sun and the Moon* (fig. 8-4), he
is loosely robed with billowing garments that emphasize the whirl-
wind of his power. Though he has the pagan body of Zeus, chief
of all the gods of Mount Olympus, his face is not that of any Greek
god, but that of Jehovah, filled with holiness and wrath. Indeed,

there are some who think that Michelangelo's model for this personification of God was the ambitious and powerful Pope Julius II.

Counterpointing the figures of Judeo-Christian mythology are the Greek *ignudi,* naked youths, that inhabit the four corners of most of the central rectangles (fig. 8-5). These are the products of the artist's admiration of Greek sculpture and of the idealized body as the most fitting temple for the human soul. In traditional treatments prior to the Sistine ceiling, fully robed and winged angels rather than nudes would have had the honor of being in the scenes from the Book of Genesis. Symbolically, the ignudi's role in the theological scheme is something like that of the angels—being somewhere between God and man—except that these figures, in personifying the Greek ideal, emphasize the capability of the human intellect to achieve divine wisdom.

The remaining panels contain the Genesis stories of Adam and Eve, the Fall of Man, and Noah and the Flood. But balancing this theme of holy vengeance is the promise of redemption, the coming of Christ, which is announced symbolically in the Jewish prophets and pagan oracles painted around the edges of the ceiling. This balance is also established aesthetically. Visual chaos is prevented by a rectangular format that serves to stabilize the numerous figures and the complex web of movement and narrative. Yet the buoyancy is not diminished. Despite the stern Jehovah, hope and glory are the basic message of the ceiling.

8-5
Michelangelo,
*Naked Youth,*
detail of fresco from
the Sistine ceiling,
1508–12.

**Barnett Newman**     The glory of Barnett Newman's painting is not conveyed by any of the features that we normally associate with religious art—not only because human images and traditional symbols are lacking, but because the religious meaning of his work does not connect in an obvious way to the Bible or any myth predicated on the supernatural (fig. 8-6).

Many of the abstract artists of Newman's generation related their personal lives and art to the philosophy of Existentialism, which asserts that man is not bound by any religion or other system of belief. This freedom, however, leaves him alone in the world and puts the burden of decision making squarely on himself. The artist must search within his own personality in order to discover a source of expression. For just as his existence is not based on an external god, so the motivations of his creativity are not to be derived from some existing set of art principles but only from within the depths of his own self. At the same time, the act of making art enables the individual to resolve some of the conflicts and problems that are a part of that self—and to overcome the terrible feeling of spiritual isolation that Existentialism involves. Artists of the 1940s and 1950s felt, as monks and priests must have felt in the Middle Ages, that they were particularly closely attuned to this religious-creative impulse, a climate of feeling that is reflected in these lines from one of Newman's essays:

> What is the *raison d'être,* what is the explanation of the seemingly insane drive of man to be painter and poet if it is not an act of defiance against man's fall and an assertion that he return to the Adam of the Garden of Eden? For the artists are the first men.

The problem, of course, with placing so much emphasis on the *creating* of art is that it sometimes left little room for the *viewing* of art—beyond the realization that it was supposed to be a visible record of an artist's spiritual struggle. This paradox was a notable feature of the abstract art of the 1950s, for the artists often seemed to consider the act of applying paint to canvas to be the main focus of the aesthetic (and religious) experience. But unlike most of the other artists of this generation, Newman sought to communicate the spiritual experience as well.

Newman's enormous canvases (colorplate 14) were usually divided vertically by one or more bands set in an expansive sea

8-6
Barnett Newman,
*First Station,* 1958.
Magna on raw canvas,
78'' x 60''.
From the series
*The Stations of the Cross:*
*Lema Sabachthani.*
Estate of the artist.

of color—this visual experience prompted one critic to claim that the artist used it to ''shock the mind.'' The huge scale is important, both literally and figuratively: optically it serves to overwhelm the viewer by engulfing his visual space; symbolically it refers to the vast expanse and loneliness of the universe. The only occupants of this space are the narrow lines of bright color that activate the surrounding field while in turn being dependent on that field for their existence. Some writers have suggested that these paintings symbolize the situation of man in the world. Others have described Newman's canvases as exhilarating, providing an experience in which religious feeling is combined with the pure enjoyment of color without the need of intervening symbols.

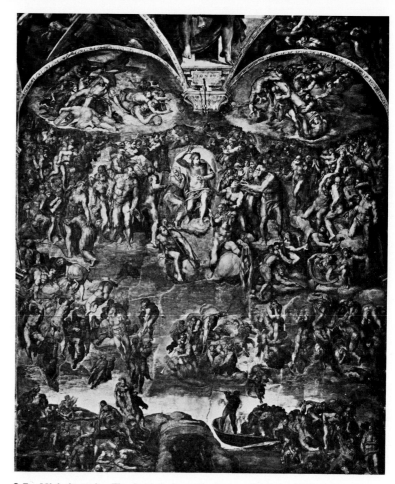

8-7 Michelangelo, *The Last Judgment*, altar wall of the Sistine Chapel, 1534–41. Fresco, approx. 43' high.

**Themes of Destruction and Evil**

About twenty years after he completed the ceiling of the Sistine Chapel, Michelangelo returned to paint another fresco on the wall behind the altar (fig. 8-7). But the differences between the two works are much greater than what might be expected from an interval of twenty years.

*Michelangelo's* Last Judgment

Rather than God the Creator, who had been the center of the generally optimistic and energetic composition on the ceiling, Michelangelo's *Last Judgment* portrayed Christ the Avenger—whose image discourages any interpretation other than one of fear and despair. And rather than a vision of Man as divine creation, there is a dark and pessimistic view of human beings as being

inherently incapable of achieving grace. The figures of the saved are not easily distinguished from those of the damned, for there is nothing of the physical grace and beauty that characterized the creatures on the ceiling. Once again the human body is naked and perhaps larger and more muscular than before, but this time it is brutish rather than heroic, bestial rather than glorious. Growing old had changed Michelangelo's attitudes toward physical beauty and even art itself, driving him toward a stricter and harsher view of religion. The bodies form a spasmodic structure of twisting flesh as souls are wrenched from the earth to be taken before Christ and judged, then lofted into heaven or dragged struggling into hell, where devils and figures from the underworld of Greek mythology await them.

The brooding quality of *The Last Judgment* was also a product of the crushing political events of the time, when the upheaval of the Protestant Reformation threatened the foundations of the Catholic Church. All of this no doubt served to confirm Michelangelo's feeling of impending doom and punishment. An idea of the depth of his despondency and sense of guilt may be had from the self-portrait that he included in the mural—in the form of the flayed skin held up by the martyred St. Bartholomew (fig. 8-8).

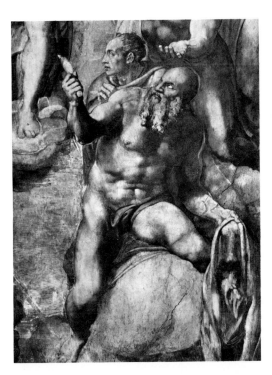

8-8
Michelangelo,
detail of fig. 8-7,
with "self-portrait."

*Goya's* Caprichos     The first series of etchings done by Francisco Goya, unlike the Sistine Chapel paintings, were not made for a church bureaucracy nor are they the artist's interpretation of major themes of Christianity. Nevertheless, the eighty etchings that he completed in 1799 express a religious dimension from a very private viewpoint. Yet, in at least one way, they can be compared with Michelangelo's depiction of the Last Judgment: Goya, who had been given to morbid thoughts after becoming deaf, also emphasized the negative side of existence in his works.

The etchings, however, do not provide a clear insight into Goya's beliefs. Do they reflect his own superstitions or mock the superstitions of others? Do they explore the kingdom of Satan or Goya's own subconscious? The separate realms of truth and dream, reason and absurdity intermingle so freely in the *Caprichos* that a quest for certainty over the artist's true intentions is almost rendered irrelevant. "The world is a masquerade," said Goya, "all would seem to be what they are not, all deceive and nobody knows himself."

In the first of the series we are reminded of the opening scenes of a comic but unhappy opera. The setting is probably the streets of Madrid, peopled by a motley mixture of rowdy children, wayward youths and maidens, gossiping bawds, and old lechers. A gloomy omen is sensed in the earliest scenes in a grotesque face here, a sinister glance there, and by the twilight character of Goya's gritty aquatint tones. It is verified later on by such spectacles as a young woman being abducted, a lover in the spasms of death, and a hanged man being robbed of his teeth. Goya's titles and comments, accompanying every etching, sometimes give us clues. Plate Three, showing a hooded figure before a mother and her children, is titled *The Bogeyman Is Coming* (fig. 8-9). The artist's notes on this particular etching denounce not only the use of fear in rearing children, but also condemn religious myths that warp human nature.

We cannot be sure that Goya himself dismissed the fear of what does not exist. The *Caprichos* is a whole course in traditional Spanish demonology. Goya borrowed the classic attributes of sorcery—screech owls, goats, cats, corpses of newborn infants, skulls, and broomsticks—and mixed these with creatures that he freely invented out of the anatomies of dwarfs, giants, and animals. Their nocturnal activities are equally capricious as playful monsters cavort and witches hold session, while hapless victims

*Qué viene el Coco.*

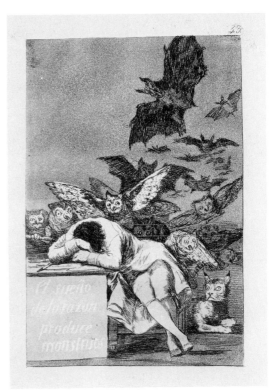

8-10
Francisco Goya,
*The Sleep of Reason Produces Monsters,*
1799.
Etching and aquatint,
8½'' x 6''.
Metropolitan Museum of Art, New York.

are caught in the middle. In Plate Forty-three (fig. 8-10) the night-time void is filled with owls, bats, and other creatures of a dreamer's own imagination. ''The Sleep of Reason produces monsters'' was Goya's acid comment on the backwardness of his age.

Goya's screams in the night are frequently echoed in the art of today. Ours is an age of terror and anxiety if one is to judge by the prevalence of this theme in the works of twentieth-century artists.

*Beckmann's*
Departure

The three-part paintings (called triptychs) that Max Beckmann did in Nazi Germany in the 1930s resemble the form of the works that were once placed over altars, but instead of the holy acts of saints, they chronicle the atmosphere of depravity and violence of the time. Beckmann's paintings often depicted mysterious and sometimes brutal scenes, but his primary concern was with space. In a way that suggests comparisons with Barnett Newman's abstractions, Beckmann spoke of ''the great spatial void and uncertainty that I call God.'' But unlike Newman, he sought to counteract the empty feeling by flattening out perspectives and crowding the figures together (fig. 8-11).

The central panel of the triptych *Departure* (colorplate 15) shows a group of people in a fishing boat. One man wears a crown, another an iron mask, and the scene, like the title, suggests that they are leaving for another land, perhaps going into exile, as Beckmann himself was to do a few years later. The side panels are of people being tortured and mutilated, tight, dark compositions that contrast with the apparent calm of the centerpiece.

8-11
Max Beckmann,
*Odysseus and Calypso*,
1943.
Oil on canvas,
59'' x 45⅝''.
Hamburger Kunsthalle,
Hamburg.

Beckmann himself was unsure of the meaning of the painting, which took him three years to complete. It was clearly influenced by his interest in the Classical myths, which were the subject of a number of his other works, as well as the powerful and frightening emotions that Hitler was arousing in the people of Germany. By uniting the evils of society with the mysterious images of myth, he was able to enlarge the scope of myth while making it more private and inaccessible.

Although indirect references to a universal evil may imply mysterious forces at work, twentieth-century art does not often make overt references to a devil or a wrathful god. Hell is possible on earth, and evil seems to stem from people or their earthly institutions; at the most, it is abstracted into a concept of man's inherent destructiveness. Modern science has replaced supernatural explanations for good and evil; in other words, it has driven God, Zeus, and Wotan out of the universe along with all the devils. This condition has led to what some call a mythological void, cutting modern man off from the world of the divine order and all the symbols that went with it. The insecurity and loneliness of this emotional wasteland, felt acutely by all kinds of artists, may account for the abundance of negative themes in twentieth-century art. Artists have retained the suffering of hell even though they have rejected the old authority for hell; and, at the present time, their downbeat interpretations may be justified by history and current events.

**Nontheistic Approaches**

Although the decline of myth has left modern man without a strong belief in the supernatural, it has not taken away his curiosity about the unknown, his tendency to look for metaphysical explanations, and his need to find meaning in life.

*Science*

The natural sciences have, in many respects, become the religion of our time. Today the debate is about whether or not the universe is expanding, and not whether God will use fire or ice to end the world. The theory of evolution—although almost as difficult to positively demonstrate as the story of Adam and Eve—is more generally accepted among educated people. But aside from the greater credibility of scientific over theistic explanations, it is probably the scientists' ability to produce technological miracles that has been most influential in overwhelming religion.

8-12
Scene from the
motion picture
*2001:
A Space Odyssey,*
by Stanley Kubrick,
1966.

Science fiction is a field of creativity that bases its content on the explanations and accomplishments of science but is free to fantasize from this base and to embellish the content into stories or myths that do not have to be proved. The science-fiction movie *2001: A Space Odyssey* (fig. 8-12) drew upon theories of evolution, learning, and space travel to create a comprehensive vision of the past and future. The author suggests that the evolution of earth technology from ape man to space man was set into motion and monitored for three hundred thousand years by a mysterious black slab that appeared to be in contact with a moon of the planet Saturn. Fascinating parables on the subjects of intelligence, mortality, and reincarnation were incorporated in the various segments of the film, helping to establish a kind of mythic depth that reinforces the realism of the sets and script. Even more fascinating was the science that went into the making of the movie itself. To reproduce the authentic-looking space hardware as well as the complex scale models and to create the effects of space travel and zero gravity required unusual ingenuity. The love of technical perfection on the part of the filmmakers even extended to the details of opening and closing the spaceship hatches of the scale models.

*Surrealism*    In many respects, religion's emotional and intuitive approach to life has been taken over by the arts. Twentieth-century painting has tended to apply this approach to abstract forms, but one major movement of the decades between 1920 and 1940 was particularly preoccupied with meaning. *Surrealism* tried to fuse conscious and subconscious realities into one super-reality, or surreality. Unlike science or even science fiction, it did not attempt to explain the workings of the world but to focus attention on its mysteries and contradictions. Where science is committed to the rational and objective, Surrealism is committed to the authority of the irrational and the subjective. In this respect it is more closely related to the unpredictable world of the demons in Goya's *Caprichos* or the mythic quality of the worship of Quetzalcoatl.

One of the most successful of the Surrealists was the Belgian painter René Magritte, who delighted in portraying visual puns and riddles, presenting contradictory and even impossible images in a highly realistic style. His incompatible combinations can cause us to reconsider our accepted habits of perception and thought—if we will take the time and effort to consider them. A painting like *The Empire of Light, II* (fig. 8-13) questions the world itself. We can see it as a nighttime scene and wonder why the sky is blue and the clouds are white, or visualize it as a daytime scene and

8-13   René Magritte, *The Empire of Light, II,* 1950. Oil on canvas, 31" x 39". The Museum of Modern Art, New York (gift of Dominique and John de Menil).

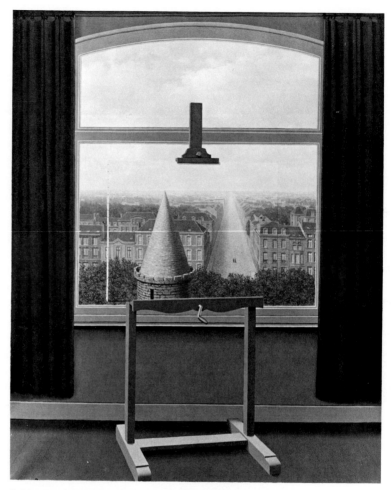

8-14   René Magritte, *The Promenades of Euclid,* 1955.
Oil on canvas, 64⅛'' x 51⅛''. The Minneapolis Institute of Arts
(The William Hood Dunwoody Fund).

puzzle over the fact that the street is dark and the windows and
street lamp illuminated. Logic is being mocked to create a new
experience out of two opposing realities. In *The Promenades of
Euclid* (fig. 8-14) Magritte's ideas are more easily comprehended
than is usually the case. A painting of a landscape stands on an
easel in front of a window opening on that same landscape. It

is placed in such a way that it appears to coincide exactly with the area that it blocks from view—pointing up the window-to-the-world character of traditional painting and echoing in this division between the world and the representation of it the illusory nature of human vision itself. Here, however, he carries the proposition a step further, drawing our attention to the contradictions inherent in the way we see by including an additional problem within the painted painting. The perspective view of the street reaches a vanishing point at the same level as the point of the tower, making them resemble each other even though we know that one is a solid object and the other a set of parallel lines that actually never touch (a major postulate of Euclid's *Geometry*).

**Summary**   A loss of purpose and meaning, a sense of insecurity and loneliness are often cited as being symptomatic of our age, and many believe that they are evidence of the fact that a religious dimension is necessary for human life. Man's earliest questions about the world and his place in it were answered with stories and myths that described the creation of earth and life and prescribed rules by which to live. Art played an important role in this process from the very beginning, serving to make the stories and explanations more understandable and vivid. The most remarkable example of this role was Michelangelo's Sistine Chapel ceiling, a vast and grandiose representation of the central themes of the Judeo-Christian tradition. Yet even as he painted it, religious wars were beginning to weaken the solidarity of the Catholic Church, marking the beginning of a decline in that role of art as well. The centuries that followed saw artists turning more and more to their own visions of life and death to express the basic religious concerns of mankind. As belief in a fixed system of values and an all-powerful God diminished, artists reflected the change in their work. The Surrealists and the Abstract Expressionists sought a religious dimension in the unexplored territories of the subconscious. More recent art appears to have ceased to attempt to deal with this dimension at all, electing to follow a road more like that of science by limiting itself to the creation or description of the simplest and most verifiable realities. But whether art (or science) will be able to serve man's religious needs in the absence of a coherent and applicable system of theistic belief is a question that cannot yet be answered.

# 9

## Images
## of
## America

It has often been said that art is a reflection of society, the product of a particular geography, climate, historical background, set of attitudes, and other factors. To sum it all up, a place and a people. This chapter is about a relatively young art that expresses an acute awareness of place and people. Perhaps because most Americans, sometime or another in their recent family histories, came from someplace else, they seem to have been uniquely conscious about where they are and who they are. And much of their art has been preoccupied with the American continent as a particular place on this planet and the American people as a particular species in the history of human civilization.

Like the American people, American art was an immigrant, and its ambivalent relationship to the art traditions of Europe has been a dominant theme in its history right up to recent times. The search for a specific artistic identity, both in form and content, was a major preoccupation. Images of America, therefore, were related to discovering not only what America was but what American art was. The following examples, spread over about a century, reflect an alternating interpretation of the American experience.

**Nineteenth-Century Painters of the Land**

Throughout the greater part of its history, the growth of American civilization was virtually synonomous with the settlement of its land. The American countryside, therefore, played a central role in establishing the American mentality. Its spaciousness was seen not only as a physical challenge to the ambitions of the settlers, but also as a symbol of the scale of American dreams. Both the land and the state of mind conducive to a tradition of landscape art were present almost since the days of independence. But in the late 1700s and early 1800s—when Constable was painting the English midlands—no significant landscape painting had yet appeared in America.

*Cole*

Thomas Cole was the first artist to point out to his fellow Americans the epic qualities of their native landscape. When he started painting, fashionable art consisted of portraits and historical subjects.

9-1 Thomas Cole, *The Oxbow,* 1846. Oil on canvas, 51½" x 76". Metropolitan Museum of Art, New York (gift of Mrs. Russell Sage, 1908).

Preferring to paint landscapes instead, he sustained himself primarily on his love of nature, tramping through the Catskill Mountains of New York with a sketchbook, until his works began to catch the eye of some artists and patrons. By the age of twenty-eight, he had achieved sufficient popularity to get financial backing for the first of two trips abroad to study European art, which at that time was caught up in the Romantic movement.

In *The Oxbow* (fig. 9-1) a gnarled tree on a wedge of hill in the left foreground acts as a foil to the expansive view on the right in which we see a great bend in the Connecticut River. The leading edge of the storm coming in from the left tends to continue the line of the hillside in an arc that goes off the canvas, further dividing the picture between the left and right—and dark and light. It is a dramatic image of the lighting that accompanies a summer storm in which some parts of the land are darkened while others remain bathed in light—an alternation that Cole repeated in the highlights on the tree and the cloud shadows of the distant hills. The drama unfolding in the atmosphere adds to the qualities of wildness that Cole admired and further emphasized in the unruly underbrush on the hill and the sense of unencumbered distance beyond. European landscapes, by contrast, were apt to show greater "discipline," having more serene vegetation and many more reference points in the composition to prevent the eye from experiencing such openness.

This kind of landscape, appropriate to the American sensibility, captured his countrymen's imagination and helped to foster the American version of Romanticism. Cole's large following of landscape artists—called the Hudson River school—were men from the East, mostly European trained. But all of them did not stay in the East and paint only the Catskills. All of America—and some other continents as well—attracted members of this school, who nurtured and spread the tradition of American landscape.

Bingham    The life and the paintings of George Caleb Bingham can be contrasted with that of the Hudson River painters. Although born in Virginia, he grew up in the frontier state of Missouri where, as a boy, he decided to take up art when he met a frontier portrait painter. He studied briefly in the East, where he picked up the idea of making his figures monumental. But rather than stay there to learn more about painting in the grand manner, he returned to Missouri to record daily life there, adapting the concept of hero-

9-2 George Caleb Bingham, *Watching the Cargo,* 1849. Oil on canvas, 26" x 36". State Historical Society of Missouri, Columbia, Missouri.

ically proportioned figures to the representation of the scruffy trappers and raftsmen who were his favorite subjects.

*Watching the Cargo* (fig. 9-2) shows three rivermen relaxing on a mudbank of the Mississippi River, while their barge is stranded on a sandbar in the shadows behind them; a sunlit piece of driftwood, to the right of the men, adds the finishing touch as it brings our attention back to the foreground. The lazy, late-afternoon atmosphere, accentuated by long shadows, emphasizes a quiet grandeur different from the wild splendor of Cole's painting. In the latter we can almost hear and feel the cold wind that introduces a storm. In the Bingham, all the strong forces are at rest, yet our feeling for the scene is just as vivid. The Mississippi was the dividing line between East and West, part of the myth and legend of America, and Bingham's interpretations of these scenes had a bit to do with creating the legend.

Before Bingham, frontier artists had recorded village and country life in terms of anecdote—that is, some minor event considered amusing or sentimental. Bingham was also a recorder of everyday life, and some of his pictures border on being anecdotal. He was not like the artists of the Hudson River school who aimed at high art and noble statements. But such a painting as *Watching the Cargo* transcends mere recording and reminds Americans of the majestic and timeless qualities of their land.

217

**Life at the Turn of the Century**

After the Civil War, the United States changed rapidly from an agricultural country of scattered hamlets to an industrial one of interdependent cities. And in the process, immense fortunes were made as tycoons fought for control of the railroads and new industries like petroleum and meatpacking. Although the late nineteenth

9-3  John Singer Sargent, *The Daughters of Edward D. Boit,* 1882. Oil on canvas, 87⅝" x 87⅝". Museum of Fine Arts, Boston.

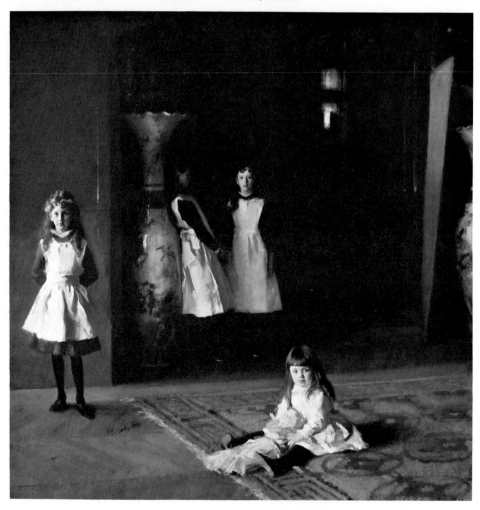

century in America was an age of rampant materialism, the new wealth also demanded culture—or at least the outer display of it. And culture to the new-rich Americans meant Europe. It was axiomatic that quality was to be sought overseas rather than at home, and American millionaires vied with one another to acquire European art and associate themselves with old-world culture. Needless to say, it was a depressing period for America's artists, many of whom gave up on their own country to become expatriots in Europe.

*Sargent*  One American artist, John Singer Sargent, had the best of both the old and the new worlds. Like so many nineteenth-century American artists, he studied in Europe. He acquired a broad, fluid-line painting style in a Parisian studio at the age of eighteen, and a few years later traveled to Spain to learn about shadows and luminosity from the work of Velásquez. Equally at home in Europe or America, his reputation was international and "European" enough to make him popular in his own land. A good eye, a deft brush, and a taste for elegance were the ideal requirements for a portrait painter of the times, and he was in demand by the fashionable set of what Mark Twain called the Gilded Age. If he were alive today he would no doubt be a member of the international jet set. But his art was certainly not of the jet age; it was conservative even by the standards of the late 1800s.

One of Sargent's best paintings, *The Daughters of Edward D. Boit* (fig. 9-3), is of four girls who appear to have momentarily stopped playing. The signs of nineteenth-century gentility are seen everywhere: in their scrubbed faces, their crisp clothes, the spacious interior, and the furnishings of the room—especially the pair of large oriental vases. Sargent made the scene seem quite casual not only by his facile painting style and unerring sense of draftsmanship but also by boldly placing one girl way off on the left. But if we look again, we see that he offset her weight by the pull of several things on the right, including the edge of the vase and the light coming from the deep space of the room behind the girls. The shadowy atmosphere that flows around every figure softens their forms and makes the light seem all the more luminous. It is a scene of refinement and grace that alludes to the advances of European art without taking the same risks; a domesticated art that reflects the values of a particular class of Americans in subject matter and style alike.

*Sloan*   In John Sloan's *McSorley's Bar* (fig. 9-4) the figures are in the shadows and the light values are nearly as luminous as in the Sargent, but we are not likely to think of the scene as one of graceful informality and natural charm. Sloan was a prominent member of a group of artists that was seeking to base American art on American subject matter—especially the heretofore untapped subject matter of the urban lower classes. Their first collective showing in the year 1908 was quickly dubbed the Ash Can school, so offended was the public by what it took to be "vulgar" painting. Yet compared with the developments going on in Europe at the time, the Ash Can school's rebellion was mild. The only radical thing about it was its subject matter; the various ways in which these artists painted reflected modes that the advanced painters in Europe had already rejected.

Sloan's broad brushwork, although earthier and blunter, is not essentially different from Sargent's. His simplified but accurate observation of human anatomy and gesture was influenced by an earlier career of illustrating for a newspaper—a factor that may also have accounted for his interest in blue-collar themes. When he settled in New York in 1904, he was impressed by the throbbing street life of the city. His portrayals of beach scenes, bars, grubby buildings, broken fences, and clotheslines were extremely provocative in the years before the First World War, but the city and its slums have become such a commonplace experience that these subjects no longer shock.

*Bellows*   George Bellows, although not a member of the original group of eight artists, was closely associated with the Ash Can school. Also a former newspaper illustrator, Bellows's style was even more exaggerated. In *Stag at Sharkey's* (fig. 9-5) he used long, fluid strokes to render the vivid movements of one of his favorite subjects. The exaggerated postures of the fighters approach that of caricature, and the ugly audience of cigar-chomping fans surrounding the ring would probably make the spectators at a contest of Roman gladiators seem genial by comparison. Bellows's attraction to the hurly-burly aggressiveness of boxing suggests that he felt that power and masculinity were important aspects of America and, therefore, of its art.

If we compare Sargent with Sloan and Bellows, we see that their differences in style, though great, are more a matter of degree: all three used broad, fluid brushstrokes and strong contrasts

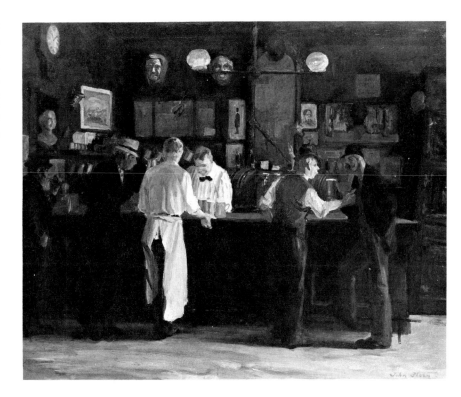

9-4
John Sloan,
*McSorley's Bar,*
1912.
Oil on canvas,
26'' x 32''.
Detroit Institute
of the Arts (gift of
the Founders Society).

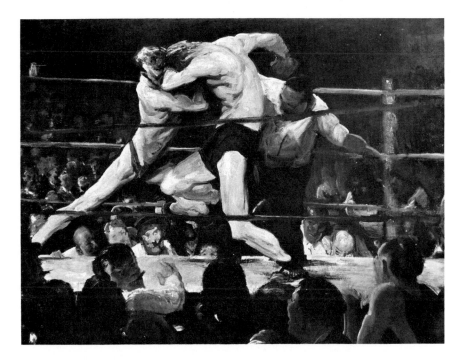

9-5
George Bellows,
*Stag at Sharkey's,*
1907.
Oil on canvas,
36¼'' x 48¼''.
Cleveland Museum
of Art
(Hinman B. Hurlbut
Collection).

of light and dark. The differences in subject matter, however, are fundamental. Admittedly Sargent is a generation older than the others, but his art is separated from theirs by at least a century. The charming girls in his portrait are of a privileged class that is recalled only in period movies; Sloan and Bellows painted a world that still exists.

## Between the Wars

After the First World War, American painting began to show the signs of abstraction. Some of it was definitely related to styles that had been established over in Europe, for a large colony of expatriate American painters and writers had sprung up in Paris, and there was a great deal of communication between the artists of that city and New York. Other forms of abstraction developed independently, in large part inspired, it appears, by a strong desire to simplify.

### O'Keeffe

The work of Georgia O'Keeffe is a striking example of the latter. Her marriage to Alfred Stieglitz, the American dealer and promoter of new art, may have had something to do with her direction, but the highly personal form of abstraction she developed was derived more from an interpretation of nature than from any particular twentieth-century school of abstract art. Her work aimed at simplification, a tendency that can also be seen in the paintings of Sargent, Sloan, and Bellows. But O'Keeffe's brushwork is much more refined, and her forms are far less detailed. These factors made it possible for her to create powerful and evocative paintings out of subjects as banal as flowers. By taking a single blossom and enlarging it until the shapes filled an entire canvas, she turned the sensual curves and colors into an almost erotic display. O'Keeffe liked living and working in the American Southwest because the clean, austere forms of the landscape lent themselves to her style. In *Black Cross, New Mexico* (fig. 9-6) we see the cool, clear, economical approach that characterizes all her work. Combining abstraction with realism, she reduced the sand dunes in the background to almost geometric forms yet modeled them to appear three-dimensional. The fragment of black cross in the foreground is so smooth that it looks like it might be carved from a very hard stone. Much of the excitement of her work lies in these tensions between the real and the abstract, and nature and the spirit. The abstract element is due not so much to actual

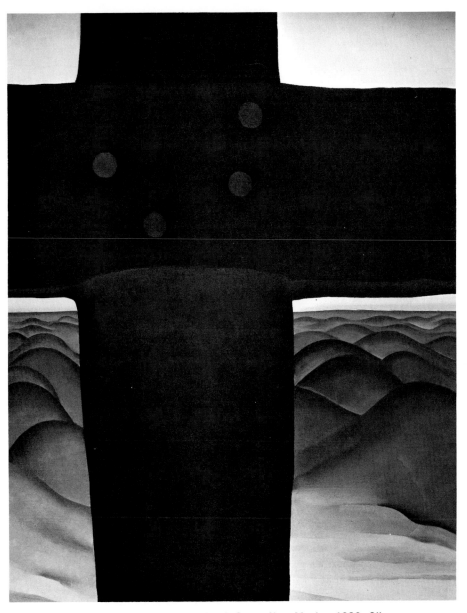

9-6 Georgia O'Keeffe, *Black Cross, New Mexico,* 1929. Oil on canvas, 36" x 30". The Art Institute of Chicago (Special Picture Fund).

distortion as to a stark revelation of the latent harmony in nature— an art that strongly implies a form of nature worship. In this sense, artists like O'Keeffe belong to the American tradition that began with Cole.

9-7
Joseph Stella,
*Skyscrapers,*
1920–22.
Oil on canvas, 54″ x 99¾″.
Newark Museum, New Jersey
(purchase 1937,
Felix Fuld Bequest).

*Stella*   Lyricism in Joseph Stella's art was identified with the city rather
than nature. He had come under the influence of the Italian Futur-
ists, a group of artists whose style broke up subjects and rebuilt
them into an overall harmony of planes and surfaces as a means
of expressing the dynamism of modern industry. Stella found their
approach well suited to his enthusiasm for the subject matter of
New York. In *Skyscrapers* (fig. 9-7) the planes of city forms

have a geometric precision similar to that of the shaded volumes of O'Keeffe's natural forms. Despite the abstraction, we can still make out familiar features of the city—skyscraper towers, bridges, cables, and smokestacks. Other features, though less specific, are very suggestive of the city, such as radiating lines that could be searchlight beams and the numerous hollows that might represent the city's many cavernous alleyways and subway tunnels. We can almost hear the buses, cabs, and wails of sirens. To many people, all of these things spell confusion and chaos; the very thought of the city inspires indigestion and frayed nerves. But to Stella, it was all poetry—a kaleidescopic harmony of exciting impressions. His extravagant statements reflected the vision of his paintings: ''The steel had leaped to hyperbolic altitudes and expanded to vast latitudes. . . .'' His faith in the man-made world compared with the romanticist's faith in the natural world; he intended his art to ''affirm and exalt the joyful daring endeavor of the American civilization.''

*Hopper*      Few painters of the 1930s shared Stella's enthusiasm for European styles or his rhapsodic feelings about urban America. Edward Hopper described an America that was immobile rather than dynamic, and coldly remote rather than exciting. His was, however, an ambivalent view, a mixture of love and hate that forced a confrontation between the byproducts of civilization—apartment houses, electricity, concrete paving, transience, monotony, bureaucracy—and the meaning of what it is to be human. His insight about modern living in America occurred before ''alienation'' became a familiar word. He was also somewhat disparaging about European imports, feeling that originality was a matter of personality rather than method; but his work nevertheless shows some of the reduction of detail and firmness of composition that was characteristic of the abstract art of the time.

Hopper was a skillful pictorial composer, not because he mastered fixed principles of design, but because he employed and precisely arranged a limited selection of details to evoke a great amount of content. In *House by the Railroad* (colorplate 16) just the right amount of candid information is presented to reveal a house in a forlorn city context. The reflected light and its complementary shadows tell as much about the time and place as they do about the building's volumes. The railroad track and its bed form a dark rectangle across the whole lower edge, brutally cutting

9-8  Edward Hopper, *Nighthawks,* 1942. Oil on canvas, 33⅛'' x 60⅛''.
The Art Institute of Chicago (Friends of American Art Collection).

off the bottom of the house, while the empty sky that surrounds it completes the sense of isolation and loneliness. Hopper's message seems to be that the alienation of neighborhoods (and the people in them) is brought about by railroads, empty lots, thoroughfares, or any number of random cancerous growths to which declining areas of the city are susceptible. And in this forbidding context, human occupation is suggested only by the randomness of the window shades—a touch of understatement that underscores the basic meaning.

The general meaning of *Nighthawks* (fig. 9-8) is more immediately apparent: a few people in a lonely cafe on a street desolated by the night. But because of Hopper's economy of means and studied arrangement, every little thing—a triangle of reflected light in an upstairs window, the cash register in the window below, a snap-brim hat, a row of bar stools, a door to a kitchen—seems to have its own mysterious private meaning, just as the lonely people seem to be separated by their private worlds.

*Motley*     Archibald Motley, a painter of Hopper's generation, presents what
seems to be a different version of city life. At first we may feel
that the crowd of elastic figures seen in his *Chicken Shack* (fig.
9-9) are the opposite of Hopper's people, but then we discover
that Motley's painting is simply another face of that same world
of frustration and despair. It is a compressed universe of street-
walkers, city slickers, and immigrants that, in the context of the
black community, suggests more complex meanings. In the first
place, it is not a homogeneous group—there is contrast between
native and immigrant, lower and middle class, single and married,
young and old. In the second place, despite the pervasive hustle
there is anonymity and depression. Motley's painting crystallizes
the dual role of city blacks in the 1930s: working for the white
man during the day, and at night imitating and mocking his habits.
Unlike Hopper's lonely restaurant, the Chicken Shack is a hub of
nighttime activity, a homely little establishment where an evening
may begin or end. As such it symbolizes the tools of survival—
therapy, amusement, and hope—in a world of racial prejudice and
economic depression.

9-9   Archibald Motley, *Chicken Shack*, 1936. Oil on canvas.
The National Archives (Gift Collection RG 200S).

Plate 17   Fritz Scholder, *Super Indian #2* (*with ice cream cone*), 1971.
Oil on canvas, 7' 6'' x 5'.
Collection Susan T. and Joachim Jean Aberbach, Sands Point, Long Island.

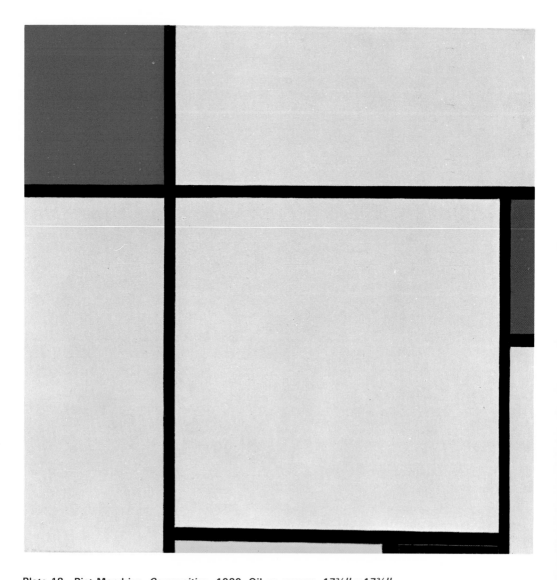

Plate 18   Piet Mondrian, *Composition*, 1929. Oil on canvas, 17¾" x 17¾".
Solomon R. Guggenheim Museum, New York (gift of Katherine S. Dreier Estate).

Plate 19   Rembrandt van Rijn, *Bathsheba*, 1654. Oil on canvas, 4′ 10⅞″ x 4′ 7⅞″. Louvre, Paris.

Plate 20   Edouard Manet, *Luncheon on the Grass*, 1863. Oil on canvas, 7' x 8' 10". Galerie du Jeu de Paume, Paris.

**Plate 21** Claude Monet, *La Grenouillère*, 1869. Oil on canvas, 29½" x 39¼". Metropolitan Museum of Art, New York (bequest of Mrs. H. O. Havemeyer, 1929, The H. O. Havemeyer Collection).

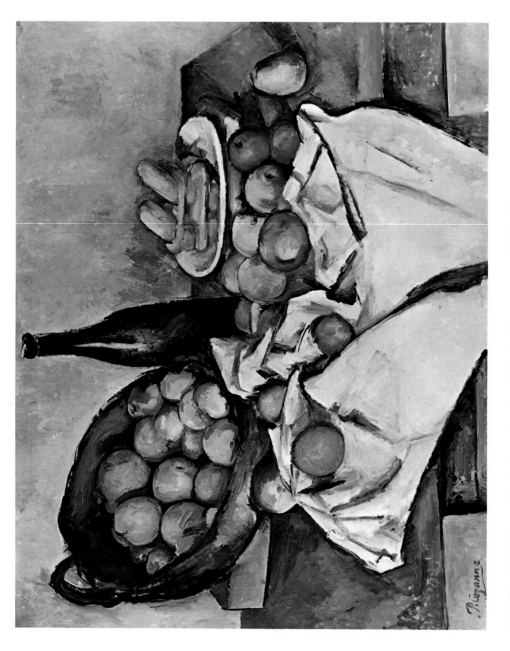

Plate 22   Paul Cézanne, *The Basket of Apples*, 1890–94. Oil on canvas, 25¾″ x 32″. The Art Institute of Chicago (Helen Birch Bartlett Memorial Collection).

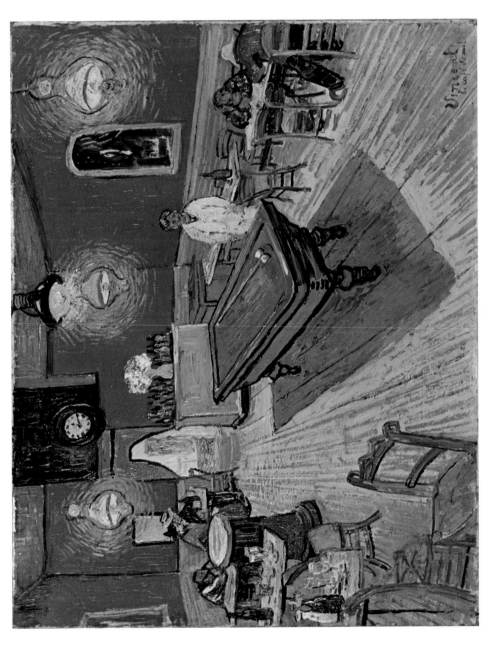

Plate 23 Vincent van Gogh, *The Night Cafe*, 1888. Oil on canvas, 27½″ x 35″. Yale University Art Gallery, New Haven, Connecticut (bequest of Stephen C. Clark).

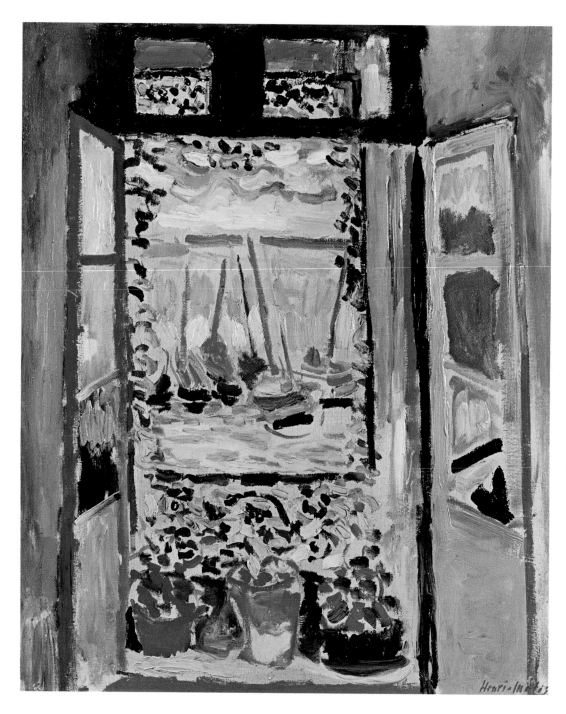

Plate 24   Henri Matisse, *Window at Collioure,* 1905. Oil on canvas, 21¾'' x 18⅛''. Private collection.

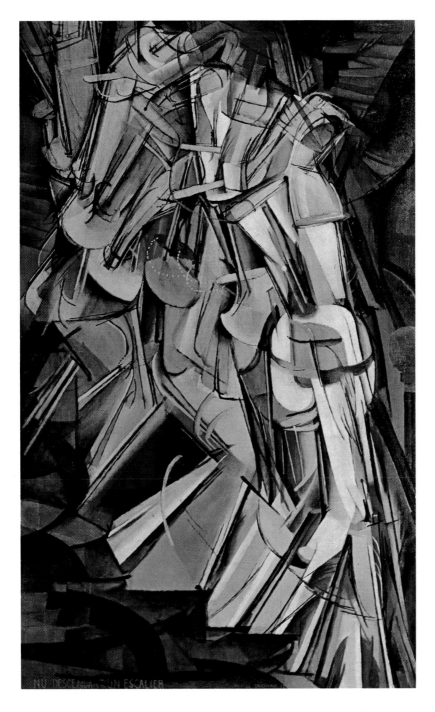

Plate 25   Marcel Duchamp, *Nude Descending a Staircase, No. 2,* 1912.
Oil on canvas, 58'' x 35''.
Philadelphia Museum of Art (Louise and Walter Arensberg Collection).

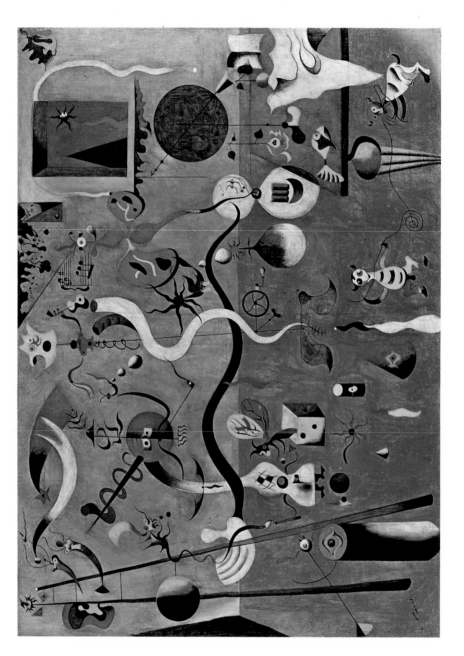

Plate 26   Joan Miró, *The Harlequin's Carnival*, 1924–25.
Oil on canvas, 26″ x 36⅝″. Albright-Knox Art Gallery, Buffalo, New York.

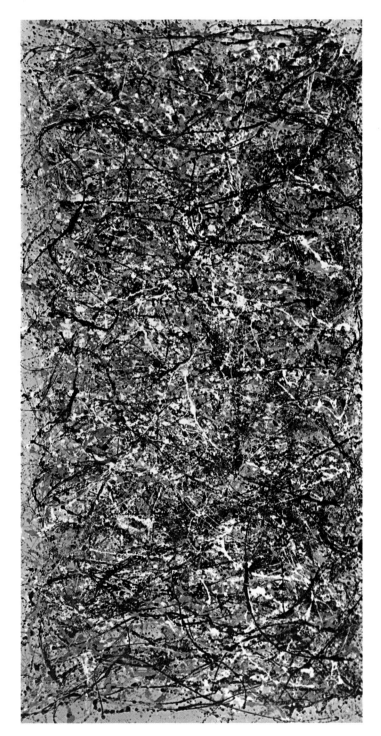

Plate 27   Jackson Pollock, *One (Number 31)*, 1950. Oil and Duco enamel on canvas, 8' 10'' x 17' 5⅝''. The Museum of Modern Art, New York (gift of Sidney Janis).

Plate 28  Willem de Kooning, *Door to the River,* 1960. Oil on canvas, 6′ 8″ x 5′ 10″.
Whitney Museum of American Art, New York (gift of the Friends
of the Whitney Museum of American Art [and purchase]).

Plate 29  Roy Lichtenstein, *Little Big Painting,* 1965. Oil on canvas, 5′ 8′′ x 6′ 8′′.
Whitney Museum of American Art  (gift of the Friends
of the Whitney Museum of American Art).

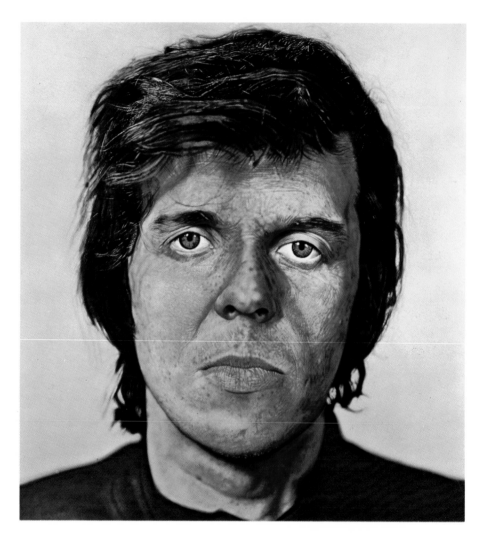

Plate 30  Chuck Close, *Kent*, 1970–71. Acrylic on linen, 8' 4'' x 7' 6''.
Art Gallery of Ontario, Toronto. Photo courtesy Bykert Gallery.

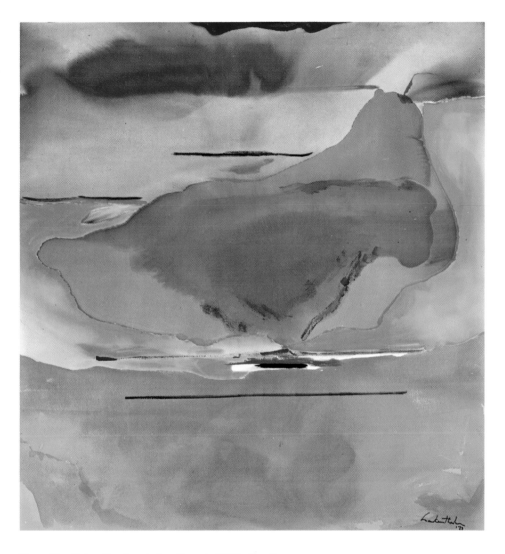

Plate 31　Helen Frankenthaler, *Cravat,* 1973. Acrylic on canvas,
5′ 2½″ x 4′ 10¾″. Collection Mr. and Mrs. Gilbert H. Kinney.

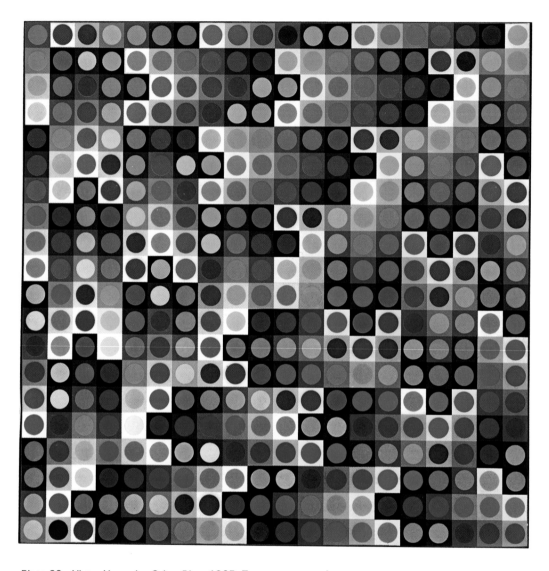

Plate 32   Victor Vasarely, *Orion Bleu,* 1965. Tempera on wood,
32½'' x 32⅝''. Private collection. Courtesy Gallerie Denise René.

**Contemporary Viewpoints**

In the 1950s the avant-garde of New York was deeply involved in abstract painting, but it was not the only important movement in America at that time. A number of artists in the Bay Area of northern California had experimented with totally abstract styles and then returned to basing their paintings on the human figure.

*Diebenkorn*

Richard Diebenkorn was one of the members of this group and perhaps the most successful in applying the dynamic brushwork and bold forms of the prevailing abstract style to the subject matter from everyday life. In *Man and Woman in Large Room* (fig. 9-10) we can easily recognize the forms of two people and detect a crude perspective in the shape that appears to be a carpet and in the top and bottom lines of the wall on the right. The static qualities of the scene are reminiscent of the world that Edward Hopper

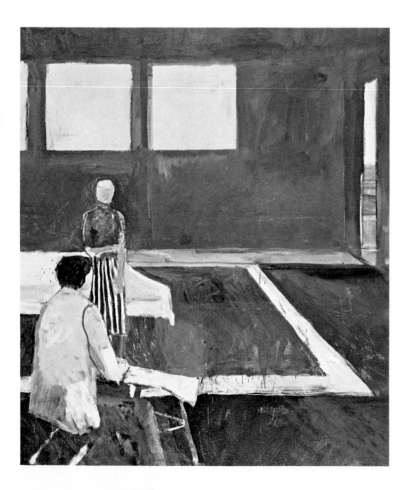

9-10
Richard Diebenkorn,
*Man and Woman
in a Large Room,*
1957.
Oil on canvas, 71″ x 63″.
The Hirshhorn Museum
and Sculpture Garden,
Smithsonian Institution,
Washington, D.C.

9-11  Ralph Goings, *Kentucky Fried Chicken,* 1973. Oil on canvas, 48'' x 68''.
Private collection.

painted, and indeed Diebenkorn's man and woman seem every bit as isolated and pathetic as the nighthawks. Yet the sense of tragedy is offset by the emotional qualities of the color and the broadly conceived composition—carry-overs from his earlier abstract style. Beyond the open door, which is a mere crack in the right-hand wall, we see a few daubs of warm, glowing color, like a glimpse of the California countryside. Ironically, the sliver of the California dream only serves to emphasize the element of disillusion that dominates the room.

*Goings*    A generation later the art of northern California had changed radically. Not only was the rebellion against abstraction complete, it had been carried a step beyond: the Bay Area school of the seventies is one of photographically precise realism. The emotional subjectivity of works like Diebenkorn's has been replaced with the scrupulous objectivity of artists like Ralph Goings.

*Kentucky Fried Chicken* shares certain elements with the Diebenkorn painting and, for that matter, with those of Hopper and Motley, but it does not share the spirit of any of them. Goings is concerned entirely with painting problems—the reflection in the booths, the varying degrees of color on a wall seen through one, three, or five windows—and makes no judgment on his subject

matter. Neither the Colonel's roost nor the snackbar are given any meaning other than that which is visible to the eye. They are not presented to us as friendly gathering places or tragic refuges but as simple facts of the California landscape. But it is easy to read things into those simple facts. Even though Goings is concerned with painting problems he nevertheless implies an interpretation of scenery that is no longer confined just to California. Just as Cole pointed out the epic qualities of the American landscape, Goings and other realists like him are pointing out some of the candy-coated and spirit-numbing banality that has spread across the continent.

**Conclusions**     One of the most interesting things about American art is that it has always been so torn between polar alternatives. In the nineteenth and early twentieth centuries there was constant disagreement about whether the emphasis in our native art should be on the word native or the word art. Nearly everyone tried to reconcile the two, but the Europeans were so much more advanced that it was impossible for the Americans to be innovative in anything other than subject matter. Only after the Second World War did they catch up with the masters of European art—and, a short time later, surpass them. By the early 1960s their position was so secure that the next important movement, Pop Art, carried an unmistakably American stamp in style as well as subject matter and was unrivalled by any other country.

*Scholder*     But America's art has also been subject to other divisions, both those that are typical of all art—the lyrical versus the dramatic, a love of nature set against a preference for the diversions of the city, or the subjectivity of the emotions contrasting with the belief that art should be an objective record—and a few others all its own. The paintings of Fritz Scholder often capture some of this distinctly American mood. A successful contemporary American artist, he is also an Indian. And though he was originally determined not to become known as an ethnic painter, he eventually began to incorporate Indian elements into his work and now identifies his art completely with Indian themes and content and believes that a "merging of traditional subject matter with the contemporary idiom will give us a truer statement of the Indian." The figure in Scholder's *Super Indian #2* (*with ice-cream cone*) is

assertively large and set in the middle of the canvas, painted in a dark, brooding brown and surrounded by rich colors (colorplate 17). He stares out at us from deep inside his own image. He too is a tragic figure, but for completely different reasons than those of the Diebenkorn or Hopper people. He is dressed in a ceremonial costume that identifies him with the old folkways of an all but obliterated culture, yet he holds an ice-cream cone, a folk object of the culture that overwhelmed his. Like the often contradictory art and history of the United States, the painting mingles the past and present, pathos and humor, and radically different ways of life.

9-12 Fritz Scholder, *Indian #16,* 1967. Oil on canvas, 71" x 71". Collection Mr. and Mrs. Robert E. Herzstein, Washington, D.C.

# HISTORICAL CONTEXT III

Earlier chapters in this book have considered art as it related to human perception and to the expression of important human themes, but in Part III we will examine art as a phenomenon in itself, concentrating on the ways that art exists in time. If we look at some of the major works of art of the past in the order in which they appeared, we will begin to discern a very definite structure, almost as if we were watching a time-lapse movie of a blossoming flower. This "design of change" is sometimes more instructive than the designs of the individual works themselves. Yet, because art is a product of human behavior, the process of change and its direction are neither foreordained nor inevitable. Art is subject to the will and actions of individual artists and the circumstances of history. In this section we will study this process as it relates to style and to individuals, and then we will examine a specific period of art history in detail.

The period to be examined is our own—that is to say, the long sequence of images and ideas that were sparked by a change that took place over a hundred years ago in Paris. It was not a sudden change nor a simple one; it had complex roots that went back centuries. Behind it lay not only the attitudes and technical discoveries of previous artists but such things as the invention of photography, scientific discoveries about the nature of light, and the great social upheaval that grew out of the rise of democratic forms of government. Conditions have changed greatly since then, and so, of course, has art. It is by studying those changes in their historical context that we shall be able to understand something of the how and the why of the art of our own period.

# 10

## The
## Object
## in
## Time

A painting or sculpture can be thought of as existing in time as well as space. Not the time of music or poetry, but the time of history. That is to say, each object of art is an event that marks a specific point in time and serves not only as a source of aesthetic pleasure but as a means of understanding something about the character of that time. As you will recall from Chapter Eight, Max Beckmann's triptych *Departure* (colorplate 15) communicates the tension and terror of life in Nazi Germany without making any direct reference to the politics of the period nor even depicting that period, while Barnett Newman's paintings of the 1950s (fig. 8-6) express something of the feeling of loneliness and underlying fears of the existentialists without even using the human figure.

Another effect of time on an object, art or otherwise, is that of physical wear and aging. In this sense every object is a continual event, undergoing constant but not necessarily visible change. And in a dynamic society like our own, it also undergoes a change in people's perception: what seemed to be terribly stylish only a few years ago now seems terribly old fashioned. In the meantime new designs have been created that surpass the other, and new ideas

10-1   The 1934 Chrysler Airflow.

have come to replace the old—a new context has evolved that is alien to the old objects. Ironically, the objects themselves play a large role in their own outmoding, for every new and different object forces us to see things in a slightly different way, and in this sense it actually changes the appearance of those objects that came before.

**Prime Objects**

A revolutionary car called the Chrysler Airflow (fig. 10-1) was shown for the first time at the 1934 Auto Show. A critic of the time wrote that it looked strange at first but that after a while ''. . . you are quite likely to come around to the viewpoint that these cars look right and that conventional cars look wrong.''

*The Chrysler Airflow*

As it turned out, the Airflow, in terms of sales, was a failure, and after three years of production, it was discontinued. The Airflow was not a bad car in the engineering sense; it had demonstrated remarkable capabilities in numerous road tests. But apparently the buying public rejected it on the basis of its ''looks''—the very thing that the writer was talking about.

Before we discount the writer's prediction, we should look at the history of automotive design during and just following the appearance of the Airflow. A sister car, the Chrysler Corporation's

10-2 The 1934 Plymouth.

10-3 (above) The 1939 Plymouth.
(left) The 1936 Plymouth.

Plymouth (fig. 10-2), was typical of the year 1934. The rear seat was directly over the rear wheels and the engine was situated behind the front axle. Although showing some evidence of the modern "sculptured" styling, its basic contours were still square, and the fenders, body panels, headlamps, and spare tire were separately attached. In the Airflow, on the other hand, the rear seat had been moved ahead and the engine was placed over the front axle. An "aerodynamic" frame gave the car a much different overall line. And finally, the smooth, continuous body sheath makes us think of the car as a single organic unit. Now, if we look at the automotive industry *after* 1934 we find that the Airflow's radical styling was gradually incorporated into the design of other cars throughout the rest of the decade. Again, the Plymouth is typical (fig. 10-3): in the 1936 version the rear seat and engine were moved forward, and the slanted windshield and the more aerodynamic body line resemble the 1934 Airflow more than the 1934 Plymouth; later, in the 1939 model, the headlamps and grill were finally blended into the body shape. Plymouth, along with other American cars, did maintain the long, straight hood and vertical front end—an accent that probably symbolized power to

the American buyer. Despite this and a few other minor modifications, the entire automobile industry turned out products that were essentially descendants of the 1934 Airflow. One direct descendant was still around many years later: the German Volkswagen, whose basic lines were almost identical to those of the two-door Airflow, even preserved the sloped front end and round fenders (fig. 10-4).

*The Shape of Time*  Relative time and formal change are the subject of a book by the art historian George Kubler, who provides a useful scheme for considering art works and artifacts in their historical context. His system not only gives us some insight into why some works are accorded more recognition than others but also explains the dynamics of stylistic evolution.

   The basic ingredient of Kubler's theory of change is a concept of relative time as opposed to absolute, or calendar, time. In other words, saying that the Airflow came out in 1934 A.D. tells us very little by itself. What we need to know is when this car made its appearance in relation to other models of passenger cars. This leads us to his concept of *formal sequences:* "Every important work of art can be regarded both as a historical event and as a hard-won solution to some problem." A radical change in the shape

**10-4**
**The 1963 Volkswagen and the 1934 Chrysler Airflow.**

10-5 Temple of Hera, Paestum, Italy, c. 460 B.C.

of a significant art object (or an artifact such as a car) is usually a purposeful solution within a sequence of designs. The solution is related to those that came before and, if it is successful, will be connected with solutions that follow. Within a sequence of linked solutions there are *prime objects* and *replications*. Prime objects are successful major inventions; they affect certain traits of all the objects that follow them in such a way that these cannot be traced directly to any of the objects that came before them. Replications, on the other hand, are merely simple variations on the theme created by the previous prime objects. (In the case of mass-produced objects, a model may have thousands of identical ''editions,'' but this is not what is meant by replications in this usage.) In Kubler's scheme the Airflow deserves the label prime object, while the Plymouths of the late 1930s were its replications. Because we did not look at a large enough span of automobile history to discover the next prime object (or the one just prior to the Airflow), we did not see an example of a formal sequence or a series of design solutions that significantly modified the shape of the car.

The series of Greek sculptures of nude youths in Chapter Six gave us a fair idea of the steps taken by the Greeks over nearly two hundred years in modifying the sculptural treatment of the human figure. Their architecture paralleled this process during the same period with the steady refinement of the Doric order, a system of architectural proportions that governed the building of temples. By comparing the Temple of Hera (fig. 10-5), built by

10-6  The Parthenon, Acropolis, Athens, 448–432 B.C.

**10-7
Changes in
Doric-order
proportions.**

Greek colonists at Paestum, Italy, with the famous Parthenon of Athens (fig. 10-6), we can follow the evolution of a complete formal sequence.

The overall sensation of the Parthenon compared to that of the older temple is one of slenderness and lighter weight, even though it is larger. This is chiefly due to the narrower columns, the greater width between the columns, and the fact that the part supported by the columns is relatively lower. The diagram (fig. 10-7) shows the stages of evolution in the silhouette of the column and the entablature (the part of the building between column and roof), and it is a simple matter to perceive the changes that took place in the proportions of each part and between related parts.

Unlike the case of the Airflow, the impulse to change the Doric order was not largely caused by the need for engineering improvements. Nor, like Greek sculpture, was it caused by new discoveries about the subject. The motivation seems to have been almost entirely aesthetic. One thing should be noted: the 480 B.C. Temple of Hera is not really a prime object; the Archaic temple, which was the first to show these traits, is no longer standing. Therefore, a replica has to represent this phase for our purposes.

In recent art history, the problem is not that of prime objects disappearing but of being able to recognize them at all in the profusion of artistic developments. The old adage of not being able to see the forest for the trees applies here—it is difficult for us to discern the broad outline of an artistic sequence in our own time simply because there are so many different objects and ideas.

241

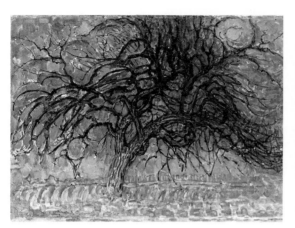

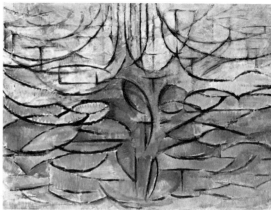

10-8  Piet Mondrian, *The Red Tree,* 1908.
Oil on canvas, 27⅝" x 39".
Collection Haags Gemeentemuseum, The Hague.

10-9  Piet Mondrian, *Flowering Appletree,* 1912.
Oil on canvas, 30¾" x 41¾".
Collection Haags Gemeentemuseum, The Hague.

*Mondrian*  Despite its apparent simplicity, the work of the Dutch painter Piet Mondrian has proved to be among the most influential in the history of art. Not only did his ideas affect painting and sculpture, they inspired profound changes in architecture and industrial design as well. Some aspect of the lives of virtually all of us has been touched by his ideas.

Early in the twentieth century, Mondrian became the principal figure in a branch of the art movement that developed the potential of geometric design. And beyond his work as a painter, he was influential as a teacher, collaborator, and the author of a book about his ideas.

His own art was initially influenced by such early figures of the modern movement as Picasso and Léger, who were at the time rejecting old artistic practices of imitating reality. Mondrian carried their insights to an extreme by entirely eliminating any references to natural objects, reducing his artistic pursuit to that of solving problems of pure form, a style he called *Neoplasticism* or "plastic expression." Aside from his position as one of the "linked solutions" in a particular tradition of modern art—which might loosely be called geometric abstraction—Mondrian's own discoveries

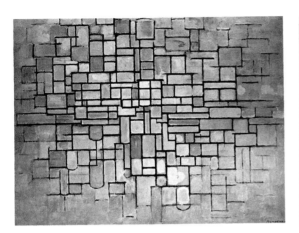

10-10  Piet Mondrian, *Composition,* 1913.
Oil on canvas, 34⅝″ x 45¼″.
Rijksmuseum Kröller-Müller, Otterlo.

10-11  Piet Mondrian, *Composition Checkerboard,*
1919. Oil on canvas, 33⅞″ x 41¾″.
Collection Haags Gemeentemuseum, The Hague.

through the historical development of his art, serve in themselves as an example of Kubler's theory of the formal sequence.

Looking at a series of paintings starting with the *Red Tree* (fig. 10-8) of 1908, we can trace Mondrian's progress through successively more simplified versions of nature (fig. 10-9) to a point where it seems to disappear altogether, and the composition consists simply of a group of rectangular elements that resemble a stained-glass window (fig. 10-10). This solution in turn undergoes a number of variations (fig. 10-11) until the elements finally reach an even simpler pattern, that of a grid with a few opaque rectangles (colorplate 18). This too undergoes continual refinement (reminiscent of the logical steps in the evolution of the Doric order) becoming even simpler without exhausting itself.

With a single-mindedness rare even in artists, Mondrian developed and refined his artistic vocabulary over a period of more than thirty years. The destiny of his austere style, although we may consider it to have been inevitable, was discovered slowly and logically by a process of continuous reduction.

This reduction laid bare the most basic principles of composition; as Mondrian stated: "Plastic art affirms that equilibrium can

only be established through the balance of unequal but equivalent oppositions." He believed that horizontal balance should not be achieved by making things identical on both sides of the middle—in other words, making a picture symmetrical. Moreover, he avoided making any two elements identical in size or shape within the same picture, for to do so would be to run the risk of defeating the composition. According to this thinking, it is the cooperation of "oppositions," that breathes life into a composition.

None of the paintings in the series shown here is symmetrical, and in the later, simpler ones equality in sizes and shapes of rectangles is scrupulously avoided; even the widths of lines are varied. Mondrian studiously manipulated these unequal elements to create a new and subtle stability. This is especially evident in his use of primary color, for the power that a pure red or yellow has for attracting attention demands that its placement be very carefully considered. Mondrian often placed his colored rectangles at the edges of the picture, so that they would not dominate an entire composition while serving to offset other elements and achieve the desired equilibrium. His compositions are so precisely adjusted that one senses that no element can be altered without upsetting the whole.

**10-12  Mies van der Rohe, German Pavilion at the International Exhibition, 1929, Barcelona.**

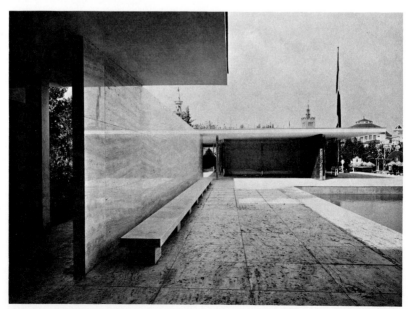

10-13

Mondrian was a founder of one of the most far-reaching developments in modern art, which had counterparts in other painting of the time and a great many descendants in our own day. His legacy, however, is to be seen more in the applied arts—functional architecture, household appliances, even the design of soapboxes—where the influence of his organizing grids and balance of oppositions is still a strong and active force. (figs. 10—12 and 10—13).

*Rembrandt*  Rembrandt van Rijn was the major Dutch painter of the seventeenth century, but, unlike his countryman Mondrian, he had very little influence on either the decorative arts or the fine arts of his time. His paintings are not prime objects in the Kubler sense of introducing traits that are visibly present in the paintings of the artists of stature who followed him, yet they are highly original and extremely powerful works.

The art of Holland during Rembrandt's generation was almost completely outside of the sixteenth and seventeenth-century mainstream. There were, basically, two artistic schools of thought in Holland, neither of which had strong reputations internationally. One, called the "Italian" school, was partial to historical subjects and the posturing of idealized bodies in impressive settings. Its roots were in Classical antiquity and the Italian Renaissance, and its principal counterpart internationally was the *Baroque* style so

10-14
Peter Paul Rubens,
*St. Ignatius Exorcising
Demons from the Church,*
1619.
Oil on canvas, 17'6½'' x 12'11½''.
Kunsthistorisches Museum,
Vienna.

magnificently exemplified by the Flemish painter Rubens (fig.
10-14), who had studied in Italy. The other might be called the
"Dutch" school. It preferred the simpler realities of everyday life—
still lifes, down-to-earth people, and landscapes—subject matter
that is referred to as *genre painting.* The outlook of a new economic
and social order (in a country that had recently opted for Protes-
tantism) favored the emergence of the Dutch school. Yet there
were many artists in Holland who still admired the Italian school,
among them Rembrandt's teacher Pieter Lastman. Inevitably,
Rembrandt's art was influenced by elements of both schools. How-
ever, he was largely self-taught, picking up pictorial ideas from
a variety of sources. Rembrandt studied and sometimes copied
other artists' works, but whatever he used he reshaped so drasti-
cally that the source is often impossible to recognize. In his own
painting Rembrandt rejected both the exaggerated idealizing of the
Baroque style and the trivial content of genre painting; he was
therefore out of step with both of the principal alternatives of the
art of his day.

In his early work Rembrandt often displayed an affinity for epic themes that was characteristic of the Italian school. Undoubtedly, the light that he used to focus attention in gloomy interiors was indebted to the influence of the recently developed techniques of chiaroscuro. But Rembrandt invested these with a powerful imagination, and did not rely on the energetic compositions and brushwork of the Baroque. *Presentation in the Temple* (fig. 10-15) demonstrates this profoundly vivid imagination. The elderly Simeon,

10-15   Rembrandt van Rijn, *Presentation in the Temple,* 1631. Oil on wood, 24" x 18⅞". Mauritshuis, The Hague.

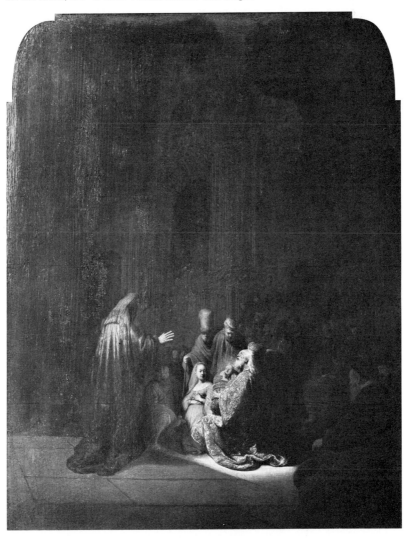

10-16   Rembrandt van Rijn, *The Blinding of Samson*, 1636. Oil on canvas, 93" x 119". Staedlisches Kunstinstitut, Frankfurt.

having God's promise that he would see the Messiah before his death, was led to the temple where Mary and Joseph had delivered Jesus for presentation. The old man, taking the infant in his arms, thanked God for keeping the promise and told Mary of her son's destiny. In Rembrandt's interpretation of the scene, Simeon and the child are isolated by a beam of light that pierces the vast, grottolike temple. The majesty of the robes of the high priest is balanced by the humility and naturalness of the rest of the central group, yet the understated naturalism actually serves to heighten the melodrama. Rembrandt has given us religious theater without resort to the superhuman figures and grandiose gesturing that was so typical of mainstream Baroque art.

The combination of realism and imagination is applied in a more typically Baroque way in the brutally shocking painting of *The Blinding of Samson* (fig. 10-16). This ten-foot-long spectacle is alleged to have been made by Rembrandt to please one of his patrons, Constantyn Huygens, who had a taste for violence and horror. Huygens should not have been disappointed, for Rembrandt portrayed the savagery of the attack with a forcefulness and terror that few of his contemporaries would have dared to match. The scene is set in Delilah's tent—she is seen fleeing with Samson's hair in her hand—and the lighting and the strong diagonals of the composition focus attention on the face of Samson as one of the soldiers drives a dagger into his eye. The terrible agony of the moment is seen not only in his face, but through his entire body, arching, and kicking—even the toes are clenched with pain.

But much of the criticism over Rembrandt's reluctance to compromise realism for the sake of taste was aimed at his unidealized depictions of women; one critic reproached him for always showing garter marks on the thighs of his nudes. In general, Rembrandt's fellow artists and critics objected to his lack of decorum and disregard of ''correct'' form, while at the same time being awed by his expressive powers.

Rembrandt's commitment to realism was due not only to his respect for sincerity and truth but to his desire to make the subject matter of his art—especially stories from the Bible—plausible and vivid, a desire that extended even to giving Dutch settings to his biblical narratives in which many of the figures were dressed in the everyday garments of burghers, peasants, and soldiers.

Rembrandt never compromised his frank realism, but after the 1630s he lost interest in putting it to the service of melodramatic effects. He turned from dramatic displays to inner feelings, concentrating on conveying the emotions of his subjects as subtly as possible. In one of his later paintings, *Bathsheba* (colorplate 19), we see the soft lighting, the open brushwork, and the more frugal composition of the mature Rembrandt. Holding a letter from King David that summons her to his palace, she stares into space. Here again Rembrandt has employed a strong diagonal composition and a contrast of light and dark to compel us to look at his subject's face. But this time they are almost unnecessary. The mixture of sadness and desire, of tenderness and foreboding that can be seen there is so strong that we can hardly draw our eyes away.

10-17
Rembrandt van Rijn,
*Self-Portrait,*
1658.
Oil on canvas,
52⅝" x 40⅞".
The Frick Collection,
New York.

Despite his genius and the immense popularity of all kinds of painting in Holland at that time, Rembrandt did not prosper. Nor did he have a happy personal life; he outlived his entire family, his last remaining son dying just before he did in 1669. Rembrandt did not leave a family of artists either. None of his students produced a significant body of work in his style, and the other artists of his time ignored it. By contrast, Rubens's grand style was extended and modified by a host of artistic heirs, including the celebrated Anthony van Dyck. Rembrandt was only rediscovered in the nineteenth century by such artists as the French Romantic Delacroix, who profited from his example but did not try to emulate it directly.

**Summary**     It is a common practice to view art as a consistent sequential development from prehistory to the present day, but little is ever said either about the nature of the relationship between time and art or about the influence of historical circumstances on artistic tastes. This chapter, using the basic observations of art historian George Kubler, has tried to deal with these problems in general terms by examining three examples of aesthetic evolution: an automobile that functioned as a prime object; a modern artist whose example made a powerful impression on his own time; and an artist who left little trace in history beyond his own work, even though that work was extremely original.

The purpose of Kubler's thesis was to draw attention to the functional relationship between changes in form and the periods in which those changes are accomplished, rather than that of providing a formula for deducing aesthetic values. Nevertheless, a theory that holds that those objects that are most admired are the ones that are repeated or modified into new objects does imply a system of valuing. And if we look back over the history of art (or objects) we can easily discover which ones turned out to be the most prophetic.

But how prophetic was the art of Rembrandt? Certainly not very much in the sense of affecting the styles that followed. Yet in another sense it was extremely prophetic—the qualities that had been overlooked in his own day were eventually discovered, and people who lived long after he did were finally able to interpret the values that he expressed. Today, in a period that stresses psychological introspection, we see in these paintings a sympathetic soul.

# 11

## Art
## at the
## Barricades

Leon Trotsky, a man who had reason to know, said in his auto-biography that "revolutions are the mad inspiration of history." Ironically, the period of history covered in this chapter roughly parallels the chain of events that marked the Russian Revolution that Trotsky helped bring about. Like a political revolution, the aesthetic revolution caused a radical change in the old order. To verify this all one need do is compare Thomas Couture's *The Romans of the Decadence* (fig. 11-1), a standard of excellence of the mid-nineteenth century, with Henri Matisse's *Joy of Life* (fig. 11-11), a masterpiece of the early twentieth century.

The early stages of the rebellion were directed against the art of the French Academy, of which Couture's painting is a good example. A jaded style of realistic painting that illustrated lofty moral themes in imaginary historical settings was surely too far out of touch with reality and therefore ripe for overthrow. But in the long run, the modern movement did much more than overturn the French Academy; it virtually annulled one of the most funda-mental premises of Western art. Since the Renaissance, European art had methodically refined the practice of imitating visual reality,

11-1　Thomas Couture, *Romans of the Decadence,* 1847. Oil on canvas,
15' 1'' x 25' 4''. Louvre, Paris.

turning the canvas into a ''window-to-the-world.'' Realism was not
the only issue of the modern movement. New possibilities for
content and media were also investigated. But in the last part of
the nineteenth century and the early part of the twentieth, the
advanced painters began to move away from realistic treatment
of subject matter toward a preoccupation with form—lines,
shapes, and colors—as the principal vehicle of artistic meaning.
Although sculpture also figured in this revolution, the spearhead
was painting. Therefore, with few exceptions, the artists cited in
this discussion are those who were involved in the enterprise of
painting.

**Manet**　Edouard Manet, a young Parisian painter (and former student of
Thomas Couture), sent his *Luncheon on the Grass* (colorplate 20)
to the Paris Salon of the spring of 1863. Manet's painting shows
four young adults in a leisurely picnic setting: two men respectably
clothed in city dress together with a naked woman and, in the
background, another young woman in a loose shift who is wading

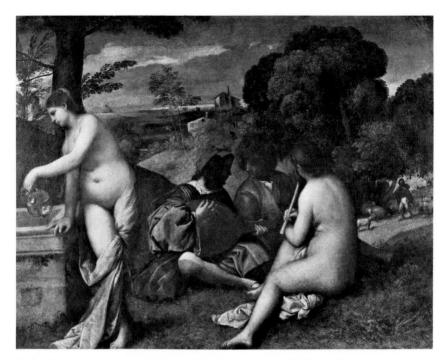

11-2  Giorgione, *Pastoral Concert,* 1510. Oil on canvas, 43″ x 54″. Louvre, Paris.

in a pond. The postures and arrangement of the people are bor-
rowed from an etching of a painting by Raphael, but the whole
idea is reminiscent of a painting by another Renaissance artist,
Giorgione (fig. 11-2). It is ironic that this work borrows from the
past, because artistic events before, during, and after *Luncheon
on the Grass* confirm its position as a prime object and its creator,
Manet, as one of the first artists of the modern era.

Held annually, the Paris Salons were the principal artistic
events of nineteenth-century France; more than just a marketplace
for art works, they were the arena for establishing reputations and
careers. (In this respect they resembled the American institution
of the Academy Awards.) The 1863 Salon turned down so many
paintings that year that the government was prevailed on to open
up another section for a parallel exhibition of rejected works—
called appropriately, the *"Salon des Refusés."* Although placed
in the alternative show, Manet's work received considerable atten-

tion—mostly negative. *Luncheon on the Grass* was considered scandalous by both the critics and the public.

At first glance it may be difficult to see why this painting caused such a furor. After all, nudes in art were quite acceptable in Manet's France (*The Romans of the Decadence* was hanging in the Louvre Museum). But to the Frenchman of that time the figures in Manet's work were unmistakably recognizable as young French people; had they resembled Greek gods they would no doubt have been acceptable. The young woman was clearly not nude for the sake of illustrating any *moral* concepts. Not only that, she broke down any remaining artistic distance by shamelessly looking out at the viewer. The nudes in Couture's Roman orgy and in other storytelling pictures of the period were at least anonymous beings unaware of the artist and his audience. To the critics of the time Manet's impropriety was compounded all the more by the liberties he had taken with other artistic traditions.

One of the things that makes Manet's work still appear so modern, and therefore so disturbing for his time, is the suggestion of contemporary life that he managed to capture in the treatment and arrangement of people. He was particularly interested in the element of chance and its use in art; spontaneity, in other words, was intentionally sought. But to the Salon public the casualness of the little gathering on the grass (which we readily accept as appropriate for a picnic) was unfamiliar if not incongruous. They were more accustomed to the mode of grouping that is seen in *The Romans of the Decadence,* where the artist took pains to pose each character, to make the light—streaming in from the upper left—set off the central group, and to arrange everything so that a viewer would not miss the point. The scenery, the costumes, and the props are all in place (one vase has even been tipped over to indicate rowdiness). MGM could not have done any better. Manet, on the other hand, could paint a vivid scene without Romans, phony gestures, or contrived compositions. But the most modern trait of Manet's people is the look in their faces. It is the cool deadpan often worn by well-to-do city dwellers to shield their personal lives.

While Manet's treatment of people foretells a modern age, it was his painting style that greatly influenced succeeding generations of artists and set in motion a revolution in artistic language.

Above all, Manet's importance was established by the liberties he took with lighting and the time-honored formula of chiaroscuro.

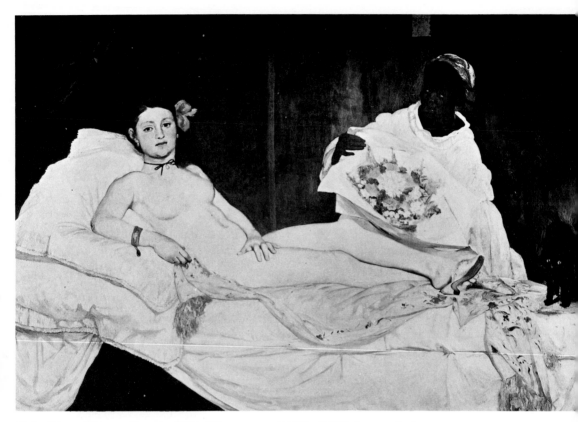

11-3 Edouard Manet, *Olympia,* 1863. Oil on canvas, 51¼" x 74¾". Louvre, Paris.

*Olympia* (fig. 11-3) demonstrates Manet's radicalism even more vividly than the luncheon scene. Although the painting was again based on an established theme used in many classic works (in this case specifically on Titian's *Venus of Urbino,* fig. 6-15), Manet's variation was clearly provocative in its modern setting—more suggestive of a prostitute than of the goddess of love. But even more provocative to critics and a public accustomed to a soft and sculptural treatment of form was the near total absence of shading. Discarding halftones and subtle gradations of light and dark to indicate the roundness of forms, Manet flattened out the figure and made it stand out clearly from the background, which is also quite flat. Along with the reduction of roundness, he also reduced

the amount of detail, suggesting the forms of bed sheets and flowers with a minimum number of brushstrokes. One artist, criticizing this reduction, said that the woman looked like a playing card; a critic compared her body to a corpse. Again, the protest probably stemmed more from the picture's realism than from its lack of realism. The indifferent expression of the face and the artless naturalness of the pose conveys an unmistakable quality of real life, as if one had momentarily distracted the naked Olympia by accidentally walking into her room. And the lack of shading and details enhances rather than detracts from this sense of reality. Manet was aware of the fact that actual light, rather than completely revealing form, sometimes flattens it out with a cold glare. In the course of seeing, we process the visual information—which may be very minimal—into what we know about an object, filling in its solidity and details in our minds. In other words, we *invent* the reality to a degree. By *not* carefully rounding forms and including details Manet simulated the conditions of vision more realistically.

## Monet and the Impressionists

Claude Monet, who was particularly interested in the task of recording visual sensations of the out-of-doors in oil paint, carried Manet's insight into the nature of vision much further. When we view his *La Grenouillère* (colorplate 21) the appearance of rippling water is startlingly real. Yet when we take a closer look, we see that he has constructed the picture out of a mosaic of nothing more than bright daubs of paint—not a single ripple or object has been "drawn" in the conventional sense.

Monet became the central figure of a small band of artists who eventually adopted the name "Impressionism" for their style, an epithet that was originally intended to deride their work. In addition to having received their first inspiration from the paintings of Manet, most of these painters—the other principal figures were Edgar Degas, August Renoir, and Camille Pissaro—also adopted the older artist's preference for themes of contemporary urban society, but with even greater enthusiasm. Their work is a record of joie de vivre, the joy of life, especially the life of the upper-middle class enjoying the pleasures of Paris and the surrounding countryside where the whole world seemed, in their paintings, to be a radiant garden. This fascination with the sunlit (or gaslit) world sometimes led to momentary glances at the world of appearances.

Monet, in particular, dedicated himself to a study of the transitory effects of light in works that turn objects as material as a stone cathedral into an ooze of color sensations (fig. 11-4). This particular example demonstrates the full implications of Monet's insight. When carried to the extreme, it points in the direction of an art of abstract forms—colors, textures, and shapes that do not seem to resemble those of the everyday visible world. Ironically, the Impressionists' insight served to heighten the effect of optical realism while leading art away from it.

11-4   Claude Monet, *Rouen Cathedral, Sunset,* 1894. Oil on canvas, 39½" x 25¾". Museum of Fine Arts, Boston (Juliana Cheney Edwards Collection. Bequest of Hannah Marcy Edwards in memory of her mother).

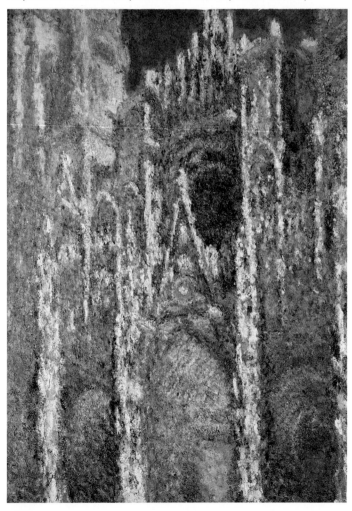

**he Birth of the Avant-garde**

There was another, perhaps equally important, legacy that Manet passed on to later generations. The furor over *Luncheon on the Grass,* rather than repelling, attracted many artists to Manet's way of thinking. The scandal itself helped to bring about Manet's leadership among the more advanced young painters. Their works were also attacked on the grounds of their unorthodox style. But if anything, the ostracism served to encourage them. Beginning in 1874, they had the audacity to sponsor their own series of public exhibitions. And by the 1890s, they had obtained the acceptance and acclaim of the official art world that had spurned their work earlier. Monet, Degas, and Renoir were to eventually capture worldwide popularity and renown. But the lag in recognition and the temporary hostility between the artists and their public was a predicament in the art world that has remained constant right up to the present day. Since the late nineteenth century there has always been an *avant-garde*—a small number of artists whose understanding of art is more advanced than that of their contemporaries, and who are therefore at odds with the public.

Today it is commonplace to think of art and artists as an adversary culture arrayed against the rest of society, especially the Establishment. But before Manet's time this situation was much less common. Artists in the past had rarely challenged the authorities that provided patronage and guaranteed their livelihood, whether they were kings, popes, wealthy merchants, or, as in Manet's day, the national academies.

**Rodin**

One artist who especially exemplified the independent spirit of the times was August Rodin, a sculptor the same age as Monet. Acquainted with many of the new painters, Rodin received enthusiastic support from the avant-garde, but he also succeeded in gaining recognition from a wider circle. At that time, academic sculpture was, if anything, in a lower state than academic painting, and the artistic and spiritual vacuum being filled by the bold works of young Rodin was appreciated even by some members of the regular art establishment.

But his unusual ideas and style were not always greeted with wholehearted acceptance. Rodin's first major public monument— begun in 1884 for the city of Calais—engulfed the artist in a decade of controversy. The purpose of the monument was to honor six fourteenth-century heroes of Calais who offered to sacrifice their

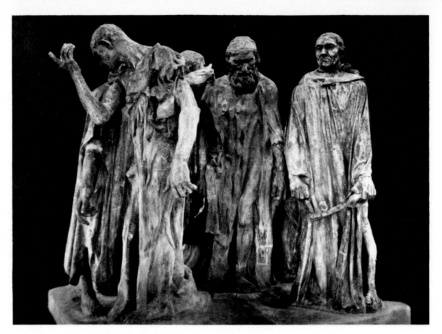

11-5  Auguste Rodin, *The Burghers of Calais,* 1884–86.
Bronze, approx. 82″ x 94″ x 75″. Musée Rodin, Paris.

lives to the English enemy to save the entire city from destruction.
Rodin elected to depict all six men at the moment each made the
decision to commit himself to the awful prospect of death. The
sponsors, however, objected to his plans, preferring a more tradi-
tional monument, with a statue of a single heroic figure to sym-
bolize all six. But Rodin refused to compromise, and for a while
the sponsors went along. However, when they saw the preparatory
models for the six figures they objected once again, this time to
the style. Rodin's roughly finished, extremely emotionalized figures
had none of the marks of conventional sculpture—which at that
time were noble gestures, carefully planned proportions, and
highly polished surfaces. Yet, despite the objections and other
problems that arose, Rodin stuck to his original idea, and *The
Burghers of Calais* (fig. 11-5) was finally installed in the city in
1895.

The complex texture of Rodin's bronze is reminiscent of
Monet's broken color, indicating his interest in Impressionistic
methods. The rough surfaces affect the play of light, often giving
the figures an unexpected sense of life, even movement. When
Rodin's sculptures had first received notice, critics accused him
of casting from life, so suspicious were they of the vibrant model-

ling of the surfaces. The right kind of lighting could imbue a Rodin sculpture with an uncanny degree of life; on the other hand, the busy texture, like the many daubs in Monet's painting, could dissolve the form to such an extent that one becomes conscious only of its glittering abstract surface.

But the seriousness of the subject matter and the vivid drama of Rodin's interpretation have little in common with the emotional neutrality of Impressionist painting. The heroic sacrifice of these historical figures is a long way from the relaxed subject matter of the Impressionists. Furthermore, Rodin put so much emotion into his work that it is difficult to tell whether the lifelike qualities are due to a realistic style or a vivid sense of human emotion.

**Cézanne**    Paul Cézanne—whose art was among the most influential in the entire modern movement—hardly resembled the self-assertive hero-artist of the avant-garde. Unlike Manet or Rodin, he was a timid and serious provincial, almost a hermit, who went to early mass and spent the rest of the day in solitude at work on his paintings. But even though he was isolated from the activities of Paris, Cézanne almost rewrote the rules of painting.

The key to these rules had to do with a new translation of nature. Artists before Cézanne, including the Impressionists, generally attempted in one way or another to imitate the appearance of nature. Though Cézanne did not disregard appearances entirely, he substantially altered them in the process of painting. But it was not an easy process; painting was a difficult, methodical labor of achieving his ends—to penetrate to the core of things, to the essence of a subject rather than concentrate on its outer appearance. The solidity of the fruit in *The Basket of Apples* (colorplate 22) is established by the use of hue rather than value. This, of course, was a practice that had started with Manet and had been developed by the Impressionists, but they had usually applied it to capturing fleeting impressions. Cézanne, however, wanted to make each apple substantial and enduring. He methodically applied reds, orange-reds, and oranges and yellows side by side in the construction of each, making the shape seem very solid—but it was a solidity frankly derived from paint and color rather than from a slick rendering of appearances. The white tablecloth is equally solid as it molds itself around and under the objects and on the table.

The field of vision of the human eye is broad, but we can only focus on one small area at a time. When we look at something we must therefore focus on several areas, but we are not conscious of there being so many single points of focus. This characteristic of vision is often captured in Cézanne's landscapes. Rather than using traditional one or two-point perspective in *Mont Sainte-Victoire Seen from Bibemus Quarry* (fig. 11-6), he combined rock surfaces, trees, and bits of sky into a multiperspective of focal points, almost like a kaleidescope. This mixture is even clearer in the still life; the cookies lie at slightly different angles, the bottle is almost at eye-level when it should appear to be tilted toward us, and the plane of the table is actually set higher on the right than on the left side. Although these competing viewpoints create tension—giving excitement to the picture—they also counter one another to create a vital stability. Cézanne was a master at balancing these opposing forces.

We can see from these paintings that another important key to Cézanne's new rules was the emphasis on composition. Every canvas was a problem to solve, not in transcribing nature but in translating the energy and order of nature into painted surface. Every color, every arrangement of an object had its purpose in the harmony of the whole system. Thus the many distortions, far from being arbitrary, were absolutely necessary to this harmony.

**van Gogh**  Vincent van Gogh was even more provincial than Cézanne. Both artists were completely outside the popular mainstream of art in their generation and even on the edges of the avant-garde movement. And both rejected the optical reality of the Impressionists. But beyond these similarities there was an essential difference between the two in their approach to art. Cézanne's interest lay in discovering and translating the essential structure of nature; van Gogh's was that of possessing the most intense human meanings of everything around him.

In a letter to his younger brother Theo, van Gogh discussed his painting *The Night Cafe* (colorplate 23): ''I have tried to express the terrible passions of humanity by means of red and green. The room is blood red and dark yellow with a green billiard table in the middle; there are four citron yellow lamps with a glow of orange and green. Everywhere there is a clash and contrast of the most disparate reds and greens.'' The clash of opposites in this

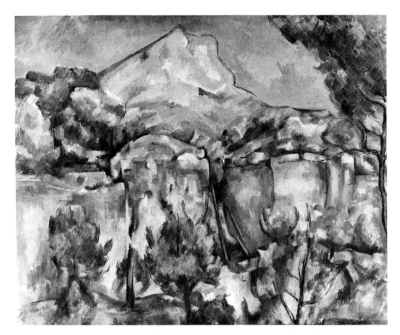

11-6  Paul Cézanne, *Mount Sainte-Victoire Seen from Bibemus Quarry,*
*c.* 1898. Oil on canvas, 25½" x 32". Baltimore Museum of Art
(The Cone Collection).

caldron of intense reds, greens, and yellows is also, in a sense, a self-portrait. With a personality marked by extreme ups and downs, and a history of failures, van Gogh probably led the most miserable life of all the modern painters. The exaggerated perspective of *The Night Cafe*—seen in the abnormally stretched pool table and the lines of the floor rushing toward a point in the back room—is counteracted by the flatness of the deep red walls. The powerful tension between colors and shapes contradict the unnatural stillness of the scene, in which quiet desperation rather than passion seems to reign.

Theo was an art dealer in Paris and through him Vincent came into contact with the avant-garde. The primary effect of this encounter on his painting was to further increase the intensity of the color. After Paris, he spent the last two years of his life in the south of France. Artistically and personally this was his most exceptional period; during this time *The Night Cafe* and many other vividly colored and emotionally powerful paintings were produced. The presence of another artist, his friend Paul Gauguin, contributed to his artistic growth but also, apparently, brought on his last period of crisis—a series of nervous breakdowns that eventually led him to suicide.

11-7   Vincent van Gogh, *The Starry Night,* 1889. Oil on canvas,
29" x 36¼". The Museum of Modern Art, New York
(acquired through the Lillie P. Bliss Bequest).

Van Gogh never ceased to paint and draw, even when he was in hospitals. His late work, not surprisingly, is more subjective and sometimes charged with greater energy than his earlier pieces. *The Starry Night* (fig. 11-7), painted the year before he died, is filled with serpentine shapes and spinning circles. Like a huge dark flame, the cypress tree reaches into a sky that seems to have exploded with celestial activity. The sense of nausea created by the waving, swirling, spinning forms of *The Starry Night* suggests an impending disaster that could be cosmic or personal. In any case, it conveys emotion primarily through shapes, textures, and lines rather than subject matter and symbolism. Paintings like this stood on the frontier of an art in which the inward reality of the emotions is expressed in the forms of the visible world—a concept that was to inspire many artists in the future.

**Gauguin**   Paul Gauguin was another *Post-Impressionist* painter who pioneered the basic principle underlying the art of Cézanne and van Gogh—the belief that the elements of form have artistic power in their own right. A profound colorist, his paintings often display an exotic palette of purples, pinks, yellow greens, and bright oranges, yet their effect is usually ingratiating and never as disconcerting as van Gogh's vivid colors sometimes are. Instead of Cézanne's multiple planes and viewpoints, Gauguin's forms are generally flat and endowed with an ornamental vigor suggestive of tropical plants. And instead of van Gogh's thick texture of brushstrokes, his painting surface is also flat (fig. 11-8). Despite the function of color and lyrical patterns as the principal focus of artistic meaning, Gauguin's paintings nevertheless draw heavily on the content of subject matter and imagery. A mystic, he loved myth and legend and chose freely from Christianity or primitive religion for his themes. Indeed, his enthusiasm for primitive culture, together with a distaste for "civilization," eventually led him to settle in Tahiti.

11-8   Paul Gauguin, *Vision After the Sermon, Jacob Wrestling with the Angel,* 1888. Oil on canvas, 28¾" x 36¼". National Gallery of Scotland, Edinburgh.

While in France, Gauguin was a prominent figure in the avant-garde movement of the late 1880s. Gregarious and verbal, he was given to expounding on art—especially his theories about the ''autonomy'' of color, shape, and line. In this respect he differed markedly from his friend van Gogh, who manifested these theories in his art but was too backward socially to circulate his ideas beyond writing letters to Theo. Gauguin had a striking personality, and young artists were naturally drawn to him. He kept them spellbound talking about his theories at informal gatherings in Pont-Aven, a small fishing village on the coast of Brittany. His influence extended beyond artists. The Symbolists, an intellectual movement mostly of poets, saw an embodiment of their own ideas in his intensification of color and simplification of form as a means to express a mystical reality. An experimental avant-garde of the literary world, the Symbolists were also obsessed with the dilemmas of conveying the invisible realities of the inner life through outer visible forms.

His popularity with the Symbolists—who reviewed him in their own magazine—aided Gauguin in gaining a wider audience. The *Nabis,* a group of young artists who were an outgrowth of his Pont-Aven gathering spread his ideas further. His ideas were even reflected in posters and caricatures. Thus Gauguin, having a more immediate impact on the world than either Cézanne or van Gogh, was very instrumental in preparing the artistic climate necessary for their art to be recognized.

11-9
Victor Horta,
Staircase, Tassel House,
Brussels, Belgium, 1893.
Photo courtesy of
The Museum of Modern Art,
New York.

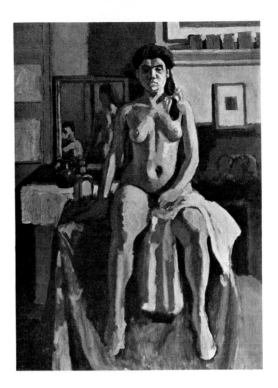

11-10
Henri Matisse,
*Carmelina*, 1903.
Oil on canvas, 32" x 23½".
Museum of Fine Arts, Boston
(Tompkins Collection,
Arthur Gordon Tompkins
Residuary Fund, 1934).

**Matisse**   Henri Matisse was already a twenty-year-old lawyer when he made up his mind to become an artist. The year was 1890, the year of van Gogh's suicide. The Impressionists by this time had won acceptance as serious artists, Cézanne was working on his artistic problems in seclusion, and a year later Gauguin would depart for Tahiti. *Art Nouveau,* a decorative movement that flourished all over Europe (fig. 11-9), was known for its striking black-and-white patterns and lurid whiplash lines—almost a caricature of the lyricism of forms in the paintings of Gauguin and van Gogh. The most prominent figure among the painters of the Paris avant-garde was Seurat (whose work was discussed in Chapter Two). Pushing one aspect of Impressionism to an extreme, he developed a system of painting with small dots of color that came to be called *Pointillism.* Founded on new theories of color, these paintings were gaining the attention of several important artists.

Matisse turned to and mastered Impressionism soon after finishing his art studies and, by so doing, came to understand the power of pure color. He also became acquainted with the work of Cézanne and found that it not only suited his own logical cast of mind but also his desire for a discipline for his compositions. *Carmelina* (fig. 11-10) shows how quickly he assimilated these

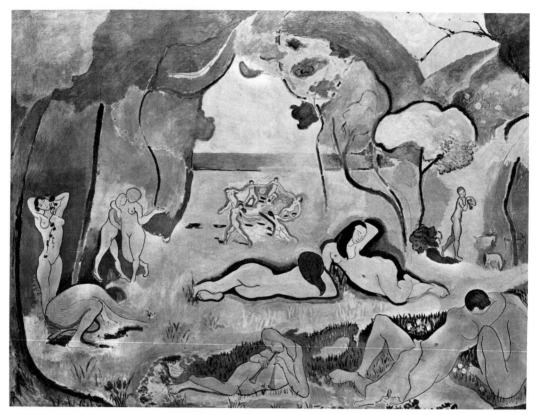

11-11  Henri Matisse, *Joy of Life,* 1905–06. Oil on canvas, 68½″ x 93¾″.
Copyright 1975 by The Barnes Foundation, Merion, Pennsylvania.

lessons. The nude and her surroundings are as solidly constructed
as they would have been by Cézanne himself. After a few other
works inspired by the older artist, Matisse took a brief fling at the
pointillist technique of Seurat. But the painstaking dot-by-dot
application of color did not appeal to him, even though the ex-
periment helped to further his development and improve his
understanding of color. He discovered van Gogh's work at a
retrospective exhibit, where he also met two other artists who were
under the spell of this emotional use of color. Through his associa-
tion with them, Matisse also came under the same spell, and the
audacity of bold color was added to his analytical temperament.

The public of Paris was given a taste of this explosive mixture at an exhibit in the fall of 1905. The outbreak of color in works like the jarring seascape in *Window at Collioure* (colorplate 24) so exasperated one critic that, as legend has it, he called the group of paintings by Matisse and his friends *"fauves"* (wild beasts). To critics, this orgy of color, most of it completely unrelated to its subject, was interpreted as an insult to both art and life. Nevertheless, the colors in *Window at Collioure* reveal a sense of purpose. The relatively solid areas of pink and blue-green within the room correspond to an exaggerated interpretation of light and shadow, while the sky and water outside are indicated with smaller, isolated strokes that suggest the brightness and the reflections. Thus the overall effect of this image of a summer day by the Mediterranean shore is all the more expressive because of the vivacious use of color.

Almost as soon as Matisse had achieved his controversial success with *Fauvism,* he felt compelled to consolidate his gains as the leading innovative artist of the time. He examined the work of his predecessors—the Impressionists, Cézanne, Seurat, van Gogh, and even the other Fauves—and developed a style that incorporated their advances while remaining completely his own. The first painting in this new manner was *Joy of Life* (fig. 11-11), a large canvas of rather conventional subject matter, a pastoral setting of naked nymphs and lovers, but treated in a highly unconventional way. Though flat and colorful like Gauguin's, Matisse's figures and forms go far beyond his in simplicity and distortion—nature for the first time is openly subordinated to the spirit of the picture. The joy in *Joy of Life* is not conveyed by the figures of the dancing nymphs but through a rhythmic line and a musical ordering of color contained in flat shapes—hallmarks of a style that he pursued the rest of his life.

**German Expressionism**

The French Fauves had their counterparts in other European countries, particularly Germany where a band of young artists calling themselves *Die Brücke* (The Bridge) had found a common cause at about the same time that the Fauves made their splash in Paris. A few years later another group called *Die Blaue Reiter* (The Blue Riders) consisting of Germans and other nationals, including the Russian Wassily Kandinsky, formed a loosely knit brotherhood dedicated to similar ideals. The work of these groups and much

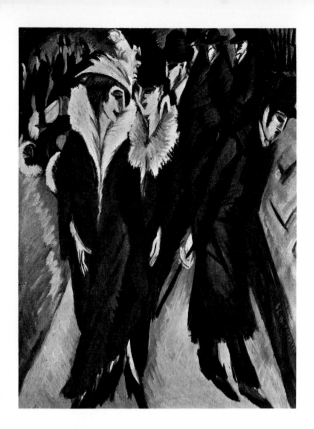

11-12
Ernst Ludwig Kirchner,
*The Street,*
1913.
Oil on canvas,
47½" x 35⅞".
The Museum of Modern Art,
New York.

of the advanced art in Germany during this period has come to be known collectively as *German Expressionism.* The frenzied, fractured compositions of Ernst Ludwig Kirchner (fig. 11-12), a member of the Brücke group, are typical of German art of the time.

The German Expressionists were the spiritual descendants not only of van Gogh, but also of the Norwegian artist Edvard Munch, whose best work was done in the decades from 1890 to 1910. This was a period of intellectual ferment and anxiety stemming from the still unresolved social problems brought on by the industrial revolution and the growth of the cities. These had a spiritual counterpart in the disturbing questions and self doubts that were surfacing in the writing of poets and philosophers. Munch created images that reflected the tensions and spiritual crises of his time in a style that contains elements of van Gogh, Gauguin, and Art Nouveau (fig. 11-13).

But the principal heroes of the German Expressionists were the Fauves. The image-provoking label symbolized their spiritual strivings, and the wresting of color from the limiting rules of conventional realism paralleled their artistic strivings. But the liberation

of color had a different ultimate purpose for the Frenchmen than it did for the Germans. French subject matter was essentially unprovocative. Color was used for color's sake, or rather, for pleasure's sake; Matisse served up a delectable concoction of color and shape primarily for the viewer's *enjoyment*. The Germans also liberated color and shape from the strict domination of subject matter but they put everything at the service of expressing deeply serious personal, social, or religious interpretations.

Of all the members of the German Expressionist movement, only the Russian Wassily Kandinsky (of the Blaue Reiter group) preoccupied himself with the abstract elements of form and color, which he, like Matisse, felt could be treated like the elements of music. It is said that his Russian origins were responsible for his rich sense of color and mystical outlook. It is little wonder, then, that Kandinsky was the first significant artist to dispense altogether

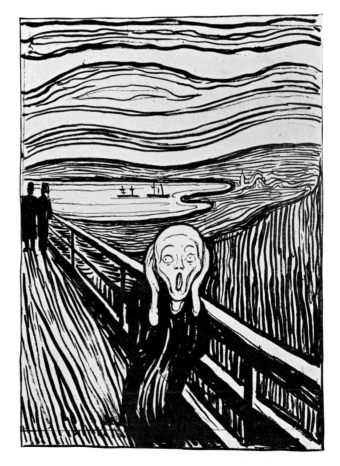

11-13
Edvard Munch,
*The Scream,*
1895.
Lithograph,
13¾'' x 10''.
National Gallery of Art,
Washington, D.C.
(Rosenwald Collection).

with subject matter and references to objects. Abstract painting was born in 1910 when he painted a completely abstract watercolor. Although such a development was inevitable, at the time it was so new that people tended to read images—people, landscapes, even cannons—into Kandinsky's work. In order to counteract this temptation and to emphasize his intent of providing an experience of pure form, he titled his paintings as if they were musical scores. His earliest experiments, consisting of floating colors and lines, were somewhat nebulous in composition; his later works were often organized around geometric shapes floating in a rainbow-colored space (fig. 11-14).

**Cubism**     The excitement stirred up by the Fauves may have been a spur for the experimental turn in the art of Pablo Picasso, for up to 1905 his work had showed relatively little daring. There is also reason to believe that after he had seen Matisse's *Joy of Life* he felt the challenge to produce an innovative painting of his own. At any rate, after working for several months Picasso produced his own landmark, *Les Demoiselles d'Avignon* (fig. 11-15). The paintings of Cézanne and contact with African sculpture were also influential in Picasso's breakthrough. The breaking up of the forms into planes was derived from Cézanne; the severity of some of

11-14   Wassily Kandinsky, *Improvisation,* 1914.
Oil on canvas, 30¾'' x 39⅞''. Philadelphia Museum of Art
(Louise and Walter Arensberg Collection).

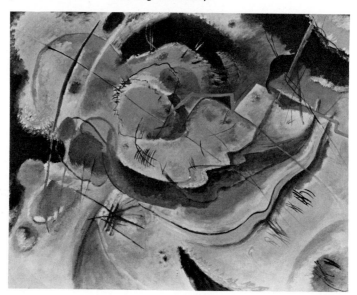

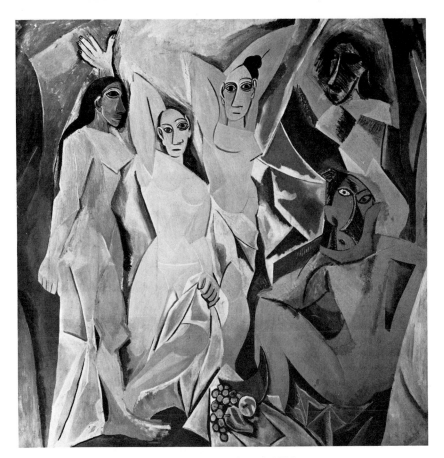

11-15  Pablo Picasso, *Les Demoiselles d'Avignon,* 1907.
Oil on canvas, 8′ x 7′ 8″. The Museum of Modern Art, New York
(acquired through the Lillie P. Bliss Bequest).

these planes—especially those of the faces—was influenced by
the African work. Picasso was the first to adapt primitive art in
his painting. Ignored for centuries by Europeans who had had eyes
only for realistic art in the Greek tradition, primitive objects were
finally being recognized for their artistic value. At the same time,
their abstract forms and directness of communication provided
inspiration for the modern artist in search of new artistic solutions:
Fauve artists rummaged in junk shops for African masks, and
members of the Die Brücke were attracted to Melanesian art.

*Les Demoiselles* was the first in a long series of bold experi-
ments with structure in painting. Teaming up with Georges
Braque, Picasso launched a major new artistic style called *Cubism.*
Despite the headlong rush into wild color of the Expressionists and

273

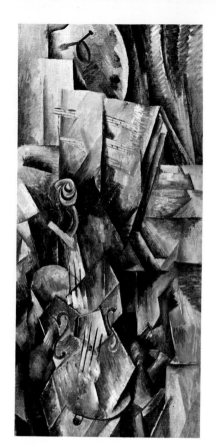

11-16
Georges Braque,
*Violin and Palette*,
1910.
Oil on canvas, 36¼" x 16⅞".
Solomon R. Guggenheim Museum,
New York.

the Fauves, the Cubists retreated to an art of values alone, painting in grays and browns in order to concentrate on structure. And while Matisse attempted to stress the physical flatness of the painting surface, Picasso and Braque sought ways to extend the impression of three-dimensional space.

Braque's *Violin and Palette* (fig. 11-16) is a representative work from the early phase of this style, which was known as *Analytic Cubism*. The entire picture surface is fragmented into angular shallow planes that recall the kaleidoscopic effect of Cézanne's landscape (fig. 11-6). But this art goes significantly beyond Cézanne's by ignoring the limitations of the visible structure of objects and remaking them so that we can see the different sur- faces—front, top, and side, outside and inside—simultaneously. In keeping with this process, the space surrounding these objects becomes mixed with it, and the whole scene blends into a single multifaceted mass. The monochromatic color, more subdued and conservative than any seen since before Manet's breakthrough of

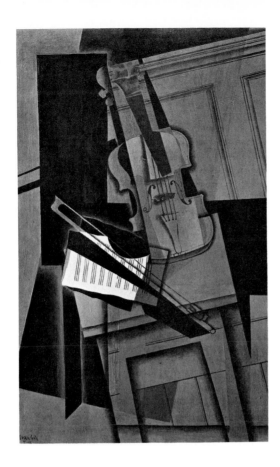

11-17
Juan Gris,
*The Violin*,
1916.
Oil on wood,
45½" x 29".
Kunstmuseum, Basel.

nearly half a century earlier, adds to the spatial mixture. Thus, while this art roughly paralleled Matisse's in its degree of abstraction, it disfigured nature with different means and for different reasons. In his painting, Matisse sought an analogy in nature for lyrical harmonies of color and pattern; Cubist art systematically broke nature down into spatial shapes and rhythms.

By 1912 the original Cubist theories had been fully developed and had launched many other movements. Chief among these was, not surprisingly, a style that Picasso and Braque developed as a variation on these earlier ideas. *Synthetic Cubism* tended toward flatness rather than dimension, and depended less on nature as a starting point—changes that corresponded not only to Matisse's preoccupation with surface, but to Mondrian's search for a simple visual order (figs. 10-7 to 10-11). Juan Gris was the artist who carried the new style to its purest expression, translating the world into a vision of smooth forms and precise edges (fig. 11-17).

Elsewhere, the geometric-Cubist impulse took other forms. In Italy a particularly dynamic version was produced under the name of *Futurism,* which directly influenced the work of American Joseph Stella (fig. 9-7). In France it launched a multitude of styles and affected a great many artists, even those who, like Marc Chagall (colorplate 12), were involved in very different pursuits. And in Russia, where a generation of avant-garde artists had appeared on the eve of the revolution, it was instrumental in the drive toward a nearly pure geometry that reached its ultimate expression in the landmark painting by Kasimir Malevich, *White on White* (fig. 11-18).

Cubist painting naturally had its equivalents in the art of sculpture. The breaking up of the image into exaggerated and fragmented planes that tried to recreate the appearance of volume had to lead inevitably to experiments with real space. Picasso and Braque had developed collage (Chapter Three), which expanded into three-dimensional forms. Constructions of wood or metal (fig. 11-19) appear to have served Picasso largely as studies for his painting, but Cubist ideas were soon taken up and developed by sculptors like Jacques Lipchitz (fig. 2-11). Years later, his invention led to the in-between art of assemblage (Chapter Three). The most impressive sculpture of this style and period came from Italy, where several of the Futurist painters essayed occasional works.

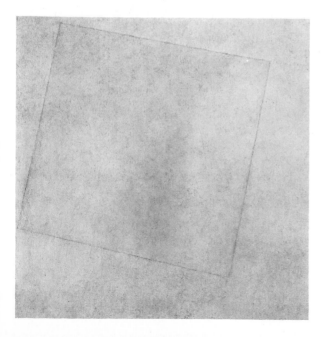

11-18
Kasimir Malevich,
*Suprematist Composition: White on White,*
1918.
Oil on canvas,
31¼" x 31¼".
The Museum of Modern Art,
New York.

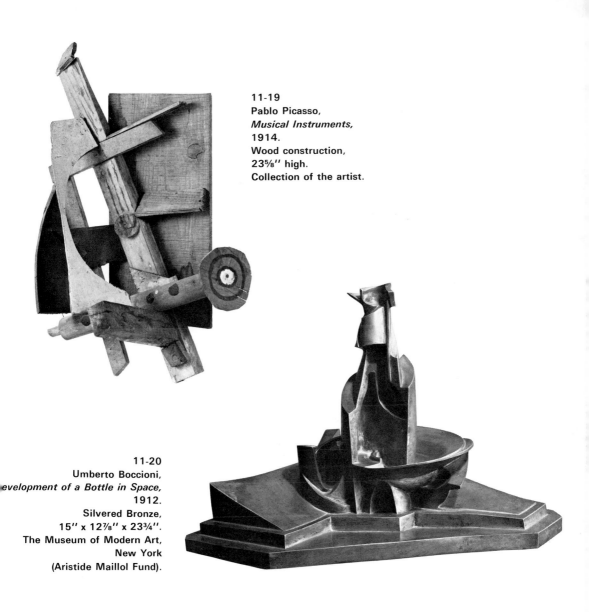

11-19
Pablo Picasso,
*Musical Instruments,*
1914.
Wood construction,
23⅝" high.
Collection of the artist.

11-20
Umberto Boccioni,
*Development of a Bottle in Space,*
1912.
Silvered Bronze,
15" x 12⅞" x 23¾".
The Museum of Modern Art,
New York
(Aristide Maillol Fund).

Umberto Boccioni's *Development of a Bottle in Space* (fig. 11-20) is far more dynamic than the works that were done in Paris, for in addition to breaking down the forms to reveal their structure, he imposed a swirling instability to the composition. Where Picasso's instruments are destined to hang against a wall, Boccioni's bottle insists on in-the-round viewing. With its clashing planes and varied perspectives, it seems like a more direct descendant of Cézanne's still lifes than Cubism itself.

**Duchamp and Dada**

The battles of the aesthetic revolution had been fought and won, up until now, mostly on French soil. America had felt a few of the shock waves coming from the European continent, but no city in America had as yet enjoyed a bombshell comparable to those of Manet's *Luncheon on the Grass* or the Fauves exhibit; at least not until the International Exhibition of Modern Art of 1913. This exhibition, now known as the Armory Show, contained more American works than others, but it was the European collection, especially the recent French works, that created all the stir.

The painting that inspired the most comments of the whole affair was Marcel Duchamp's *Nude Descending a Staircase* (color-plate 25). One wag called it "an explosion in a shingle factory," and Theodore Roosevelt said that it reminded him of a Navajo blanket. Ironically, Americans ridiculed the right artist for the wrong reasons. *Nude Descending a Staircase* was a comparatively tame version of Cubism with a touch of Futurist motion, having neither the raw shock of *Les Demoiselles* nor the novelty of the latest collage inventions.

But many of the art works created by Duchamp in the years following the *Nude* were very radical even by today's standards: for example, a Duchamp sculpture of 1917 that consisted of a urinal turned on its side and entitled *Fountain* (fig. 11-21). Christened *readymades* by Duchamp, these radical artistic gestures added a confounding feature to an already changing and bewildering art scene. The assumption that the artist controlled the form in some personal manner had never before been challenged. Duchamp seemed to be demonstrating by these acts that the premise of the uniqueness of form did not really matter, that a randomly selected object—even a banal one—could also be thought of as art, that a mass-produced urinal could rest in a museum alongside a Cézanne.

The works of Duchamp have come to be associated with *Dada,* an intellectual movement characterized by cynicism and buffoonery that was launched in Zurich in 1916. Zurich had become a haven in war-ravaged Europe for refugees of all kinds, including writers and artists steeped in pessimism about the state of European civilization—an outlook that they expressed in actions and works that were considered preposterous at the time. Poetry was created by drawing words out of a hat; artists made pictures by randomly arranging cut-out shapes. Even the name Dada (French baby talk for "rocking horse") was selected by the absurd action

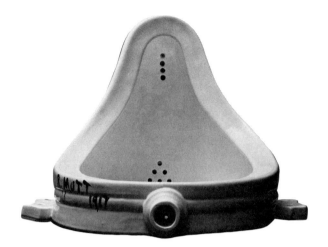

11-21
Marcel Duchamp
(signed R. Mutt),
*Fountain*,
1917.
Porcelain,
24⅝" high.
Schwarz Galleria d'Arte,
Milan, Italy.

of opening a dictionary and taking the first word that appeared. Implied in these kinds of actions was an attack on the meaning of any cultural endeavor, including art. Although Dada artists were temperamentally sympathetic to the avant-garde because of its own reputation for recklessness, modern art was not spared their sarcasm. Yet, in spite of the impudence and madness, the stunts of the Dadaists did serve to reassess cultural values and also to discover new approaches to meaning—especially that having to do with unconscious associations. ''Automatic drawing,'' a sort of spontaneous doodling, was one of the experiments Dada artists pursued to promote the notion of releasing subconscious, irrational forces in the creation of art.

**Surrealism**     The Dada movement faded away in the early 1920s, but its influence on writing and painting continued. The Dada artists, for all their perversities, made a serious case for the irrational. They were instrumental in generating the twentieth-century preoccupation with the ironic, the magical, and the unconscious—which became the foundation of *Surrealism*. A prominent Dadaist, André Breton, personally bridged the gap by leaving the movement shortly before its demise to seek to establish a new brotherhood of poets and artists. His First Surrealist Manifesto, expounded in 1924, describes the purpose of the new movement as ''to resolve the previously contradictory conditions of dream and reality into an absolute reality, a super-reality.''

The super-reality of Surrealism had been anticipated by Giorgio de Chirico (fig. 11-22), who began painting pictures of disturbingly deserted plazas as early as 1913. The exaggerated open spaces painted in a tense, one-point perspective, the long shadows, and the ambiguous architecture conspire to create the kind of ominous and mysterious sensation that we often experience in our dreams, but they also suggest the magical life of lifeless things—a carry-over from childhood, when we projected fantasy identities into inanimate objects. His art style, called Metaphysical painting, opened up possibilities for dealing with subjective experiences. As de Chirico himself explained: "The terrible void that has been discovered is the unchanging, inanimate and calm beauty of matter."

The impulse to paint dream phenomena led some artists in a direction that seemed, in one way, contrary to that of the modern movement. Salvador Dalí (fig. 11-23) revived the methods of chiaroscuro and perspective in order to represent the irrational world of dreams as vividly as possible; hence hallucinatory images

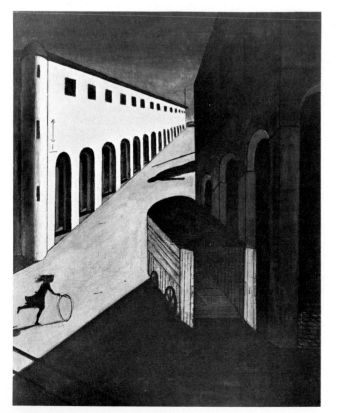

11-22
Giorgio de Chirico,
*The Mystery and Melancholy of a Street,*
1914.
Oil on canvas,
34¼'' x 28⅛''.
Collection of
Mr. and Mrs. Stanley Resor,
New Canaan, Connecticut.

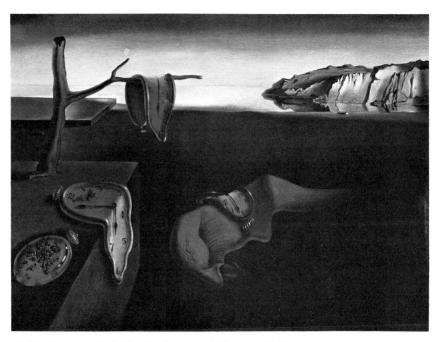

11-23  Salvador Dalí, *The Persistence of Memory,* 1931.
Oil on canvas, 9½″ x 13″. The Museum of Modern Art, New York.

and the inhabitants of the dark world of the unconscious assume the authority of photographs. Intrigued by the theories of Freud, Dalí was incredibly resourceful in inventing all sorts of dream fantasies. René Magritte (figs. 8-13 and 8-14) also painted in a realistic style but did not choose to dramatize either the style or the content of his work. He preferred instead to pose compact contradictions with simple images that are reminiscent of de Chirico's.

The other principal branch of Surrealism pursued their visions of the irrational world through automatic painting and drawing, a fact that led them gradually into forms of abstraction. Joan Miró (colorplate 26), who was inclined toward the playful and humorous, painted works that often resembled those of children. In other words, instead of attempting to interpret and illustrate a child's dream or fantasy feeling as Dalí might, Miró's painting represents how a child might express it in his own illustration. Yet there was nothing childlike about Miró's talent. He was unusually creative in coming up with ways to evoke the mysterious world of the subconscious, and came to be one of the most important influences on the American abstract artists of the 1940s—whose form of painting was to be the next big breakthrough in the world of art.

# 12

# The Barricades Crumble

Even before the Armory Show the seeds of artistic change had been planted in America. As early as 1909, Matisse's work had appeared in the gallery of photographer–art dealer Alfred Stieglitz; a little later Cubist drawings and watercolors by Picasso made their way into the same gallery. The avant-garde magazine *Camera-Work,* published by Stieglitz, printed articles by American artists and writers who were followers of the avant-garde movement in Europe. But the growth of an indigenous modern art was very sparse with only a few hardy perennials—including the work of Stieglitz's wife, Georgia O'Keeffe—able to survive in an unfriendly climate where home-grown art of any kind, let alone the modern variety, had never been popular with wealthy collectors. Thus, when the aesthetic revolution succeeded in Europe, American collectors interested in new art bypassed the local artists in favor of Matisse and Picasso.

To compound the insult, American artists, with minor exceptions, rarely gained the respect of Europeans. In the nineteenth century, all the important activity had taken place in Europe and the influence flowed just one way—*to* America. After the Armory

Show—even though the style had changed—the influence still flowed in the same direction.

In such an atmosphere of cultural inferiority it is little wonder that, during the depression of the 1930s and the world war that followed, many American artists turned away from European influences and aggressively promoted a native American art. The dominant style of this period, *Regionalism,* is typified by the works of such people as Edward Hopper and Thomas Hart Benton (fig. 12-1). But despite the excellence of some of these men, their compulsive use of local American subject matter did not help them to gain international recognition.

In the mid-1940s America emerged from the crisis of the Second World War as one of the undisputed military and economic powers of the globe. Yet, outside of Hollywood and Walt Disney, the American colossus lacked a distinctive cultural personality. Europeans still thought of American culture, especially its painting,

12-1   Thomas Hart Benton, *Arts of the West,* 1932. Tempera, 8' x 13'.
New Britain Museum of American Art, New Britain, Connecticut
(Harriet Russell Stanley Fund).

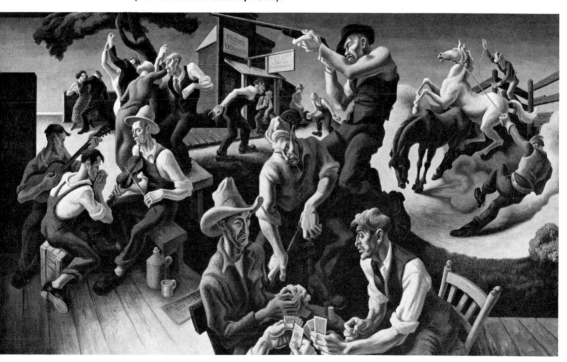

as provincial. The mass of American people seemed to be oriented toward amusement, and American intellectuals still looked on Europe as the fountainhead of serious art. Many important European artists had fled to the United States at the onset of the war, bringing with them the possibility of improving the American scene, and many young artists, eager to break out of their cultural isolation, were already beginning to learn from them.

## The Fifties

Toward the end of the 1940s a new form of abstract art began to take shape in New York. It was based in large part on the automatism of the Surrealists, but at the same time it broke with their tendency to base forms on the human figure or the landscape. In most cases the artists also rejected the traditional ways of putting the paint on the canvas, turning to other means such as dripping or throwing or using huge housepainting brushes in an attempt to change not only the appearance of the work but the ways that they thought about painting as well. And out of their rebellion and their spontaneity came the first truly American style of painting.

### Pollock

No artist in the late forties and early fifties represented the spirit of rebellion better than Jackson Pollock, a man with a personal history of restlessness that lent credibility to his reputation as a rebel. His Rocky Mountain origins, moreover, nourished a legend of the cowboy loner, a hero living out a Classical tragedy on strictly American terms. Myth, art, and man have been mingled in a way similar to many of Pollock's artistic predecessors, such as van Gogh or Picasso, but this time the myth has a distinctly American flavor.

By his twenties Pollock was familiar with the Surrealists' use of symbol and the Cubists' method of reorganizing pictorial elements. Besides Picasso, the European masters Miró and Klee were also sources of inspiration, but other factors, such as his experience as a student of Benton and admiration for certain kinds of art, particularly Mexican social-protest art and Indian sand painting, also influenced his development. Like van Gogh, Pollock borrowed from diverse teachers, but also, like the former, he absorbed their influences while imposing his own will on their lessons (fig. 12-2).

After the war many young artists, including Pollock, developed an interest in symbols. They sought to identify the content of their

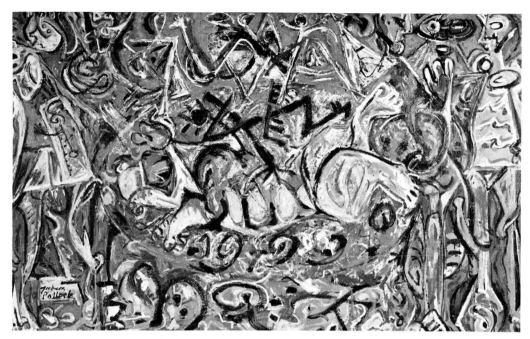

12-2  Jackson Pollock, *Pasiphae,* 1943. Oil on canvas, 56⅛" x 96".
Collection of Lee Krasner Pollock, New York.

art with broader, more universal themes, to remove it from the
narrow, pictorial subject matter of Regionalist art. To Pollock,
however, the symbols were more than just a base for universal
themes. His restless personality found relief in the symbol as an
expressive outlet. But by the mid-1940s the distinguishable sym-
bols in his painting began to lose their identities to an overall
network of lines. Realism had been destroyed to make way for
the symbol, and in Pollock's paintings symbols were now begin-
ning to give way to abstract patterns of lines.

*One* was painted by Pollock in 1950 with liquid Duco and thin
oil paints (colorplate 27). The enormous canvas (8'10" by 17'5")
was not fixed to a wooden frame and painted on an easel, but
spread loosely on the floor so that the artist could walk around and
across it and apply paint by dripping, spilling, splashing, and
scraping. Not only were symbols and realistic images overthrown,
but also traditional artistic habits. All that remained was an art

of total spontaneity. Beginning a painting with very little idea of what he wanted to do, he would develop it instinctively as he went along (fig. 12-3). According to Pollock:

> When I am *in* my painting, I'm not aware of what I'm doing. It is only after a sort of 'get acquainted' period that I see what I have been about. I have no fears about making changes, destroying the image, etc., because the painting has a life of its own. I try to let it come through. It is only when I lose contact with the painting that the result is a mess. Otherwise there is pure harmony, an easy give and take, and the painting comes out well.''

**12-3
Jackson Pollock
painting, 1950.**

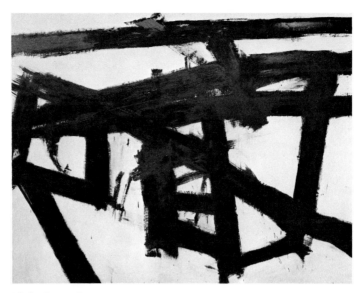

12-4  Franz Kline, *Mahoning,* 1956. Oil on canvas, 80" x 100".
Whitney Museum of American Art, New York
(gift of the Friends of the Whitney Museum of American Art).

*Abstract Expressionism*

Jackson Pollock was the first of a new generation of painters—called *Abstract Expressionists*—who captivated the art world of the 1950s. An Abstract-Expressionist work usually consisted of bold, freely shaped forms that tended to make an observer conscious of its impulsively painted surface. Within this style, a variety of approaches emerged. Franz Kline's muscular, broad slashes of black on white (fig. 12-4) can be contrasted with Pollock's thin, nervous lines; Robert Motherwell's quiet and massive shapes, which were often intended as symbols of mythical epics, seem less emotional then either (fig. 12-5); Willem de Kooning's savagely agitated paint surfaces, in which broad brushstrokes go in all directions, perhaps best epitomized the style (colorplate 28). There were important Abstract Expressionists in Europe, too, but now the relationship between European and American art had changed; European artists had to run to keep up with a vigorous new American competition. Despite their intention of making a universal art that was free of nationalism, the American avant-garde acquired a strong (and sometimes arrogant) national identity. This brand of painting had about it a romantic quality with a distinctly American accent. Its raw style and defiance of convention obviously fit the American image of informality and individualism—the folk traits of the New World.

Serious art will probably never be as popular in America as drive-in movies or professional football, but Abstract Expressionism

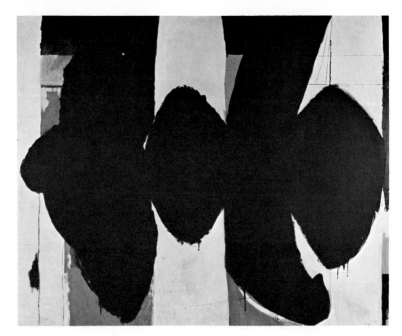

12-5   Robert Motherwell, *Elegy to the Spanish Republic XXXIV*, 1953–54.
Oil on canvas, 80″ x 100″. Albright-Knox Art Gallery, Buffalo, New York
(gift of Seymour H. Knox).

did achieve a previously unprecedented measure of acceptance.
It became a status symbol to decorate a home or modern office
lobby with striking expressionistic paintings (or at least reasonable
facsimiles). Klines and Motherwells seemed to be meant for mod-
ern interiors that alternated large expanses of plain walls with
dashes of brick, stone, and mahogany. On a different social level,
creative self-expression had completely won the day for children's
art in the public schools in which the Jackson Pollock experience
was applied to fingerpainting. But despite this seeming popularity,
the art of painting was to experience another wave of change in
the early 1960s.

*Sculpture and*
*Assemblage*

During the 1950s, developments in sculpture were generally over-
shadowed by the exuberant world of Abstract Expressionist paint-
ing. Just as in Europe in the early days of the twentieth century,
the aesthetic advances right after the Second World War were
pioneered by painters. Yet sculptors were attuned to this climate
of thinking, and though they were not the leaders, they managed
to translate the new directions into three-dimensional statements.

The tie between abstract sculpture and abstract painting of the
1950s is best exemplified in the approach of David Smith. Trained

as a painter, he first came under the influence of such people as Kandinsky, Miró, and Mondrian. But a summer job in a car factory, where he learned to cut and weld metal, together with his discovery of the welded sculptures of Picasso and González, stimulated him to pursue the art of steel sculpture.

Throughout his career Smith refused to accept any clearly stated distinctions between the aims of sculpture and painting, saying that they were separated by only one dimension. He drew incessantly, like a painter who uses drawing as a basis for a painting. And whenever he could, he incorporated color into a sculpture, sometimes covering it with layers of epoxy, zinc, or auto enamel. But the most basic relationship between painting and Smith's sculpture is the frontal quality of most of his work. Rather than several viewing points, they usually have only two—front and back.

*Hudson River Landscape,* inspired by impressions gathered on a trip between Albany and Poughkeepsie, is an example of this two-dimensional approach (fig. 12-6). The overall abstract design is horizontal and extremely frontal. This, together with the improvised character of its twisting lines of steel calls to mind the paintings Pollock made around the same time. Although the sculpture was derived from several sketches made during the trip, the connection between its abstract rhythms and the appearance of the Hudson River are more symbolic than specific.

12-6
David Smith,
*Hudson River
Landscape,*
1951.
Welded steel,
75" x 49½" x 16¾".
Whitney Museum
of American Art,
New York.

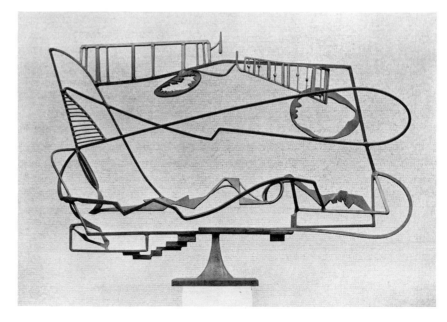

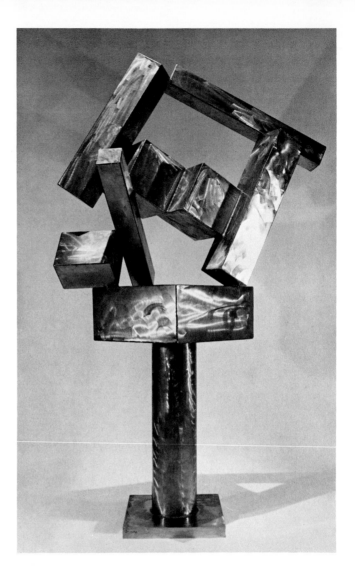

12-7
David Smith,
*Cubi XVII,*
1963.
Stainless steel,
107¾″ high.
Dallas Museum of Fine Arts
(The Eugene and Margaret
McDermott Fund).

Later, Smith concentrated on more limited shapes like the Cubi series, compositions of highly buffed stainless steel cubes that look as though they are about to fall apart (fig. 12-7). Most of these, like his earlier sculptures, are frontal, and their compositions— featuring novel situations of precarious balance—show a talent and fondness for improvising like a painter. Even the random swirls on the surfaces have the character of brush strokes. However, the most influential thing about the Cubi sculptures for later artists— both sculptors and painters—was their example of reducing a concept to a simple, straightforward geometry.

The renewed popularity of assemblage in the 1950s grew out of the freewheeling informality of Abstract Expressionism. If personal expression could be accomplished by the spontaneous spreading of paint, it could also be tied to the intuitive assemblage of nondescript materials.

By restricting the material to wood and the visual elements to mostly rectangular forms painted one color, Louise Nevelson made assemblages that retained a suggestion of order (fig. 12-8). Boxes of many sizes and shapes, all open to the viewer, were filled with chair legs, newel posts, knobs, chunks of natural wood—any imaginable found object made of wood. The series of niches crammed with protruding objects create an interplay of depth and surface, stressing visual and psychological relations between and among things. By themselves, neither the niches nor the objects have any particular meanings, but together in the assemblage they generate images suggesting Early American memory boxes or medieval altarpieces.

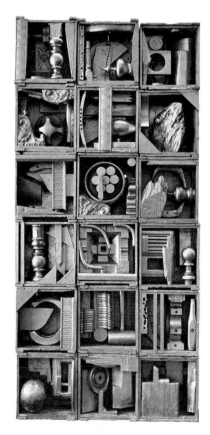

**12-8**
**Louise Nevelson,**
*Royal Tide I,*
**1960.**
**Gilded wood,**
**96" x 40" x 8".**
**Private collection.**

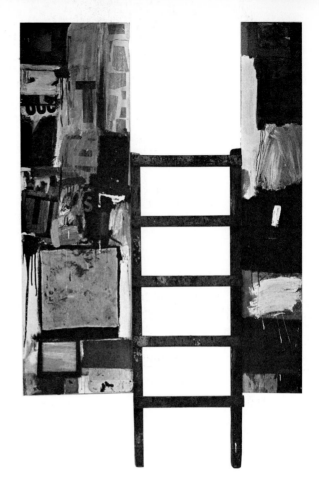

12-9
Robert Rauschenberg,
*Winterpool,*
1959.
Combine painting,
88½'' x 58½''.
Collection of
Mr. and Mrs. Victor W. Ganz,
New York.

Robert Rauschenberg and Jasper Johns—the two artists who experimented most radically and most successfully with assemblage in the 1950s—were also painters experienced in the ways of Abstract Expressionism. Rauschenberg would attach various objects—torn pictures, neckties, broken umbrellas, clocks, old trousers, pillows—to a vigorously painted surface. Although he called these works ''combine-paintings,'' some of them developed into rather substantial three-dimensional objects, especially those in which unusual compositions were created (fig. 12-9). Although his use of objects ran counter to the basic philosophy of Abstract Expressionism, his bravado use of paint revealed a profound understanding of their methods. The rich application of drips and smears that permeates and surrounds everything surprisingly creates unity out of what would otherwise be a meaningless collection. Jasper Johns's assemblages generally employed less variety and their paint surfaces capitalized on Abstract Expressionism's

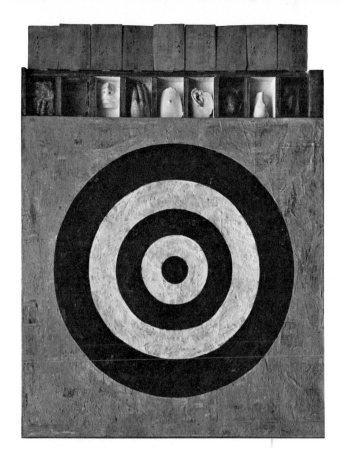

12-10
Jasper Johns,
*Target with Plaster Casts,*
1955.
Encaustic collage on canvas,
with wood construction
and plaster casts,
51" x 44" x 3½".
Collection of
Mr. and Mrs. Leo Castelli,
New York.

heavy textures rather than its brushstrokes. He made several versions of painted numbers and others of maps of the United States that were embedded in thick paint and collage and arranged like mosaics across the surface of the canvas. But he is mainly known for his elaboration of single images such as a target or the American flag. One such painting, *Target with Plaster Casts,* combined a large target with a series of plaster casts of parts of the human body set in tiny boxes above the bull's-eye—a juxtaposition that conveyed ominous feelings (fig. 12-10).

In discussions of their work, both artists tended to discourage the search for special meanings for their objects and images. Yet their inspired combinations inevitably generate connotations: Rauschenberg's rapid flux of images and surface effects can easily be seen as a reflection of our hectic times; Johns's quieter, often ironic images are suggestive of contemporary myth. Nevertheless, the interpretation of their work is open, leaving much to the individual viewer.

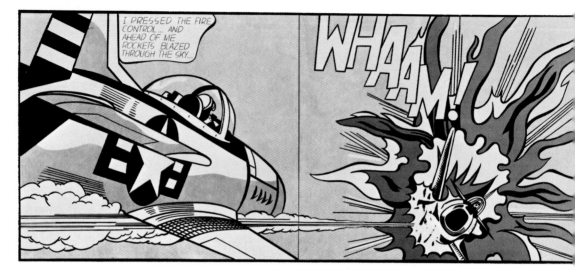

12-11  Roy Lichtenstein, *Whaam!*, 1963. Acrylic on canvas, 68'' x 160''. Tate Gallery, London.

**The Sixties**    One of the most tumultuous decades in American history was also the scene of tumultuous changes in art. Attempting to sort it all out is like trying to retrace the movements involving civil rights, free speech, peace, and gay liberation and show how they all interrelate. Ironically, in spite of the heated-up pace of change, most of the art of the 1960s had the traits of emotional detachment—a cooling off after the expressive 1950s.

*Pop Art*    *Pop Art* appears to be so different from Abstract Expressionism that it was first looked on as a total break. But there is an ambiguous continuity between the two. Even though Pop Art represented the rejection of Abstract Expressionism, the fact is that many Pop artists had begun as Abstract Expressionists, and their vision of the world was affected by that fact.

The similarities and the differences between Pop Art and Abstract Expressionism are summarized in Roy Lichtenstein's series of paintings of brushstrokes. *Little Big Painting* (colorplate 29) is an image of the marks that a painter such as De Kooning would make with a few sweeps of his large brush, right down to the "accidental" drips. But in Lichtenstein's smooth-surfaced, hard-

edged product such personal touches as drips or spills are completely eliminated. He even used enlarged "Ben Day dots"—a mechanical method of indicating tones as the background. To an Abstract Expressionist a brushstroke was the spontaneous mark of an artist's feelings, the stamp of his personality. To Lichtenstein it was another shape to be transformed by huge scale and the mechanical means of commercial art. And by his deadpan use of comic-strip methods to represent the Abstract Expressionist brushstroke, Lichtenstein was implying that the concept of art being a direct revelation of inner feeling was a myth.

The Abstract Expressionists, rejecting all reference to the everyday, transient world, conceived of human nature as noble and tried to express this in an abstract style along with an emotional use of paint. The Pop artists turned all of this insideout. Their painting methods were deliberately cool, and their themes were often taken without modification from familiar, everyday sources that had not previously been considered worthy subject matter for art. Lichtenstein himself openly imitated comic strips (fig. 12-11). In an interview titled "What is Pop Art?" he stated:

> Well, it *is* an involvement with what I think to be the most brazen and threatening characteristics of our culture, things we hate, but which are also powerful in their impingement on us. I think art since Cézanne has become extremely romantic and unrealistic, feeding on art; it is utopian. It has had less and less to do with the world, it looks inward. . . . Pop Art looks out into the world; it appears to accept its environment, which is not good or bad, but different— another state of mind.

Pop Art's vision of the world was not so cool that it precluded any judgment of what it saw. It is full of implied social commentary in its choice and its treatment of subject matter. The whole question of American themes that had been a major problem for earlier generations of artists (Chapter Nine) never even arose for the Pop artists, who plunged gleefully into the consumer society around them for their material. Just as Lichtenstein expanded the comicbook look into an art form that accurately reflected the emotional and intellectual level of the nation, Andy Warhol used massproduction techniques to emphasize the shallowness of American myths (colorplate 11), and Oldenburg combined national symbols

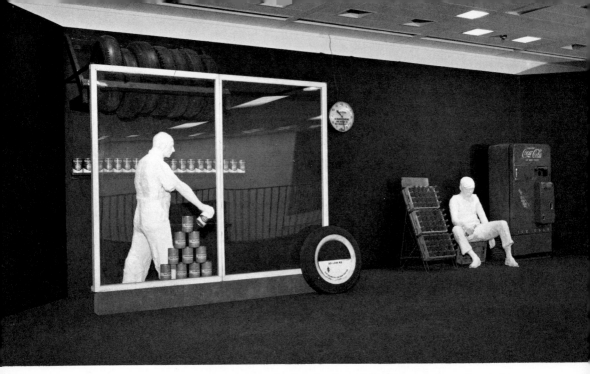

12-12 George Segal, *The Gas Station,* 1963. Plaster casts and real objects, 102'' x 288'' x 56''. The National Gallery of Canada, Ottawa.

in ways that ridiculed their purposes (colorplate 13). George Segal expressed a strong social commentary with rough plaster casts of real people set in environments of such real objects as walls, beds, or storefronts (fig. 12-12). The white, silent, frozen figures inhabit their realistic surroundings like ghosts, yet they do not seem out of place. The commonplace subject matter, the atmosphere of workaday boredom, and the static character of Segal's images invite comparisons with the paintings of Edward Hopper (fig. 9-8), who portrayed the same segment of American life in the thirties and forties. But the unusual medium evokes a more immediate sensation since the viewer encounters an environment of real objects, and Segal's pessimism is clearly related to the Pop ironies of the 1960s.

The vitality of Pop Art was instrumental in breaking the domination of Abstract Expressionism and in encouraging the growth of a great many other movements. Partly because of Pop's attraction to images of the real world, pictorial realism saw a surprising rebirth, while its use of the media as a source of style and subject matter was influential in the development of the Photo-Realist movement, which involves a highly literal translation of photo-

graphs to paintings. This particular approach to realism is made unique by the fact that the artists employ the camera to achieve visual ends that are not possible with the eye alone. Ralph Goings (fig. 9-11) uses a snapshot approach to attain a candidness and objectivity that are at odds with the classical tradition of figurative painting, while Chuck Close (colorplate 30), whose style is radically different from that of Goings, applies such elements of photography as focus, amplification, and color reproduction to the portraits he creates.

Pop Art may have established closer relations with the ordinary world, but at the same time it raised questions about the nature of art. If Roy Lichtenstein can copy a frame from a comic strip and call it art, then what about the original? When we get the Sunday papers do we also get dozens of little works of art? When we go to the supermarket are we seeing works of art on the shelves? The distinction between art and nonart has become less and less meaningful. When people first saw Oldenburg's huge sculptures of hamburgers (fig. 12-13), they insisted "This is not art, it's a hamburger." Oldenburg himself considered his work to be somewhere between art and life. Inevitably this challenge to the separation of art and nonart had to result in a challenge to the traditional separations of media.

12-13
Claes Oldenburg,
*Giant Hamburger,*
1962.
Canvas filled with foam and painted with liquitex and latex, 52" high.
Art Gallery of Ontario, Toronto.

*Minimal Art*     At the same time that the Pop artists were restoring the figure to painting and sculpture, other artists continued to develop the potential of abstract art. But unlike the Abstract Expressionists they did not work in bold gestures or inspired accidents. Even at the height of Abstract Expressionism the desire to explore the crises of one's personality through a spontaneous art was not universal among painters. Many had chosen less dramatic ways to work, preferring to concentrate on the investigation of elemental problems of color and space. Joseph Albers, for example, systematically studied the workings of the interactions of different hues in the long series of paintings that are titled *Homage to the Square* (colorplate 3), and Barnett Newman made use of the emotional potential of both color and space in his many stripe paintings (colorplate 14). At the other extreme of color painting were artists like Morris Louis (colorplate 5) who poured his paints out across the canvas in broad, smooth floods that stained the surface. Helen Frankenthaler (colorplate 31) was the first to try staining, adopting the technique from an accidental effect of Pollock, but applying it in a different way, drawing instead of dripping. She has since expanded her range of working methods to include practically every way that paint can be spread on canvas—pouring, sponging, even brushing—and has found ways to create a feeling of depth through staining. Over the past twenty years, her work has been in the forefront of the advances of *Color-Field Painting*.

*Minimal Art* was the other major branch of abstract painting in the sixties, and it too was a continuation of the work of artists like Albers and Newman, but in this case the emphasis was on form and structure. In some ways it was also related to the art of Mondrian (colorplate 18), but there is a crucial difference in approach. Though he sought balance in his work, Mondrian rejected the static, lifeless quality of symmetrical composition, and his paintings were an attempt to express a unity and a harmony of proportions that would reflect a higher order of things—an essentially religious view of art. The Minimalists, however, had rejected compositional effects in art at the same time that they rejected the undisciplined character of Abstract Expressionism, and their work therefore tended to be rather symmetrical. The dry and simple patterns more closely resemble the images of Pop than those of other abstract art, sharing the same cool attitude, carefully avoiding any emotion. If there is content in this work, it would have to do with the latent power of silence.

12-14 Frank Stella, *Itata,* 1964. Metallic powder in polymer emulsion on canvas, 77" x 122". Collection of Philip Johnson.

Although the early shaped canvases of Frank Stella (fig. 12-14) may appear complex at first glance, they represent a considerable step in the direction of minimalization. Stella aimed at consolidating the painting into a single, indivisible image and employed several devices to accomplish this: his works were usually symmetrical; limited to two unmodulated colors painted on raw canvas to increase the flattening effect (as Morris Louis did); set on unpainted frames that jutted out as much as three inches to stress the fact that this was only a surface; and structured in narrow bands that ran parallel to the edges of the frame to echo the overall shape. Stella succeeded in making his paintings refer only to themselves, an ultimate step in the exclusion of content; as he himself once put it, ''only what can be seen there *is* there.''

In traveling the long road from window-to-the-world to self-referring object, painting divested itself of content and the ability to trigger emotional reactions. Sculpture differed little from painting in this respect, but the extra dimension greatly multiplied the number of relationships between elements that the artist might work with, while its existence in *real* space helped to reinforce the sense that it was an object. Some Minimalist sculptors attempted to develop these points by creating works of several elements in

which the space between became almost as important as the solid structures. The fluorescent-light sculptures of Dan Flavin (color-plate 7) were among the first and most radical experiments in changing the space and making the viewer more aware of it. Don Judd's wall sculptures, sets of metal boxes that were attached to the wall one above the other, presented a similar idea on a smaller scale, stressing a single form through a persistent repetition of that form and equal intervals of the same dimensions (fig. 12-15). Other artists carried this concept further, displaying their work in exhibitions in such a way as to make the viewer aware of relationships between the individual sculptures and, in some cases, even between the sculpture and the shape of the room. Just as Minimal painting was far removed from the idea of a "window," Minimal sculpture aimed at playing a role quite different from that of the traditional statue isolated on the top of a pedestal.

*Op and Kinetic*

Technology pervades all of art whether it is a sculpture of polyester resin and fiber glass or a painting of the fifteenth century using oil as a medium. Some artistic products, however, make particular use of recent scientific and postindustrial technology.

*Op Art,* its name derived from the word optical, enjoyed the public limelight right after Pop Art (hence the journalistic alliteration between the names). While using the traditional medium of paint on canvas, these artists were notably skillful in applying a scientific understanding of optics. Like Minimal Art, Op Art is abstract, geometric, and hard-edged but differs principally in that it presents an active rather than a passive visual field.

Op Art grew directly out of the work of Mondrian and the artists and designers of the German Bauhaus and was influenced by the studies of visual perception that were being carried out by many psychologists and scientists from the 1920s onward. The recognized pioneer of this style is the Hungarian-born Victor Vasarely, whose work in Paris in the forties and fifties set an example for many other artists. It was a movement dominated by Europeans and South Americans living in Europe, although a few artists from the United States, such as Richard Anuszkiewicz, did develop related styles. Vasarely's experiments have covered all of the visual elements from color to line, and tend to apply the principles discovered to the creation of illusions of space. He is skilled in the art of making a flat surface appear to advance or retreat (fig. 3-10), or of establishing a number of levels within a picture (colorplate

12-15
Donald Judd,
*Untitled,*
1965.
Galvanized iron and aluminum,
seven boxes measuring
9'' x 40'' x 31''
with 9'' intervals.
Collection of Gordon Lockley,
Minneapolis, Minnesota.

32) with simple, rhythmic abstract patterns and color variations that establish their own nonlinear systems of perspective. Vasarely has also been a leader in the search for a more useful social context for art. Like the American Minimalists, he rejects the idea of art as an expressionistic gesture of the individual. Going a step further, he has attempted to find ways to place this art at the service of the public—through murals, industrial design, and the principles of mass production. For a time in the mid-sixties, while Op Art was considered fashionable, some designs were adopted, stolen, or invented for the decoration of women's clothing, but other than that the movement and its social ideals have had little impact in the United States.

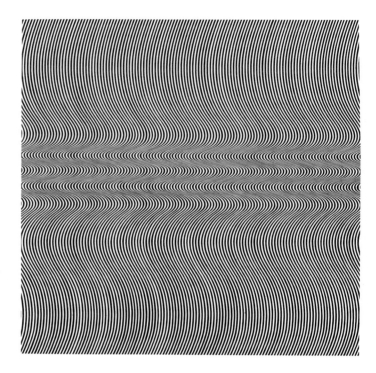

Bridget Riley (fig. 12-16), a British Op artist, has been the most prominent in the area of apparent motion, which she achieves with compact patterns spread over large areas. Systems of curving lines or other related shapes are designed so that the eye is never allowed to come to rest, an effect that can be both tantalizing and annoying. Riley has experimented extensively with color as well and is unique in her studies of graduated tone variations (with which she can add effects of depth to those of motion).

Kinetic art, which was discussed in Chapter Three, underwent an interesting new period of development during the fifties and sixties as well, its aims being very closely linked to those of the Op artists. Many of the most impressive of these artists did work in Paris with Vasarely, or were at least very much aware of what he had done. Argentine Julio Le Parc's dazzling murals of light (fig. 12-17) are typical of the approach of the European-based artists, who favored extremely simple means and tended to shy away from mechanical devices. His Continual-mobiles are de-

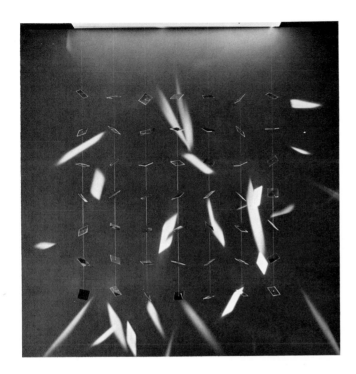

12-17
Julio Le Parc,
*Continual Mobile, Continual Light,*
1963.
Steel and nylon, 63" high.
Tate Gallery, London.

scendants, as the name suggests, of the works of Alexander Calder (fig. 3-19) and are constructed of nothing more than pieces of polished metal hung on nylon threads. But in spite of their simplicity and geometric elements, the forms these mobiles reflect on walls and ceiling ironically recall the slashing brushwork of the Abstract Expressionists.

More advanced kinetic sculpture has not been as common as one might expect in this modern era, and what has been done is not as respectful of the machine as was the case with the painting, sculpture, and architecture of the early part of the century. The impudent contraptions of Jean Tinguely (fig. 3-20) offer more to laugh about than to think about, pumping away and achieving absolutely nothing or performing such questionable tasks as drawing "abstract" pictures. Perhaps the most intriguing—and potentially frightening—branch of contemporary kineticism is that which experiments with cybernetics, the science that treats the principles of communication and control in both living organisms

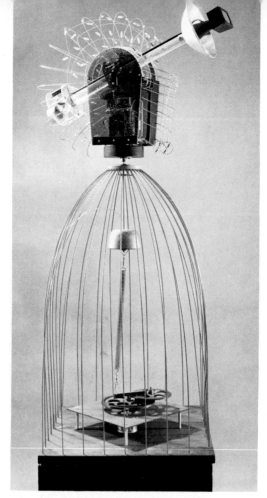

12-18  James Seawright, *Searcher*, 1966.
Metal, plastic, electronic parts,
53¾" x 20" x 20". Whitney Museum of American Art
(gift of the Howard and Jean Lipman Foundation, Inc.).

and machines. James Seawright's *Searcher* (fig. 12-18) is a "be-havioral sculpture" that responds to changes in the light surrounding it, including, of course, the blocking or reflecting of light by human viewers who approach it. The work can be programmed to seek or avoid light. Almost as if the sculpture were alive, it may follow a person around the room with its scanning mechanism. Moreover, Seawright has adjusted the relative efficiency of the various circuits that feed information about the light into the motor mechanism so that the sculpture will not merely repeat a set series of movements but can be given, as he has put it, "a definite personality."

*Happenings, Events, and Performances*

One of the most important developments of the sixties—and a key element in the overall "opening up" of art—was the adoption of live performances by painters and sculptors. This trend began with the Happening, which has already been discussed at length in Chapter Three, and became progressively more directed and concentrated in later stages that are often referred to as *events* or *performances.* The range of these activities can be extraordinarily broad, from the intensely individual to monumental operations that involve hundreds of people. An example of the latter is the wrapping of one million square feet of Australian coastline by hundreds of volunteers in 1969 (fig. 12-19). The project was the idea of the Bulgarian-born, American artist Christo, who began wrapping objects in Paris in the early sixties and slowly worked his way up through public monuments and buildings to the superscale of the Australian enterprise. His work is related to the anti-monuments of Oldenburg (described in Chapter Seven) in terms of size, but it is much more abstract in appearance. If it has any associations, it is with funeral shrouds or the sheets that cover furniture in uninhabited houses.

**12-19   Christo,** *Wrapped Coast,* **Little Bay, Australia, 1969. Cloth and rope, 1,000,000 square feet.**

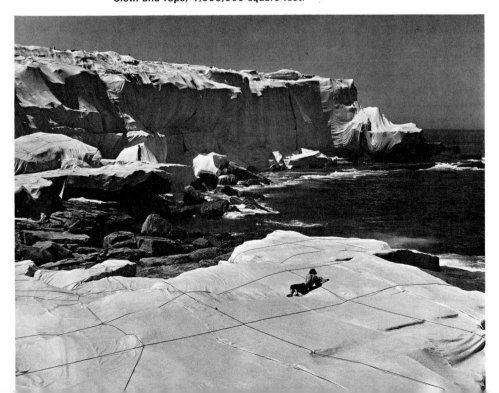

Events of this nature involve the spectator more directly than Happenings did, including him in the making of the art work— although rarely in the planning. Performance pieces, which are the other principal descendant of the expansion into theater that began with the Happening, usually involve only one or two people who present a prepared activity or carry out some form of variable experiment. Among the most successful of the performers of recent years are Gilbert & George, who bridged the gaps between art and life, the visual and the theatrical, by painting their faces with metallic paint and presenting themselves as "singing sculptures" (fig. 12-20).

12-20  Gilbert & George as Singing Sculptures
in "Underneath the Arches . . .", 1970.
Courtesy Sonnabend Gallery, New York.

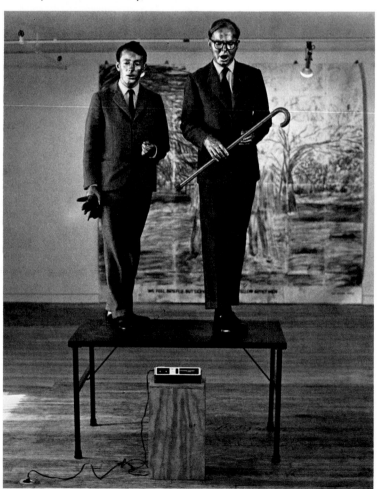

*Conceptual Art*  Happenings, events, and performances not only helped to erase the traditional distinctions between the various media and to affect the role of the viewer of art, they were also instrumental in raising some very basic questions about the nature of art. As the scale of the projects expanded to the degree that they occurred over such a large area that the participants were only able to communicate by letter or phone, the object—or any kind of contiguous visual form—was gone. The artist was like the commander of an army overseeing a huge military operation, and it was only through photographs, films, or other documents of the work that viewers were able to appreciate it. Frequently the expense or other considerations made the work impossible to create and left the whole thing in the project stage.

Some artists argued that the creation of art is possible without necessarily producing objects or events. Just as Duchamp had earlier challenged the definition of art by designating certain random manufactured objects as art works that he called readymades (Chapter Eleven), they were prepared to challenge the need for anything but the idea itself. Nevertheless, *Conceptual Art* did require some concessions to the physical world since it is impossible, short of telepathy, to communicate an idea without a medium. The documents of the Conceptual artists were for the most part borrowed from the media of everyday life: photographs, tape recordings, photocopy, or postcards.

The variety of ways in which art-as-idea has been practiced has helped to expand the range of artistic possibilities and, of course, make definitions even more impossible to establish. Some forms rely on performance as medium, others on writing, still others on normally undetectable means such as radio waves passing through a room, and the objectives of such art are nearly as many as there are artists. Rather than prove a dead end, the elimination of the art object has produced a seemingly endless number of possibilities.

**The Seventies and Beyond**  Although recent art has been dominated by developments in the United States, it is important to remember that it is all an extension of the aesthetic revolution that began over a century ago with the scandal over Manet's *Luncheon on the Grass*. Each major work of art throughout history has inspired changes in the works that followed, but this particular painting seems to be the logical choice

as the launching point of the enormous series of changes and the steady process of reduction that has marked the period we call ''modern art.''

The modern movement was never a unified or orderly progression. Viewed broadly, certain general patterns can be identified. One movement, centering on an interest in form, begins with Cézanne and links the Cubists and Mondrian with the recent geometric art of Minimalism, Op, and even Pop Art. Another, concentrating on color, begins with the Impressionists and connects Seurat, Matisse, and Kandinsky, with such color-oriented abstract artists of our own day as Albers, Louis, and Frankenthaler. The expressionistic tradition that began with van Gogh and Munch was still present in the abstract painting of Pollock and De Kooning in the fifties. The questioning stance of Duchamp remains strong in the work of the Conceptual artists. None of these divisions is clear-cut; many artists might be grouped under several headings. Indeed, the present situation defies categories.

Art in the seventies—and, presumably, in the future—is subject to an aesthetic freedom and variety that Manet could never have conceived of. Enter a gallery today and you are likely to find abstract art side by side with photographic realism, the hard edge of steel next to a formless sculpture of latex, geometric by organic, physical with conceptual. Anything is possible.

12-21

**John Baldessari**
**Cremation Piece,** June 1969.

"One of several proposals to rid my life of accumulated art. With this project I will have all of my accumulated paintings cremated by a mortuary. The container of ashes will be interred inside a wall of the Jewish Museum. For the length of the show, there will be a commemorative plaque on the wall behind which the ashes are located. It is a reductive, recycling piece. I consider all these paintings a body of work in the real sense of the word. Will I save my life by losing it? Will a Phoenix arise from the ashes? Will the paintings having become dust become art materials again? I don't know, but I feel better."

# Picture
# Credits

Chapter 1:   p. 12, Anderson-Art Reference Bureau; 13, Soichi Sunami.

Chapter 2:   p. 24, from "Information Theory and Figure Perception" by R. T. Green and M. C. Curtis. *Acta Psychologia,* Vol. 25, 1966, pp. 12–36, Elsevier Excepta Medica, North Holland; 26, Kate Morgan Guttman; 27, *top,* Gerald B. Liebenstein; *bottom,* Michael S. Smedley; 28, D. N. Chauduri, India Consulate General; 30, The Museum of Modern Art, New York; 32, Art Reference Bureau; 38, A.C.L.-Art Reference Bureau.

Chapter 3:   p. 43, Alinari-Scala New York/Florence; 45, William Dyckes; 50, Alinari-Scala New York/Florence; 51, Charles Uht; 52, eeva-inkeri, New York; 55, Alinari-Scala New York/Florence; 60, *The New York Times;* 61, *left,* Fourcade, Droll, Inc., New York; *right,* Eric Pollitzer, New York; 62, Draeger Frères; 63, W. S. Stoddard; 65, *left,* Niedersächsiche Landesgalerie, Hanover; *right,* Fred W. McDarrah, New York; 67, Gianfranco Gorgoni, New York; 70, Royal Institute of British Architects; 71, *left,* Harbrace Photo; *right,* Library of Congress; 73, Ezra Stoller Associates © ESTO; 74, Australian Tourist Commission; 75, Man & His World Photo; 76, Quebec Government Tourist Office.

Chapter 4:   p. 81, Colorphoto Hinz, Basle; 83, 84, 85, The American Museum of Natural History, New York; 87, 88, Hirmer Fotoarchiv, Munich; 89, Deutsches Archaeologisches Institut, Rome; 93, Hirmer Fotoarchiv, Munich; 96, 98, Alinari-Scala New York/Florence; 99, Photographie Giraudon, Paris; 105, Gianfranco Gorgoni, New York.

Chapter 5:   p. 107, Trans World Airlines; 108, American Airlines; 109, Alison Frantz; 110, ENIT; 111, The Public Archives of Canada; 112, Wendy V. Watriss, Woodfin Camp & Associates; 113, from "The Dogon People" by Fritz Morganthaler, © 1969 Barrie and Jenkins, Ltd., London. Reprinted from *Meaning in Architecture,* Charles Jencks and George Baird, eds. George Braziller, Inc., New York, 1970; 119, reprinted from *Le Corbusier: Oeuvre Complete,* Artemis Verlag, Zurich, 1967; 120, New York City Housing Authority; 121, Hedrich-Blessing, Chicago; 122, Alinari-Scala New York/Florence; 123, 124, Fototeca Unione-Art Reference Bureau; 125, Robert Stefl; 126, Douglas R. Long, New York; 127, Sekai Bunka Photo; 128, reprinted from *The Japanese House, A Tradition for Contemporary Architecture* by Heinrich Engel, © 1964 by Charles E. Tuttle, Inc.; 129, Sekai Bunka Photo; 131, Chicago Architectural Photographing Co.; 132, reprinted from *American Architecture and Urbanism* by Vincent Scully. Frederick A. Praeger, 1969; 133, Dan Budnik, Woodfin Camp & Associates; 134, Architekten "Atelier 5," Bern, Switzerland, Foto A. Winkler; 136, Hedrich-Blessing, Chicago; 137, Historical Picture Service, Chicago; 138, reprinted from *American Science and Invention* by Mitchell Wilson, © 1954 by Simon & Schuster; 140, *left,* General Electric Major Appliance Business Group; *right,* The Magnavox Company.

Chapter 6:    p. 146, TAP Service; 147, 148, 149, 151, 152, Alinari-Scala New York/Florence; 155, Scala New York/Florence; 156, 159, 161, Alinari-Scala New York/Florence; 166, Photo courtesy Sidney Janis Gallery, New York; 167, Culver Pictures; 168, John Nicholias, Woodfin Camp & Associates; 169, 170, Raghubir Singh, Woodfin Camp & Associates; 171, *left,* Lauros, Photographie Giraudon, Paris; *right,* Raghubir Singh, Woodfin Camp & Associates; 172, Brogi-Art Reference Bureau; 174, Photographie Giraudon, Paris.

Chapter 7:    p. 180, André Held; 182, Hirmer Fotoarchiv, Munich. Drawing by J. D. S. Pendlebury 1933/1954; 183, The Memory Shop; 186, Alinari-Art Reference Bureau; 187, *left,* Anderson-Art Reference Bureau; *right,* Anderson-Giraudon; 189, Lee A. Ransaw; 192, Harry Shunk; 194, Library of Congress; 195, Cinema Center Films.

Chapter 8:    p. 197, Pedro Rojas, courtesy of Dr. Bernard Meyers; 198, Roger-Viollet, Paris; 199, Alinari-Art Reference Bureau; 200, Alinari, Florence; 201, 204, Alinari-Art Reference Bureau; 205, Alinari, Florence; 210, The Museum of Modern Art, New York.

Chapter 9:    p. 231, Eric Pollitzer, courtesy of O. K. Harris Works of Art, New York.

Chapter 10:   pp. 237, 238, Chrysler Motors Corporation, Historical Collection; 239, *top,* Ben Kocivar, Air Pixies; *bottom,* Chrysler Motors Corporation, Historical Collection; 240, Alinari-Scala New York/Florence; 241, Alison Frantz; 244, The Museum of Modern Art, New York; 245, Evans Products Company, Portland, Oregon; 246, 247, 248, Bruckmann-Art Reference Bureau.

Chapter 11:   p. 277, Henri Mardyks.

Chapter 12:   p. 285, photo courtesy of Marlborough Gallery, Inc., New York; 286, Hans Namuth; 292, 293, 299, courtesy of the Leo Castelli Gallery, New York; 305, Harry Shunk; 306, courtesy of the Sonnabend Gallery, New York.

Colorplates:  4, photo Musées Nationaux, Paris; 6, photography by Sandak, Inc., New York; 10, Scala New York/Florence; 11, photo courtesy of the Leo Castelli Gallery, New York; 12, © A.D.A.G.P., photo courtesy of Photographie Giraudon, Paris; 13, photo by Dennis Chalkin; 19, photo Musées Nationaux, Paris; 20, photograph by Scala New York/Florence; 31, photo courtesy André Emmerich Gallery, New York.

Permission from S.P.A.D.E.M., 1974 by French Reproduction Rights, Inc. for the following: pp. 33, 166, Plates 21 and 24.

Permission from A.D.A.G.P., 1974 by French Reproduction Rights, Inc. for the following: p. 174, Plate 12.

# Suggestions
# for
# Further
# Study

Amaya, Mario. *Pop Art . . . and After.* New York: Viking Press, 1972.

Anderson, Donald M. *Elements of Design.* New York: Holt, Rinehart and Winston, 1961.

Arnason, H. H. *History of Modern Art: Painting, Sculpture and Architecture.* Englewood Cliffs, N.J.: Prentice-Hall; New York: Harry N. Abrams, 1968.

Arnheim, Rudolf. *Art and Visual Perception: A Psychology of the Creative Eye.* Berkeley and Los Angeles: University of California Press, 1954.

————. *Visual Thinking.* Berkeley and Los Angeles: University of California Press, 1969.

Ashton, Dore. *A Reading of Modern Art.* Cleveland: Press of Case Western Reserve University, 1969.

————. *The New York School: A Cultural Reckoning.* New York: Viking Press, 1973.

Badt, Kurt. *The Art of Cézanne.* Trans. by Sheila A. Ogilvie. Berkeley and Los Angeles: University of California Press, 1965.

Barr, Alfred. *Matisse: His Art and His Public.* New York: Museum of Modern Art, 1951.

————. *Picasso—Fifty Years of His Art.* New York: Museum of Modern Art, 1955.

Battcock, Gregory, ed. *Minimal Art: A Critical Anthology.* New York: E. P. Dutton & Co., 1968.

————, ed. *New Ideas in Art Education: A Critical Anthology.* New York: E. P. Dutton & Co., 1973.

————, ed. *The New Art: A Critical Anthology.* Rev. ed. New York: E. P. Dutton & Co., 1973.

Bell, Clive. *Art.* New York: G. P. Putnam's Sons, Capricorn, 1959.

Bowness, Alan. *Modern European Art.* New York: Harcourt Brace Jovanovich, 1972.

Burnham, Jack. *Beyond Modern Sculpture.* New York: George Braziller, 1968.

Calas, Nicholas, and Calas, Elena. *Icons and Images of the Sixties.* New York: E. P. Dutton & Co., 1971.

Campbell, Joseph. *The Hero with a Thousand Faces.* Rev. ed. Princeton: Princeton University Press, 1968.

Carter, Dagny. *Four Thousand Years of China's Art.* New York: Ronald Press, 1948.

Champigneulle, Bernard. *Rodin.* Trans. by J.

Maxwell Brownjohn. New York: Harry N. Abrams, 1967.

Chipp, Herschel B. *Theories of Modern Art: A Source Book by Artists and Critics.* Berkeley and Los Angeles: University of California Press, 1968.

Clark, Kenneth. *Landscape Into Art.* London: John Murray, 1966.

―――. *Leonardo da Vinci.* Baltimore: Penguin Books, Pelican Books, 1968.

―――. *Looking at Pictures.* Boston: Beacon Press, 1968.

―――. *The Nude: A Study of Ideal Form.* Garden City, New York: Doubleday & Co., Anchor Books, 1956.

Cleaver, Dale G. *Art: An Introduction,* 2nd ed. New York: Harcourt Brace Jovanovich, 1972.

Crespelle, Jean-Paul. *Chagall.* New York: Coward, McCann & Geoghegan, 1970.

de la Croix, Horst, and Tansey, Richard G. *Gardner's Art Through the Ages.* 5th ed. New York: Harcourt Brace Jovanovich, 1970.

Dorra, Henri. *Art in Perspective.* New York: Harcourt Brace Jovanovich, 1973.

Dover, Cedric. *American Negro Art.* 3rd ed. Greenwich, Conn.: New York Graphic Society, 1965.

Ehrenzweig, Anton. *The Hidden Order of Art: A Study in the Psychology of Artistic Imagination.* Berkeley and Los Angeles: University of California Press, 1967.

Elgar, Frank. *Braque: 1906–1920.* New York: Tudor Publishing Co., 1958.

Engel, Heinrich. *The Japanese House: A Tradition for Contemporary Architecture.* Rutland, Vt. and Tokyo: Charles E. Tuttle Co., 1964.

Evenson, Norma. *Le Corbusier: The Machine and the Grand Design.* New York: George Braziller, 1969.

Ewers, John C. *Artists of the Old West.* Garden City, New York: Doubleday & Co., 1973.

Fast, Julius. *Body Language.* New York: Simon & Schuster, Pocket Books, 1971.

Fernandez, Justino. *A Guide to Mexican Art: From Its Beginnings to the Present.* Chicago: University of Chicago Press, 1969.

Fleming, William. *Arts and Ideas.* New York: Holt, Rinehart and Winston, 1963.

Franciscono, Marcel. *Walter Gropius and the Creation of the Bauhaus in Weimar: The Ideals and Artistic Theories of Its Founding Years.* Urbana, Ill.: University of Illinois Press, 1971.

Furneaux Jordan, Robert. *A Concise History of Western Architecture.* New York: Harcourt Brace Jovanovich, 1970.

Gablik, Suzi. *Magritte.* Greenwich, Conn.: New York Graphic Society, 1973.

Gibson, James J. *The Perception of the Visual World.* Boston: Houghton Mifflin, 1950.

Giedion, Sigfried. *Space, Time and Architecture: The Growth of a New Tradition.* 5th rev. ed. Cambridge, Mass.: Harvard University Press, 1967.

Godfrey, F. M. *Italian Sculpture,* 1250–1700. New York: Taplinger Publishing Co., 1968.

Gombrich, Ernst H. *Art and Illusion: A Study in the Psychology of Pictorial Presentation.* 2nd ed. Princeton: Princeton University Press, 1961.

Gombrich, Hochbery, and Black. *Art, Perception and Reality.* Baltimore: Johns Hopkins University Press, 1972.

Goodman, Nelson. *Languages of Art: An Approach to a Theory of Symbols.* Indianapolis, Ind.: Bobbs-Merrill Co., 1968.

Goya, Francisco. *Complete Etchings.* New York: Crown, 1943.

Graves, Robert. *The Greek Myths.* Vol. 1. Baltimore: Penguin Books, Pelican Books, 1955.

Haftmann, Werner. *Painting in the Twentieth Century.* Vol. 1, *An Analysis of the Artists and Their Work.* New York: Praeger Publishers, 1965.

Hamilton, George H. *Manet and His Critics.* New York: W. W. Norton & Co., 1969.

Hartt, Frederick. *History of Italian Renaissance Art.* New York: Harry N. Abrams, 1969.

Hess, Thomas B. *Barnett Newman.* New York: Museum of Modern Art, 1971.

―――. *Willem de Kooning.* New York: Museum of Modern Art, 1969.

Hess, Thomas B., and Ashbery, John, eds. *Avant-Garde Art.* New York: Macmillan, 1971.

Hodin, J. P. *Oskar Kokoschka.* Greenwich, Conn.: New York Graphic Society, 1966.

Hogg, James, ed. *Psychology and the Visual Arts.* Baltimore: Penguin Books, 1970.

Hunter, Sam. *American Art of the Twentieth Century.* New York: Harry N. Abrams, 1973.

————. *Modern French Painting.* New York: Dell, 1956.

Huxtable, Ada L. *Will They Ever Finish Bruckner Boulevard?* New York: Macmillan, 1970.

Ivins, William M., Jr. *Prints and Visual Communication.* Cambridge, Mass.: M.I.T. Press, 1969.

Jacobs, J., ed. *The Great Cathedrals.* New York: American Heritage, 1968.

Jaffé, Hans L., ed. *Mondrian.* New York: Harry N. Abrams, 1970.

Jean, Marcel, and Mezei, Arpad. *The History of Surrealist Painting.* Trans. by Simon Watson Taylor. New York: Grove Press, 1960.

Jencks, Charles, and Baird, George, eds. *Meaning in Architecture.* New York: George Braziller, 1970.

Kahler, Heinz. *The Art of Rome and Her Empire.* New York: Crown Publishers, 1963.

Kepes, Gyorgy. *Language of Vision.* Chicago: Paul Theobald & Co., 1945.

Khatchadourian, Haig. *The Concept of Art.* New York: New York University Press, 1971.

Kirby, Michael, ed. *Happenings: An Illustrated Anthology.* New York: E. P. Dutton & Co., 1965.

Klingender, Francis D. *Animals in Art and Thought.* Ed. by Evelyn Antal and John Harthan. Cambridge, Mass.: M.I.T. Press, 1971.

Kohler, Wolfgang. *Gestalt Psychology.* New ed. New York: Liveright, 1970.

Kubler, George A. *The Shape of Time: Remarks on the History of Things.* New Haven: Yale University Press, 1962.

Lal, Kanwar. *Immortal Khajuraho.* Delhi: Asia Press, 1965.

Lippard, Lucy R. *Pop Art.* New York: Praeger Publishers, 1966.

Locke, Alain, ed. *The Negro in Art: A Pictorial Record of the Negro Artist and the Negro Theme in Art.* New York: Hacker Art Books, 1971.

Louis, Morris. *Morris Louis.* Ed. by Michael Fried. New York: Harry N. Abrams, 1971.

McFee, June K. *Preparation for Art.* 2nd ed. Belmont, Calif.: Wadsworth Publishing Co., 1970.

McLanathan, Richard. *The American Tradition in the Arts.* New York: Harcourt Brace Jovanovich, 1968.

McLuhan, Marshall. *Understanding Media.* New York: New American Library, Signet, 1971.

Martindale, Andrew. *Gothic Art.* New York: Praeger Publishers, 1967.

Meyer, Ursula. *Conceptual Art.* New York: E. P. Dutton & Co., 1972.

Michalowski, Kazimierz. *The Art of Ancient Egypt.* New York: Harry N. Abrams, 1969.

Mingazzini, Paolino. *Greek Pottery Painting.* Trans. by F. B. Sear. London: Paul Hamlyn Books, 1969.

Mondriaan, Pieter Cornelis. *Plastic Art and Pure Plastic Art.* New York: George Wittenborn, 1945.

Muller, Joseph-Emile. *Rembrandt.* Trans. by Brian Hooley. New York: Harry N. Abrams, 1969.

Neumeyer, Alfred. *The Search for Meaning in Modern Art: Die Kunst in Unserer Zeit.* Trans. by R. Angress. Englewood Cliffs, N.J.: Prentice-Hall, 1965.

O'Connor, Francis V. *Jackson Pollock.* New York: Museum of Modern Art, 1967.

Owings, Nathaniel A. *The American Aesthetic.* New York: Harper & Row, 1969.

Peacock, Carlos. *John Constable: The Man and His Work.* Rev. ed. Greenwich, Conn.: New York Graphic Society, 1972.

Popper, Frank. *Origins and Development of Kinetic Art.* Greenwich, Conn.: New York Graphic Society, 1969.

Powell, Ann. *The Origins of Western Art.* New York: Harcourt Brace Jovanovich, 1973.

Ramsden, E. H. *Michelangelo.* New York: Praeger Publishers, 1971.

Read, Herbert. *The Art of Sculpture.* 2nd ed. Princeton: Princeton University Press, 1961.

Rewald, John. *Post Impressionism: From Van Gogh to Gauguin.* New York: Museum of Modern Art, 1962.

Richter, G. M. A. *A Handbook of Greek Art: A Survey of the Visual Arts of Ancient Greece.* 6th rev. ed. London: Phaidon Press, 1969.

Rickey, George. *Constructivism.* New York: George Braziller, 1967.

Rose, Barbara. *American Art Since 1900.* New York: Praeger Publishers, 1967.

———. *Claes Oldenburg.* New York: Museum of Modern Art, 1969.

Rosenblum, Robert. *Cubism and Twentieth-Century Art.* New York: Harry N. Abrams, 1968.

Rubin, William S. *Dada, Surrealism and Their Heritage.* New York: Museum of Modern Art, 1968.

Rudofsky, Bernard. *Architecture Without Architects: A Short Introduction to Non-Pedigreed Architecture.* Garden City, New York: Doubleday & Co., 1969.

———. *Streets for People.* Garden City, New York: Doubleday & Co., 1969.

Russell, John. *Seurat.* New York: Praeger Publishers, 1965.

Sandler, Irving. *The Triumph of American Painting: A History of Abstract Expressionism.* New York: Praeger Publishers, 1973.

Schefold, Karl. *Myth and Legend in Early Greek Art.* New York: Harry N. Abrams, 1966.

Scully, Vincent. *American Architecture and Urbanism: A Historical Essay.* New York: Praeger Publishers, 1969.

Seitz, William. *The Art of Assemblage.* New York: Museum of Modern Art, 1961.

Sewter, A. C. *Baroque and Rococo.* New York: Harcourt Brace Jovanovich, 1972.

Shearman, John. *Mannerism.* Baltimore: Penguin Books, Pelican Books, 1973.

Shepard, Paul. *Man in the Landscape.* New York: Alfred A. Knopf, 1967.

Solomon, Stanley J. *The Film Idea.* New York: Harcourt Brace Jovanovich, 1972.

Sontag, Susan. *Against Interpretation and Other Essays.* New York: Farrar, Straus & Giroux, 1966.

Talbot-Rice, David. *Art of the Byzantine Era.* New York: Praeger Publishers, 1963.

Taylor, Joshua C. *Learning to Look: A Handbook for the Visual Arts.* Chicago: University of Chicago Press, 1957.

Tralbaut, Marc E. *Van Gogh.* New York: Viking Press, 1969.

Waldman, Diane. *Roy Lichtenstein: Drawings and Prints.* New York: Solomon R. Guggenheim Museum, 1969.

Willets, William. *Foundations of Chinese Art.* New York: McGraw-Hill, 1965.

Wollheim, Richard. *Art and Its Objects: An Introduction to Aesthetics.* New York: Harper & Row, 1968.

Wright, Frank Lloyd. *When Democracy Builds.* Chicago: University of Chicago Press, 1945.

# Index